A Garden of Bi

Table of Contents

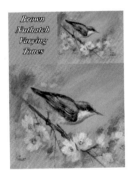
Lesson 1- 28

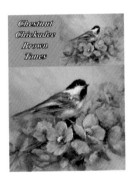
Lesson 2- 45

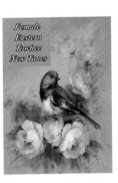
Lesson 3- 60

Lesson 4- 77

Lesson 5- 92

Lesson 6- 107

Lesson 7- 122

Lesson 8- 139

Published by
Jansen Art Studio Inc.
Elizabethtown, PA USA
David and Martha Jansen

Multimedia Content
Jansen Studio Productions
Ironville, PA USA
Jessica Jansen & Dave Parmer

Copyright Notice

1

Brushes Used in this Book

Paint It Simply- Fusion Specialty Brushes

Brushes Used for These Lessons

Brushes by Global Art Supply
This lesson is painted with the fusion flats and filberts. You can use either the flat or filbert in these lessons.

Brushes I used in these lessons
Fusion Flat Size 4, 6, 8 and 10
Fusion Flat Size 3/4 inch.
Watercolor Round # 4 or # 8
Raphael 16684 # 3 Quill for some liner details.

Fusion brushes must be used for these techniques. Attempting to use other brands and types of brushes will only lead to frustration. This is an American made brush that is very versatile. The brush hair is a synthetic squirrel and is very soft. It is much softer than normal acrylic brushes. This allows the artist to achieve a softer look to the painting with fewer strokes. This is very desirable for the techniques shown here because, with the Paint It Simply lessons, we don't want to blend. Achieving a soft look quickly is desirable.

Heritage MultiMedia® Paint System

Not all acrylics are the same. As a matter of fact, industry standards dictate controls over the labeling of acrylics as to quality and durability. For example, most bottle acrylics are not "artist" quality. To be labeled "artist quality" the paint must have little to no filler added. The artist quality paints are designed to be mixed together to form new and traditional colors. Be careful when selecting paint and make sure you are using the best quality you can afford.

For this book we are using Global Art Supply's Heritage MultiMedia® Acrylics. The techniques described in this book have been formulated to work with this paint line. **Substitution of brands is not recommended** as the mixing and technique results will not be the same, and you will hinder your ability to learn the techniques.

Heritage MultiMedia® is a resin based acrylic that can be easily converted into watercolor, Global Colors (oil emulation), and tempera colors. Basically, the artist controls the paint film, not the company.

Preparing the Surfaces for These Lessons

For these lessons I use Super MDF wood panels or Canvas Panels that I make. Please see GlobalArtSupply.com of detailed canvas making instructions. Whatever surface you choose to use, it should be semi-hard. We achieve this by mixing the base color with an equal amount of Heritage MultiSurface Sealer which will harden the paint layer making the techniques easier to accomplish.

Step 1
Mix White, or Medium White, with equal amount of MultiSurface Sealer and base the desired surface. Apply with soft brush or sponge shown here.

Step 2
Sand the surface with 150 to 220 grit sand paper to smooth. Do not use too fine a paper such as 400, because you will make the surface too slick.

Step 3
Transfer design or sketch with pencil. Follow next directions from each individual lesson. Give the surface a light transparent coat of paint and Extender.

Step 4
When coating the surface do not have too much paint or too thin (watery). This will make painting the design more difficult. Just a light coat, stretch it out.

Varnishing Your Finished Painting

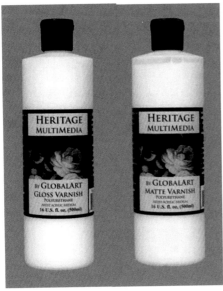

Heritage Varnishes are a state-of-the-art clear, non-yellowing, resin-based polyurethane varnish. They brush on smoothly and are self-leveling so that the artist doesn't have to stroke and stroke to smooth it out. It will give the quality protection of a Polyurethane varnish with the ease of application you have enjoyed from acrylics. Heritage Varnish is excellent for both interior and exterior use. When dry, it creates a hard, durable satin, gloss or matte finish that is ideal for artwork on a variety of surfaces. It dries quickly in 5 to 10 minutes, depending on weather conditions. You can slow that drying time with the addition of Extender Medium to the Varnish. For best results, thin the varnish with a little to equal amount of water. This makes application easier. Mix varnishes to create desired sheen. To make a Satin finish mix the Gloss and Matte Varnishes 1 to 1. Heritage Varnish is compatible with all Heritage paints and mediums. It is non-toxic and cleans up with soap and water. Because it is an acrylic product, it should not be used over oil based products.

Directions: Surface should be dust free and completely dry. Shake well then let the bottle stand for a few minutes. Apply with a brush or sponge. Varnish is easier to apply if thinned with water. Apply with a wet brush. Mist the surface with water if varnish begins to dry before you have finished varnishing. You can lengthen the drying time with the addition of Extender Medium. Additional coats can be applied as soon as the last coat is dry. Rinse brush thoroughly after use. Clean up with soap and water.

Two coats are sufficient for indoor use, three coats for exterior use. When applying multiple coats of varnish, allow NO MORE than 24 hours between coats. If you wait more than 24 hours, a light sanding with 400 grit sandpaper can be done to create better "tooth" for the final coat.

Making Global Colors using the Global Palette

To make Global Colors, we need to evaporate some of the water from the paint and replace it with our concentrated Extender Medium.

How long does it take?

This is a difficult question to answer because evaporation is different is different parts of the country. Generally, it takes 24 to 48 hours. The longer you leave the color open to evaporate water, the longer the open time of the final paints. You can achieve a 30 hour drying time if left open for 1 week.

How long can I store the Globals?

If you paint every few days, just put the lid on the palette and that is enough. If you are not going to paint for 1 week or 1 month, cover with press and seal before applying the lid. Properly stored the self life is indefinite. We have some Global Palettes that are perfect and 4 years old! Take care of your palette. With proper care and storage the paint will remain moist as in the tube. If you do not store properly, the paint will dry out!

Step 1

Step 2

Step 1

Fill the desired well 1/2 to 3/4 full of with the desired color of paint.

Step 2

Add about 20% to 25% Heritage Extender. No need to be perfect! Close is ok!

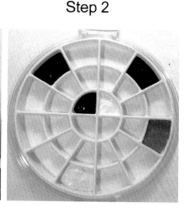

Step 3

Step 4

Step 3

Mix the color and Extender very well. This is important. Mix until the paint is creamy.

Step 4

Let the color stand for 24 to 48 hours while water evaporates. Stir the colors every 6 to 8 hours to help the evaporation of water.

Step 5

To store colors for a long time, cover the palette with Press and Seal before putting on the lid of the Global Palette.

Step 5

Step 6

Step 6

For longer storage you can mist the lid of the Global Palette with distilled water. Do not mist the paints.

Rendering Your Painting and Making a Plan

When painting birds, there are several approaches one can use. You can take a small liner brush and render each feather in precise detail and give the bird the ultimate realism. I painted some of these years ago and, while the painting came out beautifully, it didn't feel like a painting because it had no stroke movement. It was just a thousand fine liner strokes. While technically appealing, it didn't satisfy the artist in me nor really look like a painting. Now, that being said, not everyone will agree with my feelings. That is ok. The art world is huge and there is room for many opinions. Even mine. When I use paint and brush, I want it to look like a painting.

For me, I love the power of the stroke and the movement of thick paint. I guess that comes from years of Rosemaling and Alla Prima painting. So, when I paint, I like to feel paint! I love paintings that go from found to lost. This means that there are areas that are "blurry" or unrefined. This is what happens in nature and we should do the same thing in our paintings in order to accurately capture the feelings of nature.

Which each painting, I start with a plan. That plan can be as simple as: let's paint a flower. But, it is still a plan. Allowing some freedom in this plan will increase your creativity. However, you must understand the elements of the plan and the necessity for those elements in your painting. I can start with a very detailed plan which outlines colors, brushes, and techniques or I can start with a very simple plan and develop the painting along the way. The simple plan will have the same elements to the painting as the more complicated plan.

Art is about refining and developing your plan. With the designs in this book, we will set a goal with each painting and then head toward that goal. If your goal is to paint exactly like I did then you will be copying. If your goal is to understand my thought process, then your painting will be a little different than mine and that is wonderful. Both are ok. What is important is to set the plan, the expectation, and stay with it to avoid frustration.

For these paintings I set some plan guidelines like this:
1. Which object is the most important? If this painting is about the bird, I must paint the bird with the most interest. This means using more color contrast, more detailed strokes and liner movements. Textures and mottled color generate even more interest.

2. Am I rendering a realistic bird or painting an artistic expression of the bird? This is one of the most important questions an artist should ask about each painting. As I grew in my artistic understanding, I went through several stages. First, I wanted to paint realistically. I studied blending and made all my paintings very smooth. Later, I wanted to paint more casual and impressionistic. Realistic paintings will have defined edges and precise color changes. When you relax the edges and allow for the strokes to show you create the feeling of a painting. Paintings have texture and strokes that give the viewer the feeling of a painting and not a photograph.

3. When painting the bird, first I will establish the undertone, then the darker and lighter areas. I slowly refine the bird until I add the amount of detail desired

4. Work and rework the painting and allow it to evolve. This is how I like to paint. I paint each painting for what it needs at any given time. I do not follow specific steps because this can lead to copying. Copying is ok, but when I create a new design, I need to make a plan.

So, to start a painting, your plan can be very simple. These are just a few guidelines to help you develop the painting. Do not plan too much. If a plan is too detailed, you will shut down your creativity. You always want to leave room for changes within the painting. Painting is about change.

Rendering the Bird Image

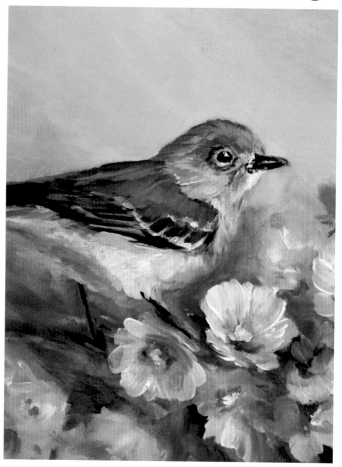 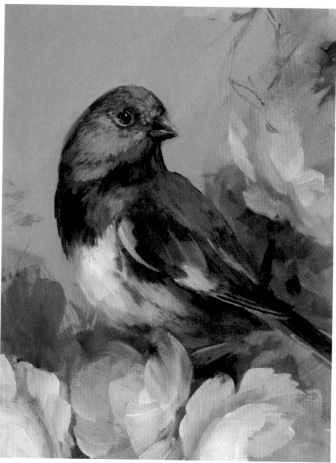

Here are 2 examples of paintings in the book and my thought process that goes with them.

The Vireo on the left is painted more casually. The image is rendered as a painting. Notice how relaxed the brush strokes are. The feeling of the feathers is loose and not perfect. I use a large brush to capture the movement in the painting.

The Towhee on the right is painted precisely. While not a realistic bird, I do take time and care with the image. The details are more accurate with lines carefully applied with the negative painting technique. I enjoy both looks when painting. Both are correct and both are fun to paint. One is loose, the other is more precise.

Creating a Vignetted Painting

To vignette a painting is to apply color while maintaining some of the original background. I have read many rules over the years- such as 20% of the painting must be the white of the canvas. I don't know if agree with that, but it is a good place to start.

Basically, the artist chooses the interest area and contrasts it with a background color. That expression softens as the you move away from the center of interest. In this example, notice how the blue contrasts with the head of the Chickadee and then softens, even with strokes, to the medium toned background. You can add other colors. It is an artistic look that I love exploring.

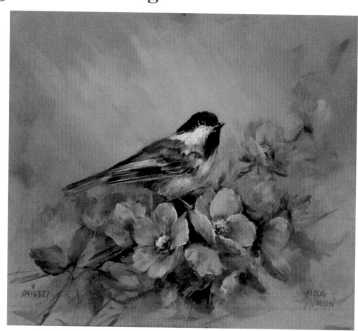

Anatomy of the Bird

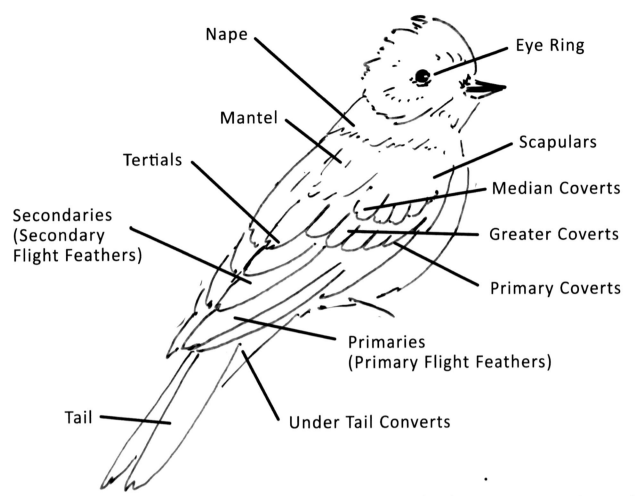

Nape

Eye Ring

Mantel

Scapulars

Tertials

Median Coverts

Secondaries
(Secondary
Flight Feathers)

Greater Coverts

Primary Coverts

Primaries
(Primary Flight Feathers)

Tail

Under Tail Converts

When painting birds, you must decide how you're going to render them. Are you creating a painting in which some of the anatomy will be lost to the art or a detailed study where you paint them a little more realistically? Anatomy is important. Each bird is a little different and sometimes due to position you do not see all the feather groupings.

Just like I explain in flower painting, it is easier to paint something if you understand its structure. You do not have to memorize all the parts, just be aware of them because structure gives you ideas on how to paint the birds. It shows you in which direction to move the brush. Let's take a brief look.

There are many parts to the bird, but I generally divide it into just a few areas for ease of painting. Flight Feathers, Mantle, Coverts, Tail, Head and Eye Ring. Head and tail are easy. Here are the others:

Flight Feathers-Primaries, Secondaries and Tertials.
These are the largest feathers on the bird and are on the wing. I paint them with the longest strokes.

Coverts
Median, Greater, Primary- These are smaller feathers that cover the flight feathers. They really make up a larger visual part of the wing and are stacked in layers.

Mantle
This represents the beginning of the back on the bird. I will call the top of the wing the mantle in the instructions for ease of understanding. The mantle sits on top the scapulars (on top of the front of the wing). I generally paint this area all as one movement for ease.

Making a Quick Sketch- See the Bird's Lines

Many times I work from photos of real birds, but it never hurts to know how to make a quick sketch. Any good plan starts with a quick sketch. Each artist is different in their approach. I do the following: Vary the movement lines of the head and body to turn the head in different directions. Look at each pattern in the book and see if you can find the lines.

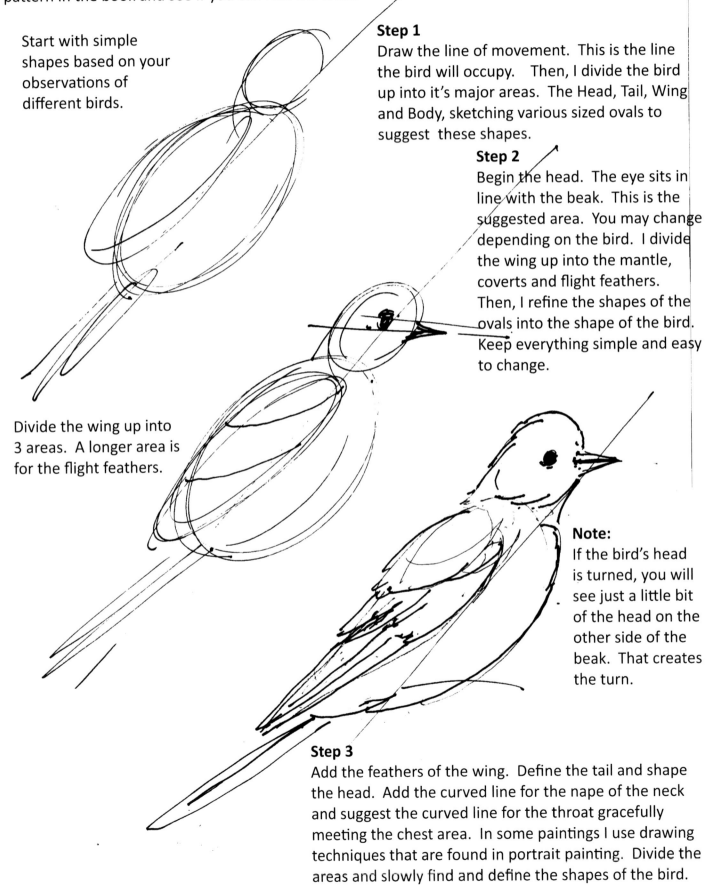

Start with simple shapes based on your observations of different birds.

Divide the wing up into 3 areas. A longer area is for the flight feathers.

Step 1
Draw the line of movement. This is the line the bird will occupy. Then, I divide the bird up into it's major areas. The Head, Tail, Wing and Body, sketching various sized ovals to suggest these shapes.

Step 2
Begin the head. The eye sits in line with the beak. This is the suggested area. You may change depending on the bird. I divide the wing up into the mantle, coverts and flight feathers. Then, I refine the shapes of the ovals into the shape of the bird. Keep everything simple and easy to change.

Note:
If the bird's head is turned, you will see just a little bit of the head on the other side of the beak. That creates the turn.

Step 3
Add the feathers of the wing. Define the tail and shape the head. Add the curved line for the nape of the neck and suggest the curved line for the throat gracefully meeting the chest area. In some paintings I use drawing techniques that are found in portrait painting. Divide the areas and slowly find and define the shapes of the bird.

A Quick Overview of Design

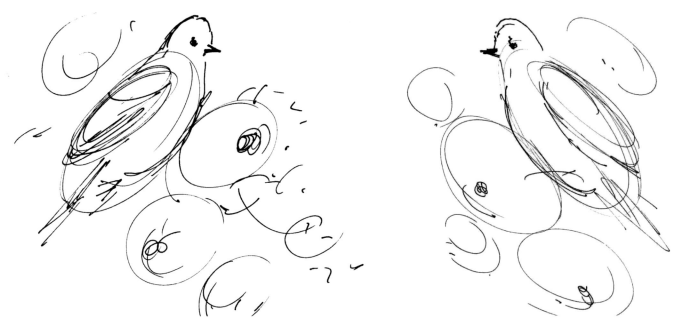

This book doesn't focus on design, but here are a few things to think about as you paint the lessons. If the bird is the center of interest in your plan, it needs to be the largest object in the design.
This is called design weight.
Secondly, the direction the bird is facing creates a journey in the painting. The viewer will look where-ever the bird is looking. Try not to have everything facing in the same direction. Roses should angle differently than the bird. Stems and line movement should be in a different direction than the way the bird is facing.
For more design study, look for our YouTube videos or design series DVDs. Create your own paintings!

Contour Feathers and Length of Feathers

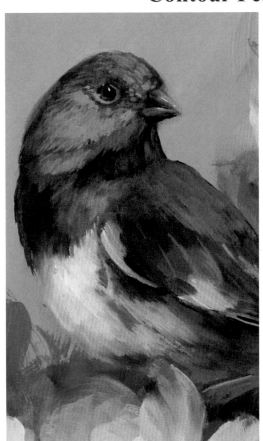

Using contour following strokes is very important because they give shape to the bird.

Notice how the feathers flow around the head. The shorter feathers are always around the beak area. Sometimes they are just small taps of the brush.

As you go down the body, the size and stroke length of the feathers increases. In the lessons you will see me feather the birds back and forth several times until I establish the look that I want.

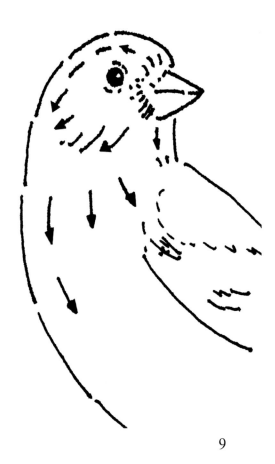

9

Rendering the Lost Edge

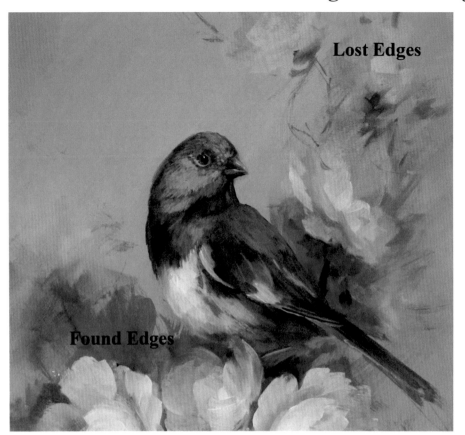

Lost Edges

Found Edges

What makes a painting different from a photo? Painting represents the brush and how we use that brush defines the type of artist that we are. Every artist uses a brush differently and that is what makes a painting unique.

To render a painting realistically, there are techniques we use to define the edges of the painting. These techniques support the details that you would see in real life. Artists, however, create interest and depth of field in the painting. What we see happen over a long distance, the artist compresses into a small area. This effect is enhanced by what we call the lost edge. Lost edges develop the depth of field in the painting.

When I was a decorative painter, I would transfer the design and then fill in the design with color, making sure I followed the design exactly. This precise line from the pattern always left a hard edge of color in my paintings. However, we need to control the hard edges to increase interest and depth in our paintings. As an object recedes in nature, the human eye loses the ability to see the edges clearly. Details diminish and the edges become softer. It is like looking at a mountain in the distance. You can't see all the trees that are on that mountain, but they are there.

The wren painting above shows the lost edge technique. In real life, or in a photograph, she is so close to the blossoms that the viewer would see those blossoms in detail with defined edges. Because it is a painting, we soften them for interest.

Brushes for Feathering Techniques

When deciding which brushes to use, I think about the edges that the brushes create as well as the details. The type of edges you want will depend on the plan you have developed. In most lessons here, I want detail feathers around the beak and eyes. Then they slowly soften as they go down the body of the bird. This gives the face more contrast which causes the viewer to be drawn to that area.

I break brushes down into the types of details they give the feathers:
The Raphael 16684 #3 quill makes very small additions of color that are perfect for fine details. However, it doesn't make soft edges so I only use it in the feather or face details.
The # 4 watercolor round, or sometimes the # 8, is one of my favorite brushes for painting birds. It makes both soft and hard edge feathers depending on the pressure you use and the consistency of the paint. We will show you this in the feathering section.
Next are the Global Art Supply fusion flats in various sizes. They don't create as fine an edge as the rounds so I use them to establish color movement and then detail more with the round if needed.

Basic Steps before Feathering Your Bird

Before we go into feather details, we need to develop the techniques we will use in the painting. I use several painting techniques, from Alla Prima to Half Tone, but we need to develop the overall progression of colors. The technique is what you use to apply the paint to the surface and soften the edges. The overall approach gives you the main directions of the painting.

For example, with many decorative painting styles we follow: base coat, shadow, highlight, and liner work. For these lessons, we use Alla Prima or Half Tones techniques, but we also need an overall approach to the painting. If the approach isn't clearly established, you will play and overwork areas. Work with a plan and keep moving so that you develop life and energy in your painting. Let's take a few minutes and look at the overall approach before we get into the feathering details.

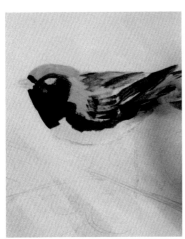

In all my plans, the bird is the most important and controls the painting. So, I want to paint the bird with the most life and energy possible. This will come from multiple applications of color. In a decorative painting, I would base coat- adding one application with each step. With these designs, however, I repeat the applications several times. Often I go back 4 or 5 times to get depth and color interest. Repeating your color applications adds so much to the life of the painting.

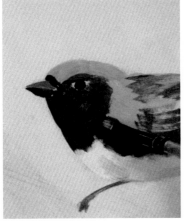

Basic Steps to Start the Painting. I alter slightly from lesson to lesson.
Step 1
Find the undertone for the bird or flower. This is like the base color but a little more. Most of this color will be covered up by the feathers. I try to look through the feathers to see what colors that area might be. A tan color for a brown bird, cool toned red color for a bright red bird, and gray tones for a blue bird etc.

Step 2
Find some shadow tones. Not the darkest but these help define the areas of the bird.

Step 3
Soften the shadow tones with a slightly lighter and warmer version of the undertone. Begin to add some details and begin the feathers.

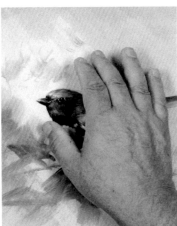

Step 4
Using your finger, soften the movement to the body of the bird. This adds soft flow between the shadows and mid tones. I build more feathers on top of this movement with the feathering techniques.

Feathering Techniques
Fine Details & Small Feathers

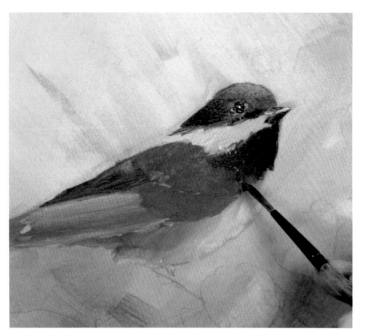

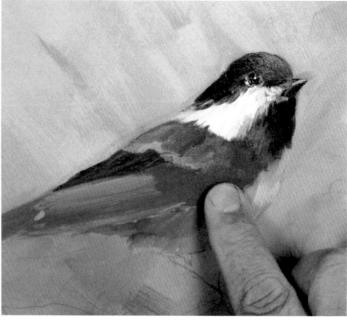

First apply the undertone. Then apply the light, if painting the light breast area, or shadow, if feathering around the beak as shown here. Use stiff or thick paint and not much Extender Medium. We want the paint to move together as we add more and more details.

After applying the darks and lights, soften the colors together with your finger to create a base for more movement. Move your finger with the contours of the bird. Here I move up and down and slightly curve the edges for roundness.

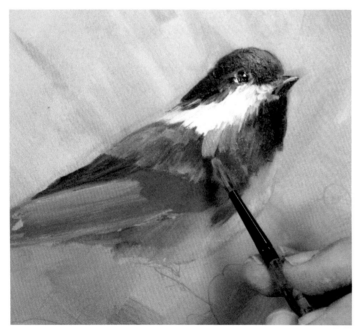

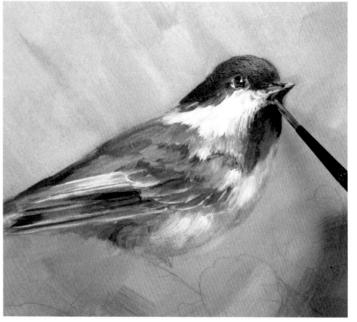

I flatten the #4 round to begin making smaller strokes of color. Let the round "fan" out at the tip so it makes uneven strokes. Work back and forth with the lights and darks following the contours of the area you are feathering and the suggested lengths of the strokes. This builds even more movement for the detailed feathers.

Now you can use the point of the # 4 round, or if adding small detail feathers around the eye and beak, the # 3 quill. Use the point and work the colors back and forth establishing the movement. Sometimes I finish a feather pulling down, and sometimes pulling up. Vary directions so you get the most interest to your small feathers.

Feathering Techniques
Negative Feather Painting

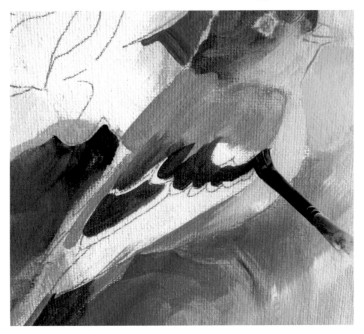

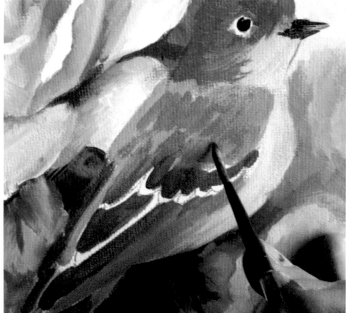

First apply the undertone. Then apply the light, if painting the light breast area, or shadow, if feathering under a wing. You can use the flat or the round brush for this technique. Base in the desired color of the area. I will sometimes leave a little light edge for the tip of the wing.

Mottle down the other colors of the wing. Many times when doing the negative technique, I paint the feathers in reverse as shown here. Stroke down the feather and stop short of the end of the feather. Leave light ends to the feathers, or you can apply these in the next step.

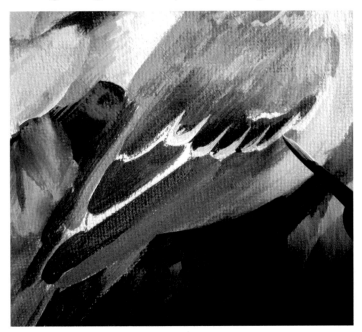

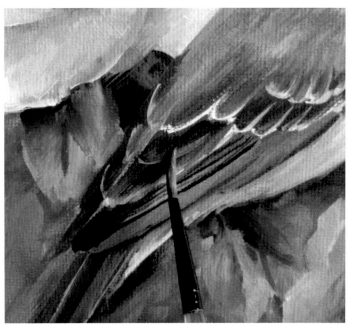

The next step is to apply the light ends to the feathers. The negative painting technique works well for birds that have light edges to the feathers. I do this for many varieties of birds of prey. Using the point of the round or even the liner brush for smaller feathers, add the white tips to the feathers. Apply more than needed.

Now using a dark color first, followed by a medium tone, begin to paint down the length of the feather stopping just a little before the end of the feather. You can put on a very detailed yet casual light end to the feather. I believe it looks more real than just applying light lines to the end of the feather with a liner brush. It is faster too.

13

Feathering Techniques
Large Areas

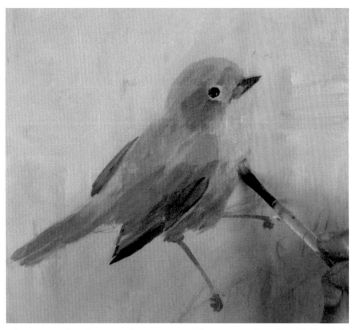

First apply the undertone. Then apply the light, if painting the light breast area, or shadow, if feathering under a wing. For larger areas of feathers I usually use a medium sized flat brush. Use stiff or thick paint and not much Extender Medium. We want the paint to move together.

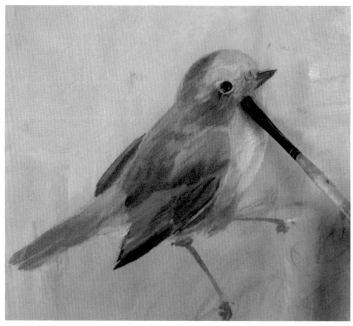

Apply some shadows with the larger brush. Use short strokes of the color so that you get some movement between the colors. This step I will repeat several times between the light and the dark tones creating movement between the colors and values.

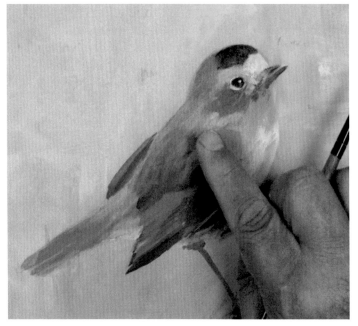

This is the most important step. Once you have added enough color to the surface of the bird and created the light and dark values, move the color around with your finger. Because the paint is so thick, it will not blend easy and the colors will "flow" together and mottle.

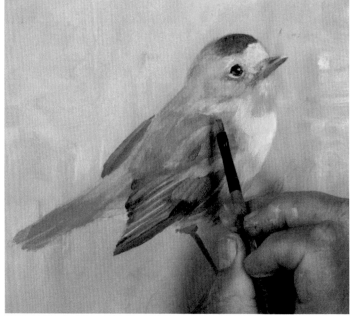

The last step is to use the small flat to add any final feather movement on top of the softened feathers. I usually keep this to a minimum. I will sometimes use the round or the liner to add a few smaller color highlights to finish the effect.

Consistency of the Heritage Paints

Notice The thick paint and how it does not "run" together on the palette. It "flows" around but keeps it's consistency

The Heritage Acrylics are thick bodied acrylics designed for professional artist painting. You can do a variety of techniques with the colors which we will introduce you to in this book.

Acrylic Painters

Today, many acrylic painters in the decorative painting industry are accustomed to using low quality bottled acrylics and "flow" acrylics that are meant to be thin. Many acrylics used in decorative painting are designed for stroking and simple painting techniques.

Paint companies thin the acrylics to make them flow better. Because of this, if you have painted with bottles or used "flow" acrylics, you are used to thin paint. This can present a problem when you paint the techniques in this book. You may have the tendency to apply the color too thinly. This causes the paint to dry too quickly and prevents you from developing the depth of color necessary to add interest to the painting. Keep this in mind as you paint through the lessons. In these techniques I use very thick color!

Application of Paint

One of the most common issues in new painters is the fear of using paint. This fear causes a new artist to use less paint, apply thin color and try to stretch their mixes with water. Over the years, while developing these techniques, I noticed I was slowly applying thicker and thicker paint.

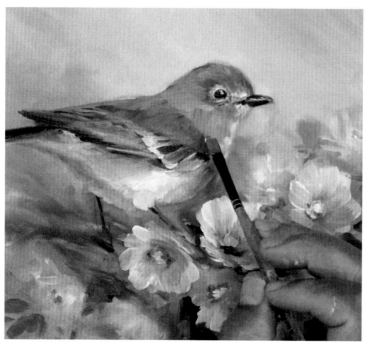

Paint must be used thick enough on the surface so you can use your finger to "push" it around and create the soft undertones for the feather. Blurry paint!

John Singer Sargent, who was one of the greatest Alla Prima painters of the 19th century, said that an "artist should apply the paint so it flows together. " I studied his paintings in several museums in Europe and the USA. They looked so thick and fresh and had huge amounts of paint. But what did he mean by "flow" together? My first thought was paint has to be thin in order to flow together. Many paintings later, I realized that the paint must be thick enough so that it "moves" together but doesn't blend.

Thin paint "runs" together. Thicker paint moves together while keeping the color clarity intact. You want to be able to control the movement and the softness of the colors. To do this, you need thick paint. Lots and lots of thick paint. That is the secret!

15

Alla Prima Painting Technique

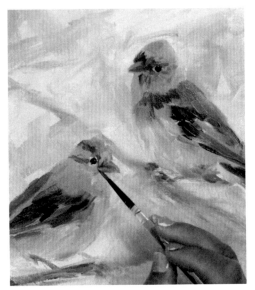

I work the entire painting first

As stated earlier, I make a plan and follow it with a chosen technique. I use the Alla Prima technique for most of the lessons in this book. This method requires a wet surface in which to paint your birds. We paint into a wet background for several reasons. One is the ability to quickly change a color and even erase a color just by rubbing it out with your finger. Another is the color variation that this technique gives. Many painters mix their colors in batches or buy premixed bottled colors because they do not want to mix. Brush mixing, however, is an essential key to learning to paint. Without that, you are just painting by number. Variations of color are critical to developing interest in the painting. So, artists look for techniques that allow them to quickly and efficiently change the color while maintaining control. Alla Prima provides that vehicle.

First, I wet the background with thinned color. Then I begin to state the undertone of the birds with mottled tones. The color on the background must not be too thick nor too loose. Everyone's hand and stroke pressure are different, but you will find the correct amount through trial and error. If an area dries on you, simply re-wet the surface before continuing. It is that simple. Some like to work a small area at a time. I prefer to work the entire design. Wet the surface, casually establish the bird with the undertone and then step out and begin some of the other shapes in the painting. Add background leaves, shapes and colors. Do not work the elements with great detail. I think of it as slowly turning the focus knob on a camera. Start blurry and then slowly bring the painting into focus with refining.

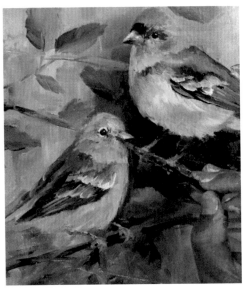

Repeat all objects several times

With Alla Prima, you progress through the tones. You are slowly warming, cooling, brightening and dulling. I usually look for the undertone which is the base tone of the bird. It is a mid value version of the bird. For example, a white bird will be a grey color. I will describe this color to you in each lesson. Establish the mid tone. I then generally develop the dark tone. Most of the time I do this for both the birds and the flowers. Many of the backgrounds in this book are light, so the dark values give contrast. Use them to establish some shape and form before the highlights. Work wet into wet.

Acrylic painters

For years I had the problem of playing in my paint. Acrylic painters often have this trouble. While you play, the colors and background will dry. Global colors can give you longer working times, but be careful. Establish the colors and move on. Think of the camera. Work the definitions in the birds and flowers with the knowledge that you will return to it again and refine it further. There is no need to paint a perfect bird right from the beginning. So please follow this rule: Don't Play! Move and keep moving. Slowly build the strokes. Read through the lesson. How many times to you see me rework and area of feathers? 5, 6? I do it many times, each time adding more and more movement. You cannot get some of the beautiful looks that I achieve with the birds in just one application.

Half Tone Technique

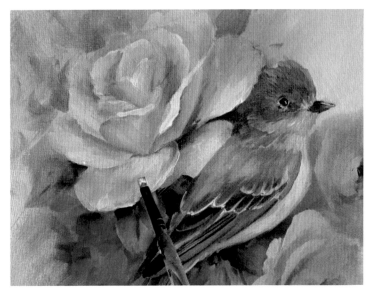

Set multiple tones next to each other with very little blending. Use optical blending to make softer.

The Half Tone technique from Volume 1 is one of the first techniques I used as I expanded my acrylic techniques. It is a very fun technique and can render beautiful flowers and birds very easy.

Start by basing in part of an object. This can be with a light or dark tone. Normally it is a dark tone. The next step is to make the opposite tone. So if you make a dark tone first, make a light tone second. Apply both tones in the areas they will occupy. This gives the artist a look at the painting of light and dark.

Next, soften the effect with a half tone. Brush mix the dark value and the light value together on the palette making a tone in between the 2 values. Next apply that tone between them. Do not blend together. Just stroke on the tone.

Next, make a tone halfway between the middle tone and the light value. Apply that between those two tones. Then make a tone between the dark and the middle tone and apply it in that area. Slowly refine the tones each time making a half tone between the two colors you want to soften.

Finally you can soften the effects with a brush or your finger. Often I leave the brushwork and it blends visually when you step back from the painting. Many artists paint at an easel so that they can step back to see if the tones blend with the eye. This is called optical blending.

Painting the Sfumato Technique

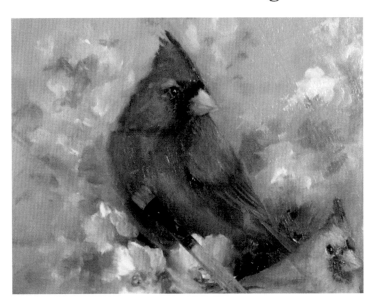

Set multiple tones next to each other with very little blending. Uses optical blending to make softer.

Sfumato is a technique made famous by Leonardo da Vinci on the Mona Lisa. The word is from the Italian word sfumare, which means "to tone down".

With this technique the artist presents no harsh lines. Tones are softened with small strokes of a cloudy or compliment color which causes them to recede. This can also be used to create better realism in a painting. It is very similar to chiaroscuro, which I have used in Dutch paintings, to push the receding edges of objects back towards the background.

For the Cardinal lesson in Volume 1, I used this technique to push the male Cardinal behind the female. It works well on the reds of these birds.

I did not use this technique in this book, but I hope you take some time to explore it.

Additional Techniques Used In This Book

Transparent Color Washes- Sketching Shapes

Artists for hundreds of years have concentrated on paint consistencies to enhance the designs. With these lesson you will see several times where you add various colors into the background and also within the petals. This is called a "mosaic" of color. When you apply this mosaic of color, vary the consistency by thinning some colors with additional Extender Medium. Varying the consistency of the colors will increase the variation within the blossoms. The soft blending that occurs as you move the brush around the surface is controlled by the paint consistency. If a certain lesson is not working, I highly suggest changing the consistency of the paint for a better result.

Light Color Petal Edging

The Fusion brush excels in applying white edges then softening them with other strokes. Tap one edge of the brush into the White or light color. Sometimes I use the chisel edge, flat edge or at an angle. Wiggle the brush as you draw the outside edge of the petal. Varying the amount of paint will create different petal effect. Once I have drawn the outside edge of the petal, I then stroke the brush back and forth to fill in the petal with color. If anything gets too harsh or too much, I soften with my finger.

Brush Mottling

This is a technique we use extensively in this book. To create a mottled brush you need to have colors about the same consistency. Place the colors right next to each other on the palette. Tap the brush up and down on the palette to load into the brush. Do not stroke the brush on the surface of the palette because this will cause them to blend and soften. Tap the colors on the palette just enough to cause them to load into the tip of the brush. Apply the colors to the flower or blossom with a light tapping motion. Use a very light pressure on the brush so that the tapping doesn't continue to blend the colors. A great technique for interest in the flowers.

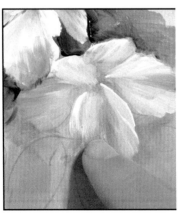

Lost Edge of the Petal

Artists are painters of edges. We fill in pattern lines or paint objects with edges that give them form and structure. The edges though are very important for dimension within the painting.

In real life, the human eye can not see all the details in objects that are far away. Edges of the objects "blur" as you get farther away from them. Our eyes are used to seeing this concept everyday. To capture this visual depth, the artist will paint a very clear edge to objects that they want to come forward such as the front petal of a flower. They will soften or blur the back ones so they recede. I use my finger for this. Softening the edges of objects that are not important brings forward the others.

Additional Techniques Used In This Book

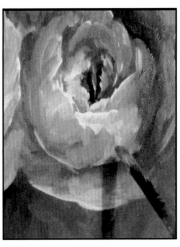

Push Strokes

Many artists tend to get trapped in one direction painting. Painting in multiple directions increases interest. The fusion brush is a very soft brush. It can be used in many different ways to create many beautiful looks. One look that I love is to "push" the brush instead of stroke the brush. Stroking can give a stiff look if you do it too much. When pushing the brush, the soft hairs of the fusion brush spread out and apply the paint in a very casual manner that can not be created by stroking. Pushing strokes can be used with soft finger blending and stroking to create a wide variety of looks on a petal.

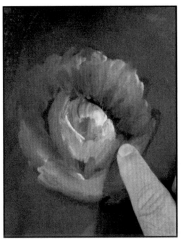

Pushing Color

I love the casual look that is created with the fingers. Apply color to the surface. Mottle several colors. Pushing color works the best if the background is wet with thick paint. Most techniques require thicker paint so make sure you have it on the surface. Apply the paint with the fusion brush. Then, using good pressure with your finger, push the paint around into the shape of the object you are painting. I love to do this technique on the fronts of roses, where you want the colors to mottle and swirl, but not to blend. Too much brushwork can blend the color where pushing them around with your finger preserves the color.

Negative Painting

Use the background colors to clean up edges rather than reapplying the edges to an object. This technique works very well when you are working on a wet background. Paint the desired object. Sometimes I will paint the object, a petal for example, then wipe my finger over the petal to soften and carry some background color into the petal. Then come back with a slightly larger brush with background in it and paint the background which will shape the edge. This also makes the object look more transparent. When painting, you can make edges with the objects color, and also in the reverse with the background. Negative painting in another great technique to add interest.

Lifting Off

Many times we paint the object with layers of color. With most decorative techniques with add colors that are needed to the object. With lifting off, you paint, then cover it, then lift the second color off revealing the first color. Apply base color. Then apply the shadow as needed on the object. For example at the bottom of the bowl. Then apply the mid value and highlight as desired. Many times you need to reapply or "restate" the shadow because we lose it. The fusion brush, and sometimes your finger, you can start at the shadow and push up to lift off some of the base color and highlight, revealing the shadow again. Variation!!!

19

Additional Techniques Used In This Book

Optical Blending

This is a concept made famous by the Impressionist painters of the late 19th century. With this, the artist leaves portions of the painting "unblended" allowing the viewers eye to blend the tones from a short distance. Usually the artists take a step back of about 3 feet to view the painting. This softens the effect. The photographic cameras usually soften the effects of a photo. When artists paint from that photo, the result is an over blended painting. To combat this, we leave more areas of color exchanges. Try not to stroke more than 3 times in any area. Do not stroke many times! Leave streaks.

Blur Objects for Depth

This is a technique that is very important to the lessons in this book. Here we will start large areas of color. Do not paint each object perfectly. We leave edges undefined. I describe this to students in this way.... We start the painting like we are looking through a camera that has not focused on the subject. Do not find the edges.... Move colors and strokes around without finding perfect shapes. Think of it as slowly turning the focus ring on your camera, bringing it into focus. This will help develop tremendous depth in your painting. Start soft and undefined. Slowly add more edges to object.

Flow Texture

The secret to a successful painting is paint. We say in the Program: "It is easier to paint with paint!" This is so true. When painting the lessons you need to use a lot of paint and use if fast.
One of the greatest painters during the 19th century said that the artist should use paint so thick that is flows together, rather than mixing. This is the technique! Do not mix, let the color "swirl" and flow together, then optical blending will soften the colors when view from a short distance.

Corner Detailing

For the majority of the lessons in this book, I used the flat brush. With the filbert, we learn to use the edge of the brush, creating the "edging" technique used to draw petals. With the fusion flat brush, we use the corner of the brush to create edges and add the small details. The corner of the flat does not make the details as precise as a round brush so it is perfect for this look. Pick up thick paint on the corner of the brush, use different pressures of the brush to make different effects. I usually like to mottle the color on the palette, then corner the flat with the mottled color before detailing.

Next we need to talk about some various colors and color ideas. I mix for variation of color. This is why I use limited palettes. Below are 2 pigments you can add the Paint It Simply

Burnt Sienna is a pure pigment and is an the earth color. A burnt orange color, it is extremely warm in temperature. Think of it as a toned orange and you can predict mixing results with ease. Mixing Burnt Sienna with Hansa Yellow (shown on the left) yields a wide range of toned yellows. At the top, the yellow mixes are cooled with a tiny touch of Black or a little Red Violet as shown at the bottom. Adding a touch of Black to the Burnt Sienna alone will give you beautiful umbers. Add a touch of Blue for soft greys when lightened with White. You can make endless color combinations!

Pine Green is not a pure color but rather mixed from many pigments. Some artists have trouble mixing greens so it is a great shortcut. Pine Green is a warm color. (See the example above from left to right.) Add Hansa Yellow for bright yellow greens. Add a touch of Phthalo Blue for intense teal and blue greens. Tone with Burnt Sienna to make brown greens. Mix with Red Violet for cool darks. Add Black for deep dark greens. It is a powerful benchmark green for your limited palette.

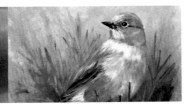

Greens- Leaves, Scrolls

Hansa Yellow will make a wide variety of greens. On the left you can see Hansa mixed with Phthalo Blue on the right tiny touch of Carbon Black. Combine both for more greens!

Yellows- Flowers, Leaves, Scrolls

Hansa is a bright yellow. I like to use it soft. Add some browns (shown below) and touches of Red Violet and red add more variety. White lightens and opaques the yellow.

Reds- Flowers, Leaves

Naphthol Red Light is a warm red orange. Red Violet is a cool Red Violet. Mix together to make a wide range of reds and lighten with white to make soft pinks.

Blues- Flowers, Leaves, Scrolls

Phthalo Blue on the palette is a dark blue which leans to the green side. If you add a tiny touch of Red Violet, then lighten with white, you will make a wide variety of blues and blue violets.

Oranges- Flowers, Leaves

Hansa can be used as a base for a wide variety of oranges. Tiny touches of Naphthol Red Light make warm oranges while touches of Red Violet make cooler oranges.

Browns- Flowers, Leaves

Base Brown is 2 parts Naphthol Red Light and 1 part Carbon Black. I vary this color in many brush mixes with additions of Hansa Yellow which lightens and make more sienna colors.

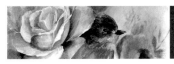

Temperature is one of the most important principles in our Paint It Simply program, but also the hardest concept to "see". To make this concept easier to understand, we selected very limited colors, each one chosen with temperature in mind. You can paint temperature, without "seeing" it if you follow these principles. Lets take a look at temperature.

Cool Color		**Neutral Temperature**		**Warm Temperature**
Red Violet Carbon Black	Titanium White	Phthalo Blue	Hansa Yellow	Naphthol Red Light

Red Violet is the coolest color in the beginning Paint It Simply palette. Many think that blacks are the coolest. This is not true- some blacks are even warm. Our Carbon Black is considered a neutral leaning cool. White is a Neutral color.

Many think that Phthalo Blue is cool. This is not true. Ultramarine Blue and Phthalo Blue are warm colors. There is not a manufacturer today of a cool Ultramarine Blue. However, blues will appear cool when you use them in association with warmer colors.

Look at the scale above, Phthalo Blue is slightly warm of neutral and is cooler than Naphthol Red Light. So, if both are used in a painting, the Phthalo Blue will look cool and the Naphthol Red Light will look warm. The human eye is constantly balancing colors. You may see the blue as cool in a painting, but it only appears that way based on the colors that surround it. Trust the scale above and you can paint temperature in any Paint It Simply lesson.

What Happens to Yellow?

At the top is Naphthol Red Lt and Carbon Black. The red will warm and the black will cool. If you increase the black, the color becomes greener and cooler. If you increase the red, the color become more orange and warmer.

The second mix shows Red Violet and Carbon Black. Here you will always make the color cooler since both colors are cool. There are many ways to cool a color.

The last shows Hansa Yellow and Black making greens. The green cools from left to right because Black is cooler than Hansa. Add Red Violet and the color cools even further.

Color tone refers to the mixing of a neutral color with a pure color. For example, if I take Hansa Yellow ,a bright, slightly warm yellow, and add a touch of light grey, I have made a tone of Hansa or a tonal color of Yellow. This is a broad definition of the term.

In this book we will not use the grey tonal values of color. We will not mix black and white to make grey and then add that to a pure color. Instead, we will mix complimentary colors which make greys that have more life and better harmony with the other colors in the palette. Lets look at some examples and how we can add "tonal harmony" to our colors.

Above, I have mixed Hansa Yellow with the tonal range of white and black. This is a broad definition of tonal color-making: a tone that is a softer, less intense tone of Hansa Yellow. This is a Tone of Yellow.

The second example uses Phthalo Blue, Naphthol Red Light, and Titanium White. This makes a "tertiary color." Tertiary means 3. The three primary colors are red, yellow, and blue. When these 3 colors are combined in any variation, they make a "tone" of a color because they make a "tertiary"grey. Add white to lighten the color to the value of Hansa, thus making a grey tone or Tonal Yellow.

In the lessons, when I want to mix a tonal variation of a color I use the "tertiary" tone. For example, to make a tonal variation of red, I will add greens. Greens are blue and yellow, thus red, yellow and blue. Making tonal colors is easy in these lessons, just combined everything to make a tonal color!!!

Brightness or Intensity in a color is also referred to as Saturation. There is a scale for this brightness that is used by companies to establish a language of color. For Paint It Simply, we need to understand a just few principles. Lets take a look at some color.

In the tonal lesson we learned that any tertiary color (or grey) will tone a color. Any tertiary will work. Also, we want to create harmony within our painting. Harmony is when all the colors go together. When we use a common toner to adjust the brightness of a color, we also increase the harmony between the colors. This is a benefit of using a limited palette.

In this example, I mixed Brown (2 parts red to 1 part black). The top line is Hansa Yellow mixed with Brown. The intensity (or saturation) of the yellow is reduced as it moves from left to right. Next, I made green with Hansa Yellow and a touch of Phthalo Blue. By slowly adding Brown, the intensity reduces from left to right. Both colors have harmony because I am toning with the same color so they "go" together. In this case, Brown is our common toner.

The next example shows the "grey" method of toning. Greys and blacks are added to Hansa Yellow to lower the intensity. However, you can see that Yellow turns green with the addition of Black. Adding small touches of Red will bring the Yellow back to a Toned Yellow. Blacks are wonderful to tone with and do add harmony. Sometimes, they change the "hue" or color, as in this case, yellow becomes green. Using tertiary colors can lower the intensity while maintaining the same hue.

25

Painting The Blossoms In This Book

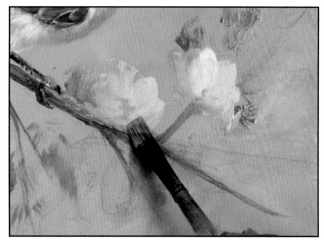

An artist can easily put too much work into the flowers when painting them in conjunction with the birds. I notice this problem with my students all the time. The job of the blossom is two-fold.

First, it adds additional color and movement to the design and contrasts with the main object- the bird. Some artists place birds with complimentary colored blossoms for contrast. Others create a secret bird by nesting them amongst like colored flowers. Both work as long as the blossom and bird are balanced.

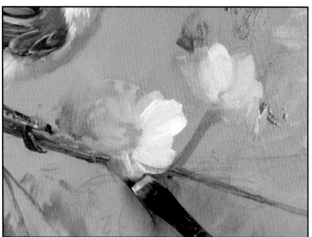

The second role of the blossoms is to add a natural setting to your painting. It is similar to painting the human figure in a room or leaning against the chair. In a setting, or alone, each painting captures the main subject while adding different visual experiences for the viewer.

For me, I like the added interest of the blossoms. If I have a colorful bird, then I don't need many more touches, but a subtle bird may require the addition of blossoms to add additional variety to the painting.

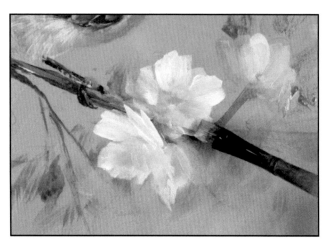

The main subject is the bird. Keep that in mind as you paint the accent blossoms. I start them very soft, just mottling the color into the wet contrasting colors around the bird. Slowly, I add more color to the flowers, building color until they contrast the bird, but do not distract. That is a fine line. Many times I apply color and then decide the color may be too bright. Then I use my finger to push the color back into the wet base colors to soften them.

Blossoms also add different directions to the movement in the design. Movement increases interest and turning flowers in different directions adds movement. Slowly lighten the blossoms until you achieve the look that you want.

Remember the blossom are not the center of interest and need to balance with the birds. Vary the colors, but too much can distract from a bird that doesn't have a lot of contrast. It's a balancing act. That is art!

Creating New Looks and Backgrounds

I started my career as an artist as a decorative painter. In the 1980-90s we didn't vary the backgrounds of our paintings. I used to think there was nothing better than a smooth, perfect background. Part of the reason was that I didn't know how to vary the background.

When I started to paint landscapes, I began to think about the depth in the painting. Everything in nature has form. The bushes, trees, and shrubs are not flat; they are round. When you paint a bird sitting on a branch, the branch is round. There are more branches behind and around the branch and underneath the bird. For years, I painted the main objects but not the supporting elements. This made my paintings flat. One reason I firmly believe in studying different styles of painting is that new ideas and looks come from many sources.

When you paint the backgrounds in this book, think of landscapes. Think of distant mountains and trees. Outside areas need movement, but that movement should be atmospheric like a landscape. Soften outside areas and create more edges and color contrast in the center where you will paint the bird. Just like painting a distant mountain, the soft outside edges will add more interest to your painting and increase the depth to the objects in the painting.

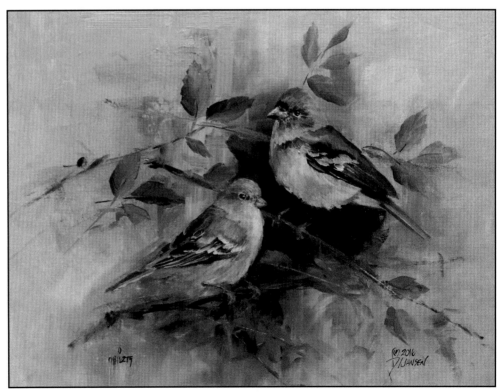

Art is about creating a visual experience for the viewer so why not take all that open area in the background and add a little movement? Think round, think depth and use your background.

Brown Nuthatch Varying Tones

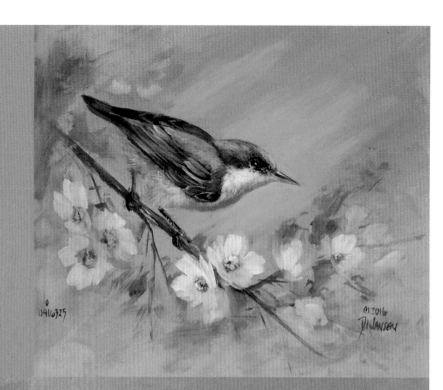

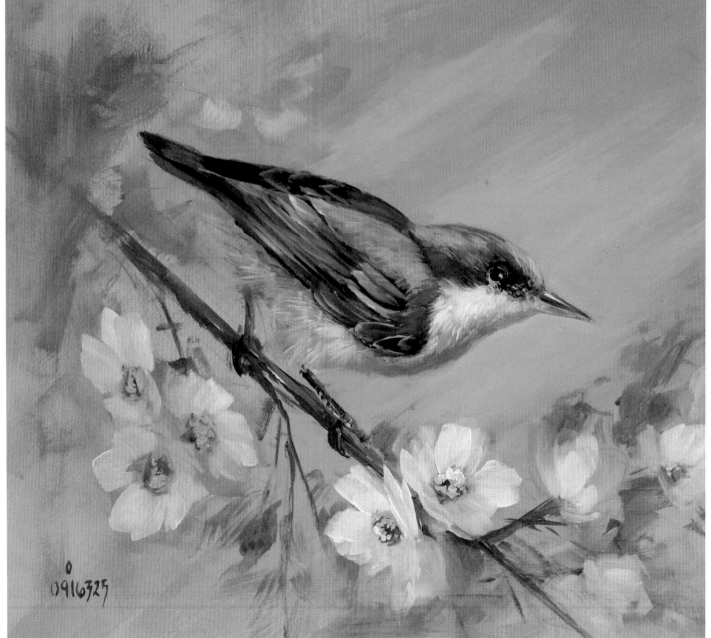

Brown Nuthatch- Varying Tones

 In the first two volumes of this series, we began the painting with the Alla Prima technique. We will also paint Alla Prima for these lessons, however, instead of applying one main under-tone, we will vary the tones which will give additional life to the bird.

In the last book, we talked about painting our birds a little more realistically. Now, we want to come even closer, but still keep the painterly look to the birds that make them a work of art. How do we do this? Vary the color tones!

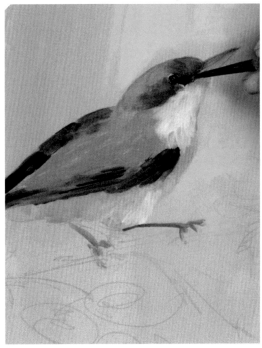

In book two we began with a common undertone and built from there. In these lessons, notice that I base with multiple warm and cool tones and then move to shadows and lights. We will vary the colors again as we build layers of feathers.

Let's look at grey. It is not a single color. Greys can be warm or cool. The tones can lean a little to the blue side or a warm yellow side. Browns can lean yellow, red and even to the cool side of blue. Expand the way you mix these tones on your palette so that you vary them when painting the birds. Notice as you go through the lessons the new variation in my colors. Look at the steps as I change the tones. Create new looks! Let's give it a try!

Paint It Simply Palette
Base Color- Medium White Grey,
White + touch
Black and Yellow Oxide
Palette Colors

Paint It Simply Colors
Naphthol Red Light
Red Violet
Carbon Black
Phthalo Blue
Hansa Yellow
Titanium White

Additional Palette Colors
Pine Green
Burnt Sienna
Yellow Oxide

Wood Surface
11 X 14 Wood or canvas panel

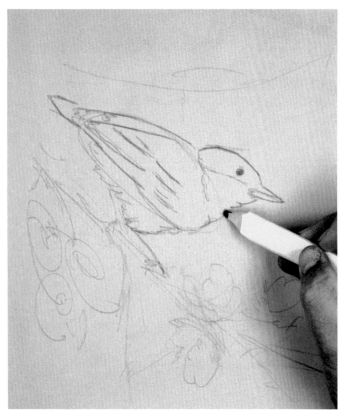

Step 1 Base the board with a medium white color and then sketch or transfer the design we will paint.

Step 2 Mottle the large flat with some Phthalo Blue + touch Red Violet and then lighten with some white.

Step 3 Add this to the background behind the bird. Then using a paper towel, wipe off the excess so you can see your sketch of the bird.

Step 4 On the palette mottle some Burnt Sienna with some Yellow Oxide. I used a # 4 fusion flat brush to do this.

Step 5 Using short shape following strokes begin to base in the head of the bird. Go around the eye and follow the contours of the head.

Step 6 Mottle the brush with Burnt Umber and tiny touch black to darken the color on the palette. Move the color to one side so we can build several values of colors.

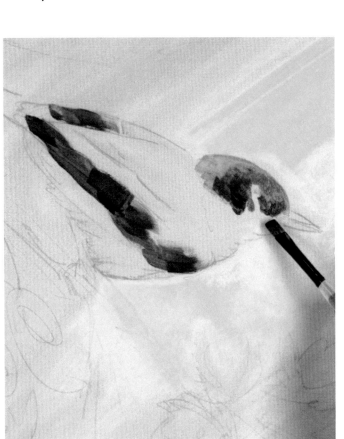

Step 7 Add some dark shadows to the head near the color transition of the neck and along the wing and breast area. Just darken some strokes to create interest.

Step 8 Mottle the brush with some blue, black and then lighten with some white. Do not over mix the colors so the strokes will have more interest.

31

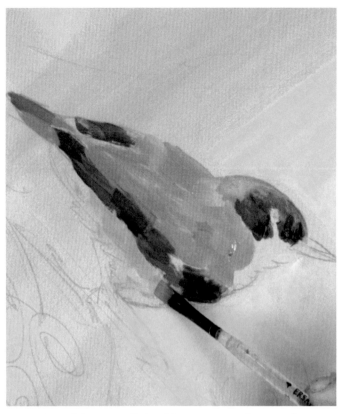

Step 9 Add some light blue grey color to the wings, mantle and along the bottom of the wing in the breast and tail area.

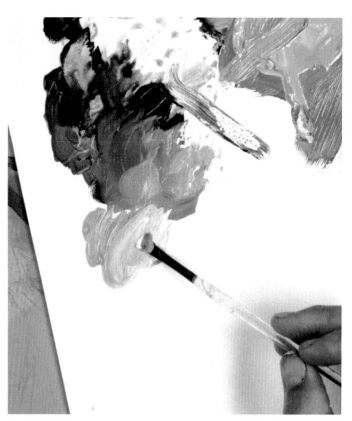

Step 10 Mottle the brush with some Yellow Oxide and white. Notice that I did not clean my brush. This helps the colors transition.

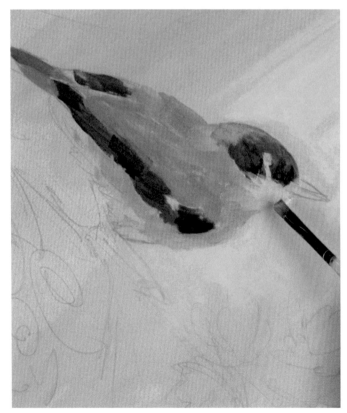

Step 11 Add this light yellow to the neck area using some contour following strokes. Pull the strokes in towards the wing and down along the breast area.

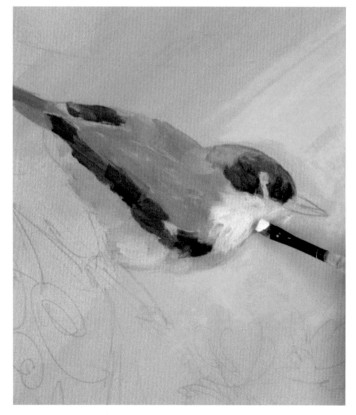

Step 12 Mottle the brush with additional white and stroke some lighter color into the neck area. Do not cover up all the initial light yellow.

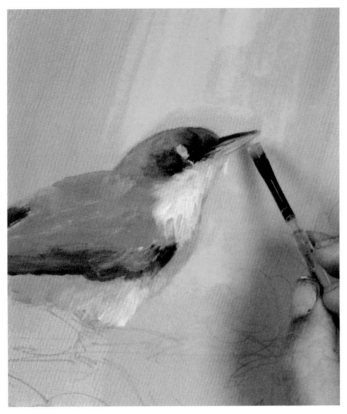

Step 13 Mottle the brush with some of the grey from the wing, then lighten with additional white and using the chisel of the flat, add the light part of the beak. Top is Burnt Umber.

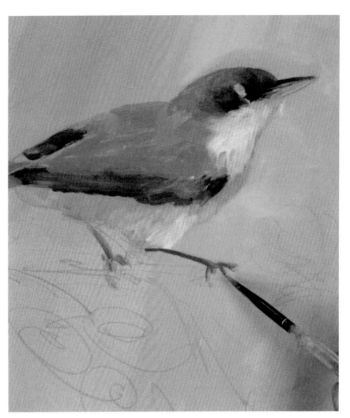

Step 14 Use the chisel of the flat or the point of a round and some of the greys to suggest the legs of the nuthatch. Just casually suggest them for now.

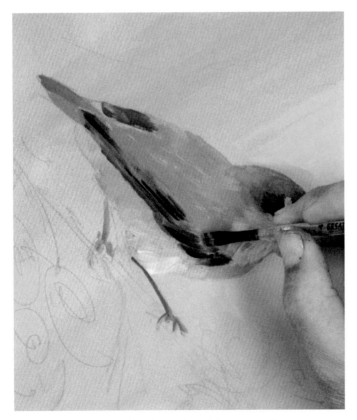

Step 15 Mottle the brush with some Burnt Sienna and pull some short covert strokes (small feathers covering the wing feathers). Pull up and slightly curved.

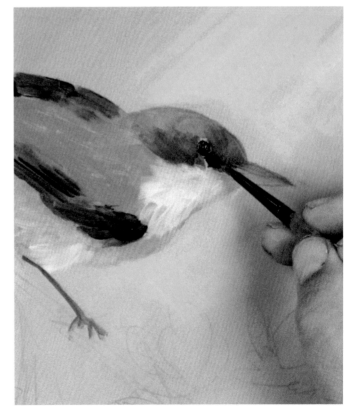

Step 16 Mottle the brush with some Burnt Sienna and set the eye first. Mottle the brush with some black and Burnt Sienna and add a smaller darker pupil of the eye.

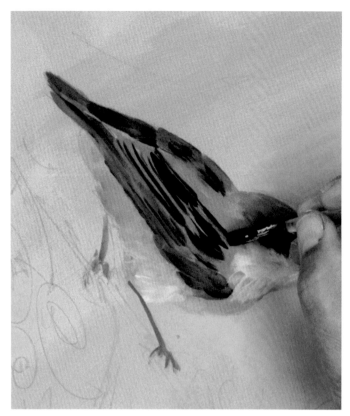

Step 17 Mottle the small flat with some Burnt Umber and touch black, and using the chisel of the brush begin the strokes that suggest the flight feathers on the wing. Vary widths.

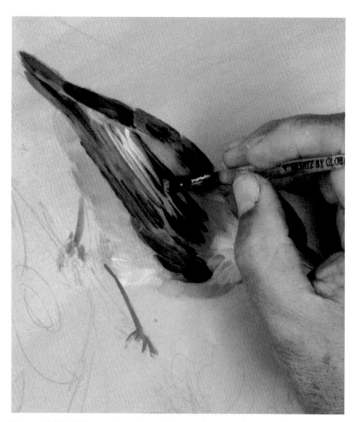

Step 18 Wipe the brush and mottle with some greys and white and add some strokes between the darks we just applied.

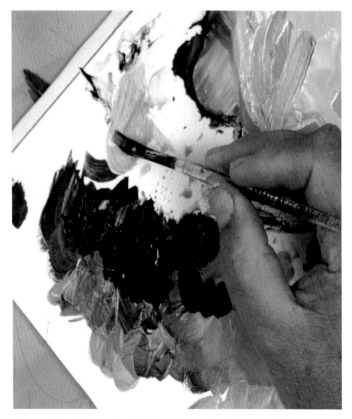

Step 19 Vary the light grey with Burnt Sienna or blue tones. This variation makes a lot of interest in the bird. Take the time to vary the colors as you add the strokes.

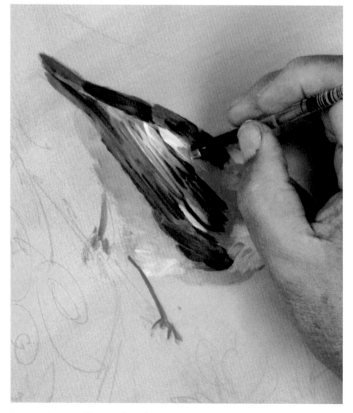

Step 20 Follow the long strokes of the wing feathers, then for the coverts, pull some smaller strokes up the back towards the mantle of the wing. Vary the amounts of white.

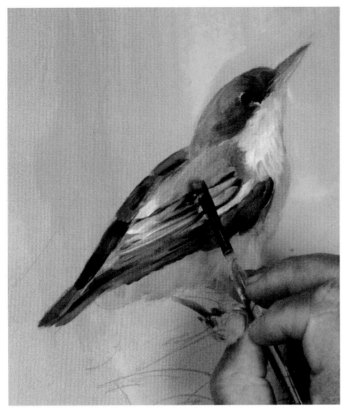

Step 21 Mottle the brush with some greys and pull down the mantle of the wing towards the white colors we just applied. Stroke into the light colors of the neck a little to incorporate.

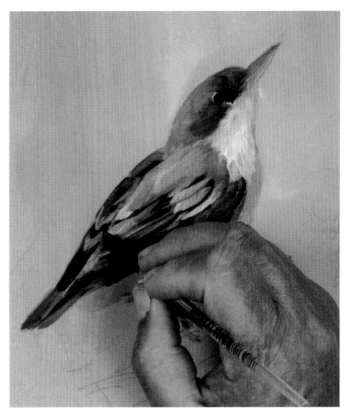

Step 22 Use the chisel of the brush with some greys and add the lights to the tips of the wing feathers on the other side.

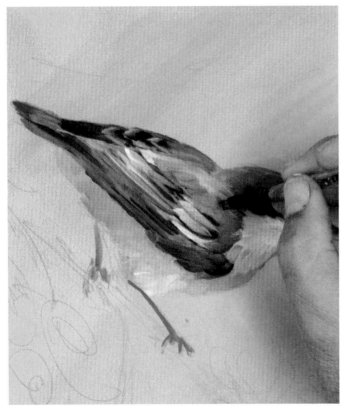

Step 23 Vary the greys and stroke back through the mantle. I get the most interest in the birds by repeating colors several times, varying the tones slightly each time I repeat.

Step 24 Mottle the brush back into the white. Notice all the variations of white I have established already on the palette. Do not paint too long with one color, change adds interest.

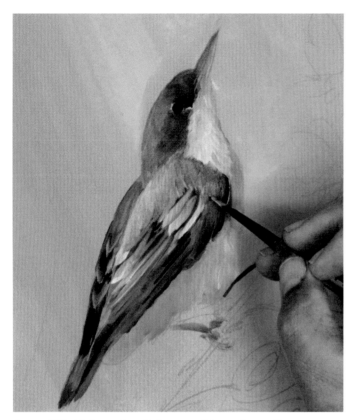

Step 25 Using the # 4 round brush, pull some greys over some the Burnt Sienna areas that we established earlier. Use shorter strokes and allow some of the Burnt Sienna to show as well.

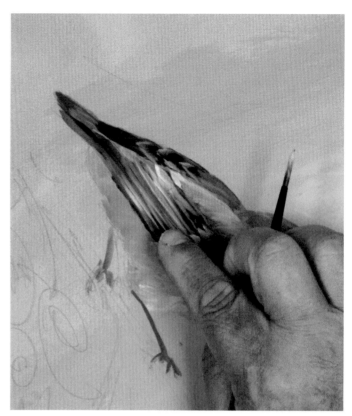

Step 26 Add greys to the wing feathers. This will vary the whites we applied earlier. Always look for ways to vary the colors. Soften the colors with your finger.

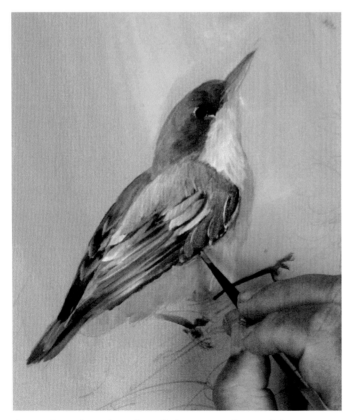

Step 27 Use the tip of the round to add some white edges to the feathers. If you get too much, negative paint the white out with some Burnt Sienna or grey.

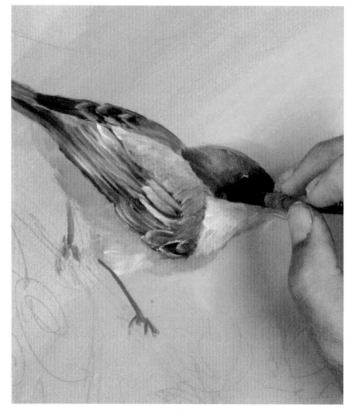

Step 28 Restate some of the Burnt Sienna around the head where if joins the mantle of the wing. We now need to concentrate on the head to vary the colors.

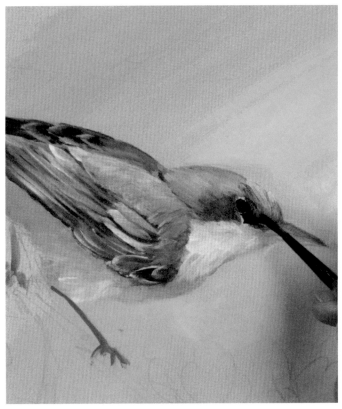

Step 29 Mottle the tip of the round with some Burnt Sienna, Yellow Oxide and then lighten with white. Add smaller feather strokes around the head using contour strokes.

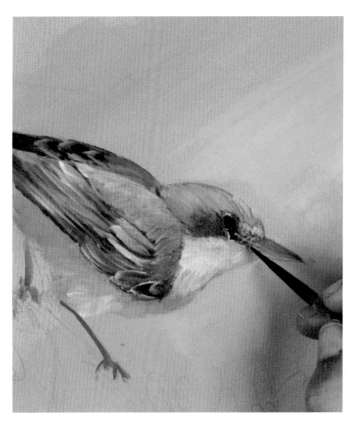

Step 30 Use just the tip of the brush with some white to add some white small feathers around the beak and eye. This represents the tips of the smaller feathers in this area.

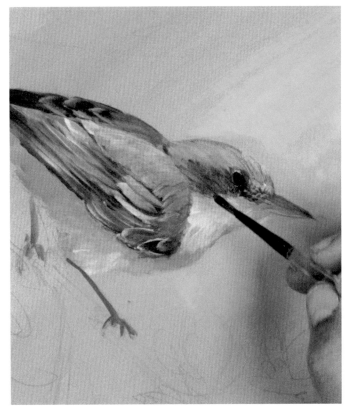

Step 31 Using the tip of the #4 round brush mottle with some Burnt Sienna begin some smaller strokes of shadow where the colors come together.

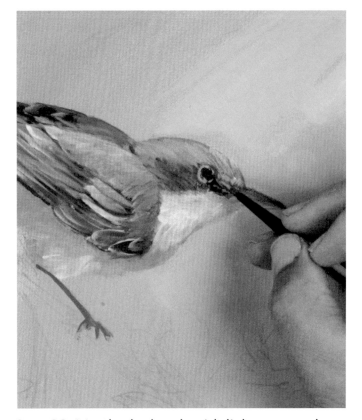

Step 32 Mottle the brush with light grey and white and add the eye ring around the eye and then a few strokes over the shadows we just applied.

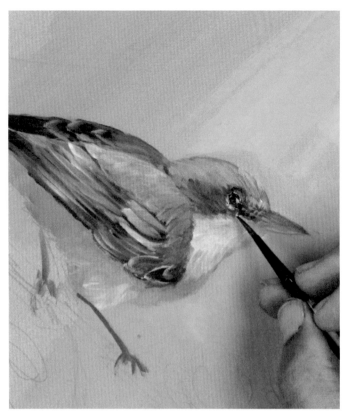

Step 33 Use the tip of round to add the light grey shine to the eye, then tap very small some white shines into the eye ring.

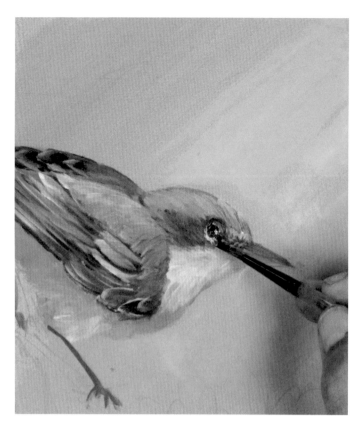

Step 34 Mottle the brush with some Burnt Umber and touch black and soften the lights. I work darks and lights, back and forth, several times to get the interest I want.

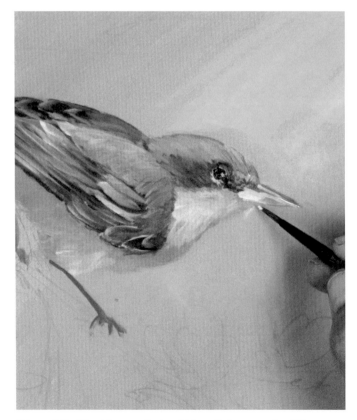

Step 35 Tip the point of the # 4 round with some white and add some very small strokes around the beak. These are the smallest feathers on the Nuthatch.

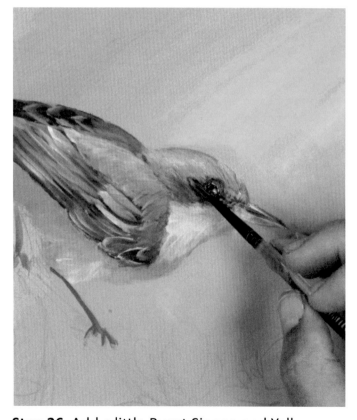

Step 36 Add a little Burnt Sienna and Yellow Oxide to the white and add contour strokes to the back head of the nuthatch.

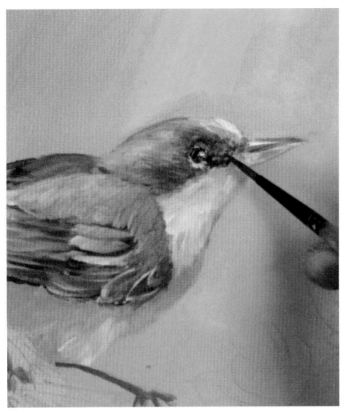

Step 37 Restate the darks between the eye and the beak. This is one of the most interesting areas, so I like to apply several tones and values to keep that interest.

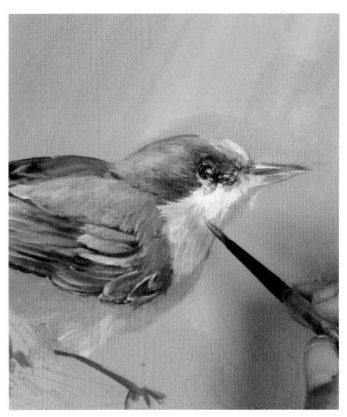

Step 38 Mottle the brush with more lights and yellows and add some additional small light strokes under the eye, then drag over the color break to create small feather movement.

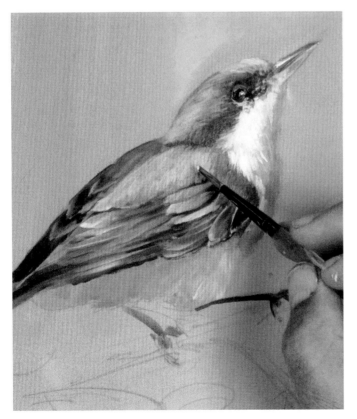

Step 39 Lighten the greys and drag over the mantle of back and create some medium sized stroke feathers to add some interest to this area. Break up the tones.

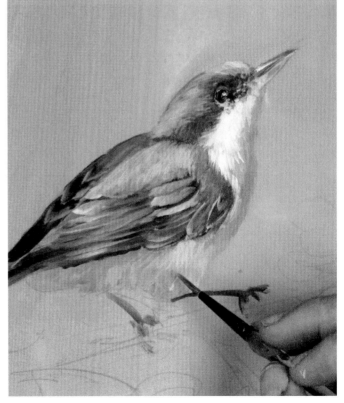

Step 40 Add some smaller strokes of light to the body, pulling down over the legs to help set the legs into the body.

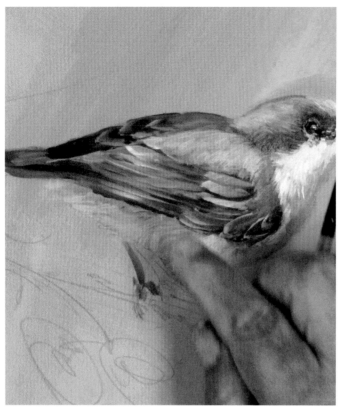

Step 41 Towards his tail, I soften the feathers with my finger to push them into his body. This will also create a softer area that will make the details advance.

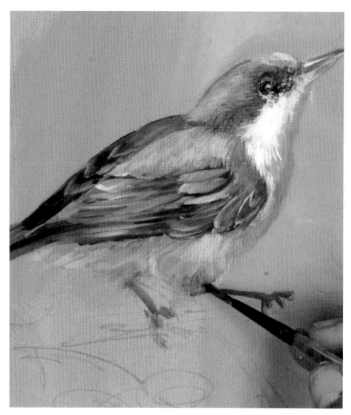

Step 42 Add some yellows and browns over the legs to help set them in. This color also helps with form shadow, rounding his body.

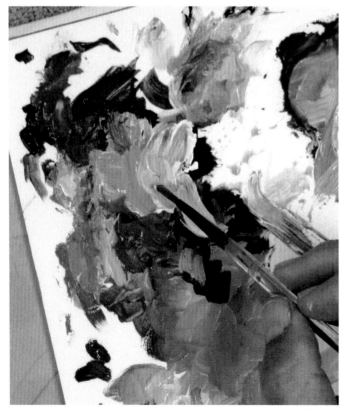

Step 43 Here you can see my palette with all the various mottled greys and browns. Wide variety which adds so much to the bird. Mottle with some light grey, slightly yellow.

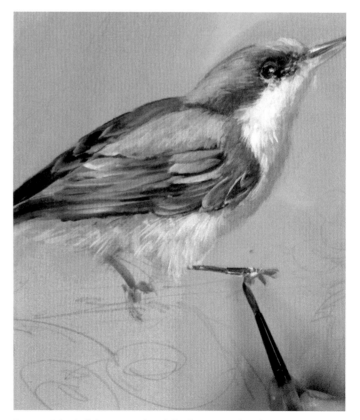

Step 44 Add some highlights to the legs with taps of the brush. Use just the tip and keep casual.

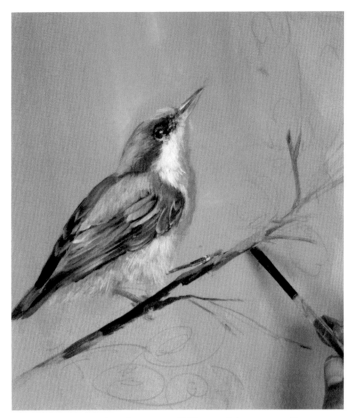

Step 45 Mottle the small flat with some Burnt Sienna and using the chisel add the stems under the bird. Lighten the color with white and touch yellow and add some highlights.

Step 46 Mottle the Pine Green with some Burnt Sienna, which will tone. Using the 3/4 inch brush casually add some leaves and green movement to the background.

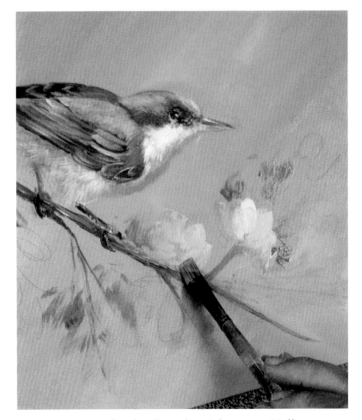

Step 47 Mottle the brush with some Yellow Oxide, touch Hansa and white to lighten. Add some yellows to the areas of the flowers. I am using a #10 flat.

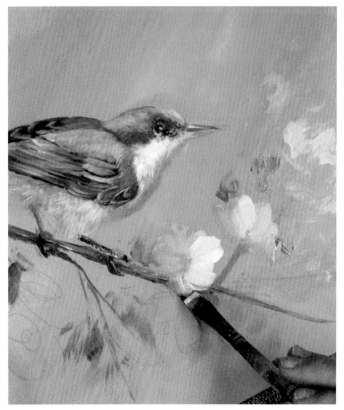

Step 48 Lighten the color with some white and begin to build the petals on the blossoms. Keep more light and edges to the petals near the Nuthatch.

41

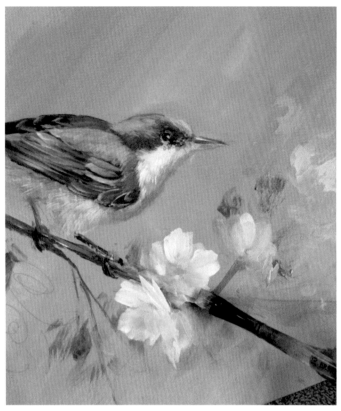

Step 49 Continue to build the shapes of the blossoms with whites and yellows. Here I am pulling some yellow out from the center to add some shadow interest.

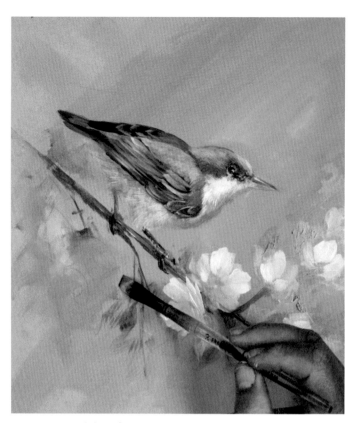

Step 50 Add soft yellows and tan colors under and behind the bird to add movement to the background.

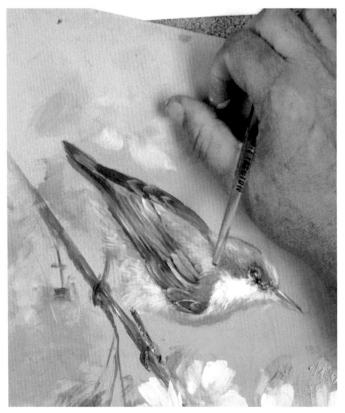

Step 51 Add some soft yellows up and around the Nuthatch and then soften them into the background with your finger.

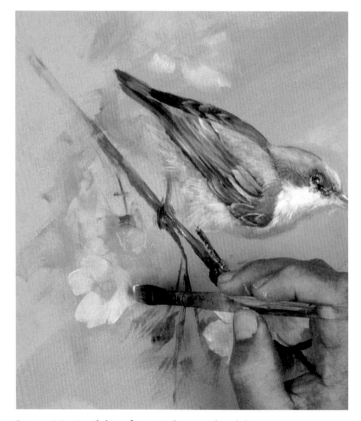

Step 52 Build soft petals on the blossoms below the Nuthatch keeping the lighter and more intense blossoms near the Nuthatch. Soften the outside edges of the petals.

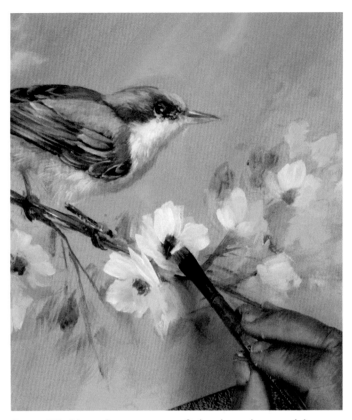

Step 53 Use the corner of the brush to add some Burnt Sienna in the centers, softening the colors on the outside blossoms.

Step 54 Mottle the brush with some yellows and lights, I used Yellow Oxide and Hansa Yellow then lighten with some white.

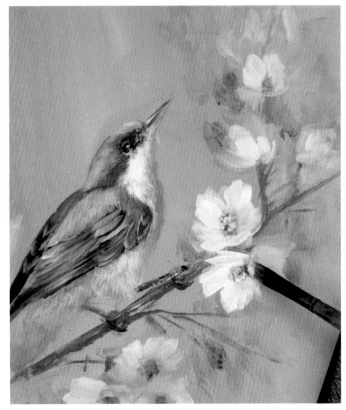

Step 55 Using the corner of the brush add the centers to the blossoms with light taps of the brush. I make more in the ones closer to the Nuthatch and less on the outside soft ones.

Step 56 Mottle the brush with some Phthalo Blue and white to lighten.

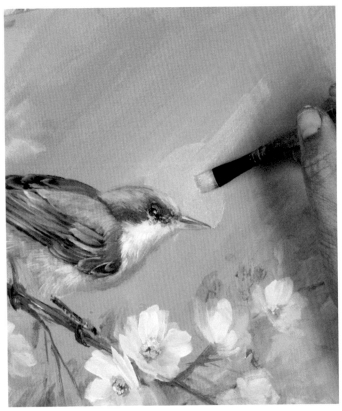

Step 57 Add some light behind the head of the Nuthatch to clean up the color and soften the streaks. Too many steaks in the sky can distract from his head.

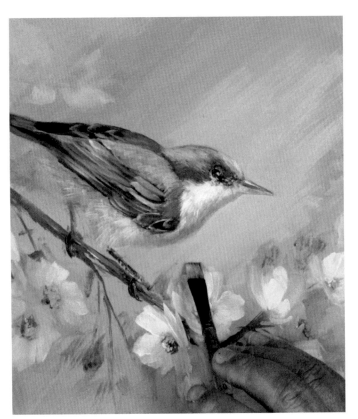

Step 58 Carry the color under the bird to clean up and push the Nuthatch forward.

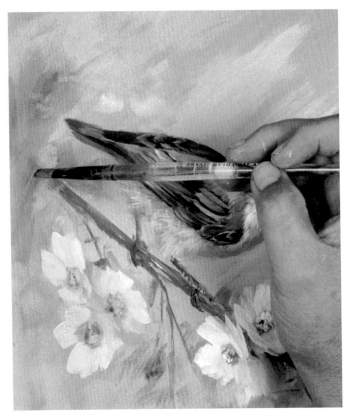

Step 59 Add some soft movement to the end of the design. I added some vertical movement which helps stop the eye and move it back to the bird.

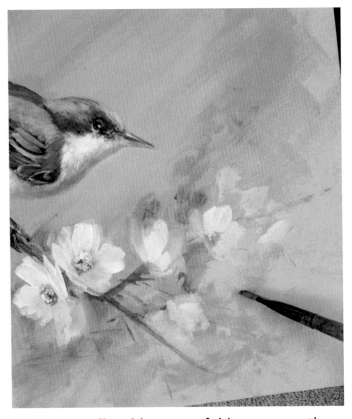

Step 60 Finally add some soft blossoms on the outside of the design to gently lead the eye out in the direction that he is looking. Enjoy!

Enlarge Pattern
127% to Original Size

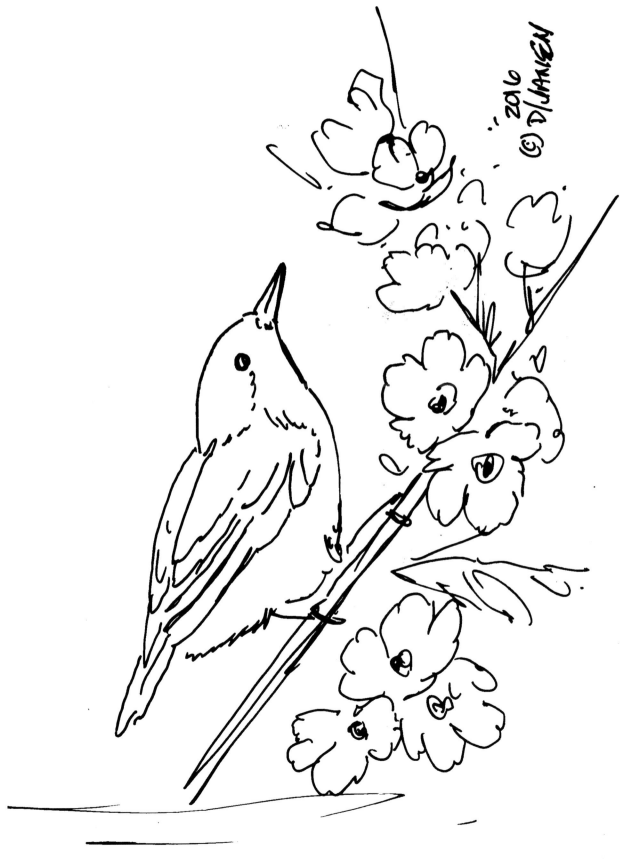

Chestnut Chickadee Brown Tones

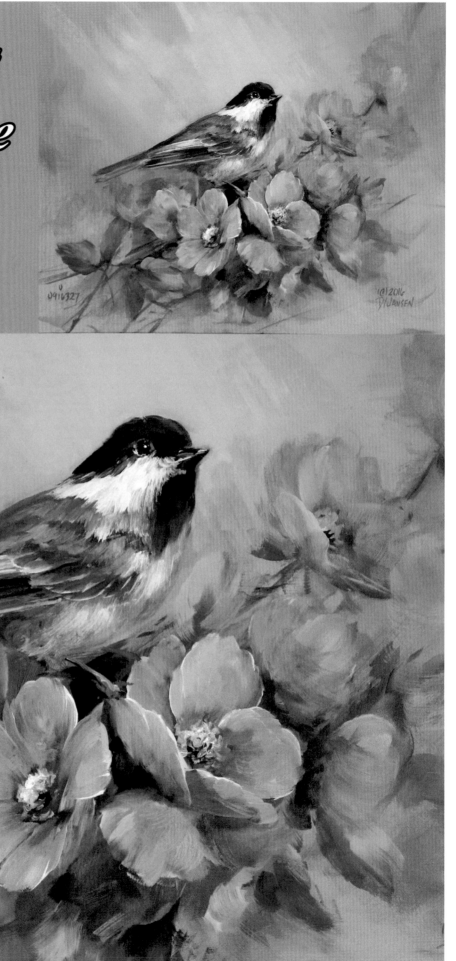

Chestnut Chickadee- Browns Tones

In my opinion, Brown is one of the most difficult colors to vary. This is why you will often see me use Burnt Umber and Burnt Sienna in the same painting. In the last lesson, you learned that each color could have warm and cool versions of the basic tone. You can also shift the tones in different directions.

For example, Burnt Umber is a very toned warm red-brown and Burnt Sienna is a warm orange-brown. Both Browns are toned quickly with a touch of Pine Green. A yellow-green, Pine

Green tones because it is a compliment to the red spectrum while maintaining the warm temperature.

A touch of Blue added to the Browns will tone them slightly and take the Browns to the cooler Violet side. By using both Burnt Sienna and Burnt Umber in the same painting, we make it easier to vary the tones and for our eyes to see the differences.

Burnt Sienna is a warmer, lighter Brown than Burnt Umber. However, Burnt Umber is more opaque and can overtake Burnt Sienna. The Chickadee lesson is a great way to practice mixing with these two very traditional pigments to make new versions of brown!

Also, we will use these tones to vary the white area on the Chickadee. The white band is a major area of interest in him so changing the white colors is essential. Let's give it a try!

Paint It Simply Palette
Base Color- Medium White, White + touch
Black and Yellow Oxide

Palette Colors

Paint It Simply Colors	**Additional Palette Colors**
Naphthol Red Light	Pine Green
Red Violet	Burnt Sienna
Carbon Black	Yellow Oxide
Phthalo Blue	Burnt Umber
Hansa Yellow	
Titanium White	

Wood Surface
11 X 14 Wood or canvas panel

Step 1 Mottle a light blue to blue violet with Phthalo Blue + touch Red Violet, lighten with some white and add to the background like the last lesson. Medium White based board.

Step 2 Mottle the brush with Pine Green and Yellow Oxide. Add some of this color to the blues to soften it and make a light green to blue green.

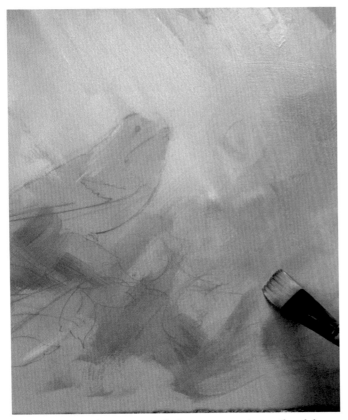

Step 3 Mottle some of the greens into the blues below the bird. This suggests some leaves and green areas below the bird.

Step 4 Mottle black, Burnt Sienna and Burnt Umber. The main painting colors of the Chickadee.

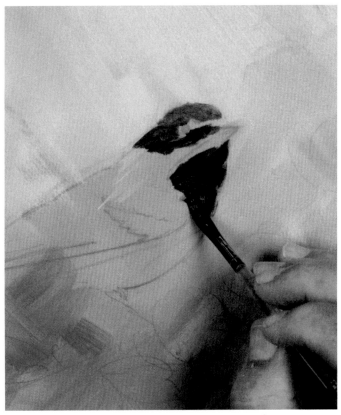

Step 5 Add Burnt Sienna to the top of his head and then darken with some Burnt Umber and add his throat and lower part of his head around the eye.

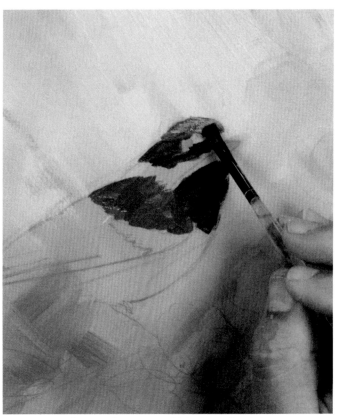

Step 6 Lighten the top of his head with some Burnt Sienna and White. I also added a touch of Yellow Oxide to vary the color. Add the mantle with Brunt Sienna, touch Nap. Red Lt.

Step 7 Mottle a light grey with the Burnt Sienna, yellow, white and touch Phthalo Blue to grey the color.

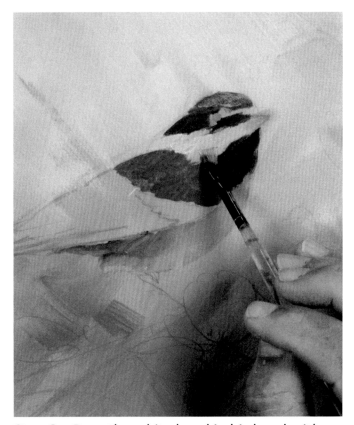

Step 8 Base the white band in his head with the grey tone, changing the tone as you base it in with more blues and yellows.

49

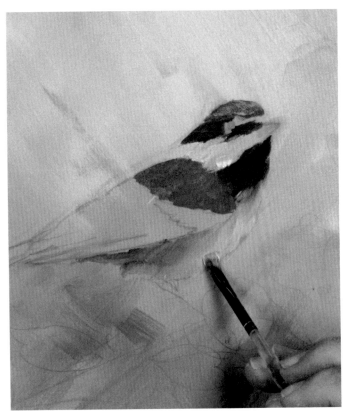

Step 9 Mottle the color with Burnt Sienna and then base in the breast area of the Chickadee. Darken the color a little under his wing.

Step 10 Mottle some darker greys with Burnt Umber, Burnt Sienna, black and white. Vary the color with the different umbers and white.

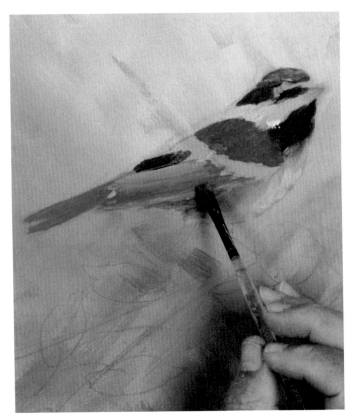

Step 11 Add strokes of the color to his wings. I use longer strokes on the flight feathers. This gives a different look than the body feathers.

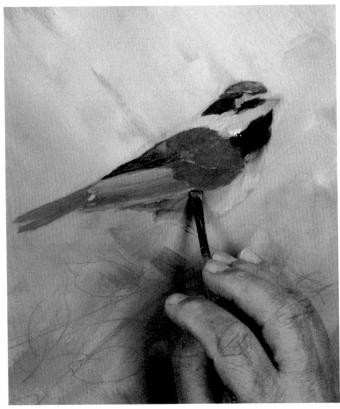

Step 12 Darken the color with more umber and black and add the coverts to the top of the flight feathers.

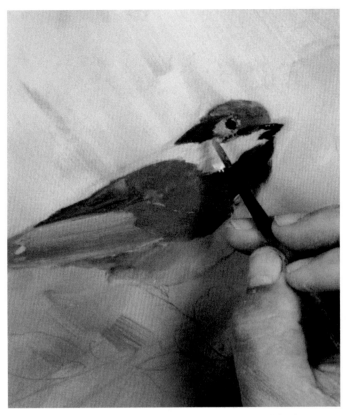

Step 13 Using the # 4 round brush and light Burnt Sienna, add the ring around the eye. Add small amount of black with some grey to the beak, and then the eye.

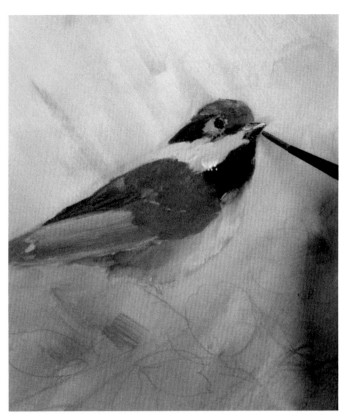

Step 14 Lighten the beak with some touches of lighter grey and white.

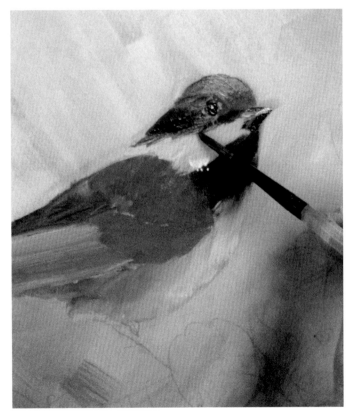

Step 15 Add a touch of Burnt Sienna to the eye to warm it and then tap browns around the eye to incorporate the eye ring into his head. Add white shines.

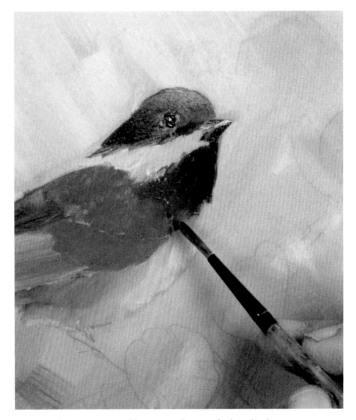

Step 16 Use smaller strokes of the lighter browns to add some lights to the neck feathers. These are a little larger than the strokes we used on the head. Follow the contours.

51

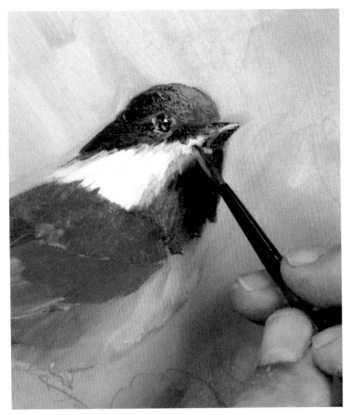

Step 17 Restate some browns around the beak. I constantly restate with various amounts of browns to vary the tones. Carry down into the white band.

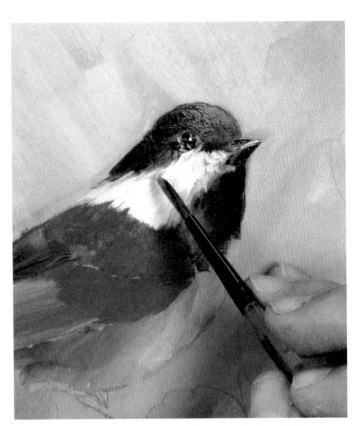

Step 18 Add some lighter brown behind the eye and some small touches of white around the eye to add more interest.

Step 19 Mottle the brush with some Burnt Sienna, Naphthol Red Light, Hansa Yellow and Yellow Oxide. Always vary the color as you apply.

52

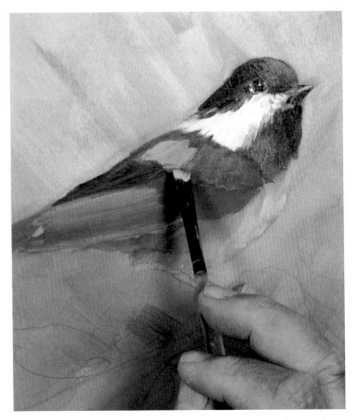

Step 20 Add lighter strokes to the mantle and coverts of the wing. Slightly longer strokes than we used on the neck. The #4 fusion flat is perfect for this.

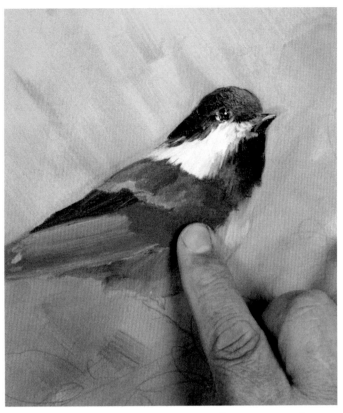

Step 21 Soften the colors into the wing with your finger. I place, soften and then repeat the colors several times to get the movement.

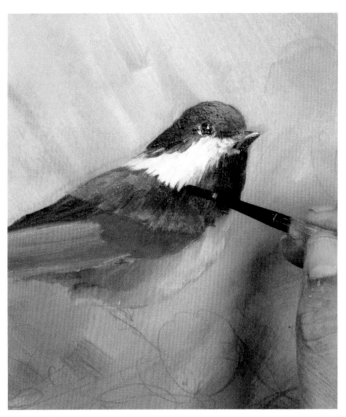

Step 22 Mottle the tip of the # 4 round with some Burnt Sienna and negative paint up and into the white with the tip of the brush. This is another way to make the look of small feathers.

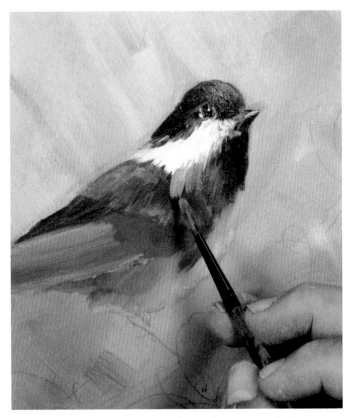

Step 23 Mottle the brush with some of the grey tones from the wing (Step 10) and pull down across the white and Burnt Sienna areas to make the grey band of color.

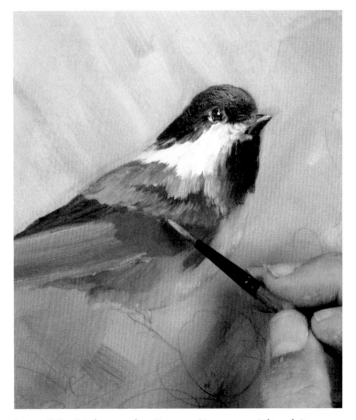

Step 24 Lighten the Burnt Sienna with white and Yellow Oxide and once again state some smaller light strokes in the mantle of the wing.

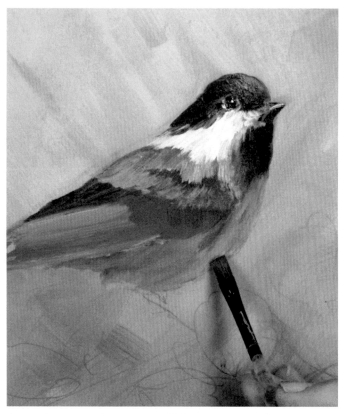

Step 25 Mottle some of the greys and Burnt Sienna on the # 4 flat and add movement to the breast feathers.

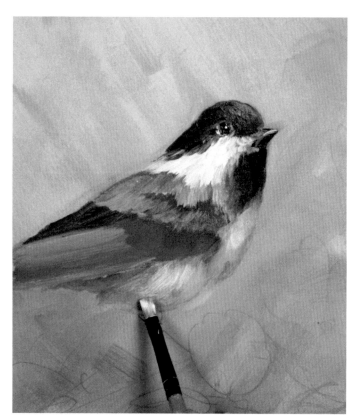

Step 26 Lighten the color with some white and add some strokes pulling down across the breast of the bird. Vary the tones and lights.

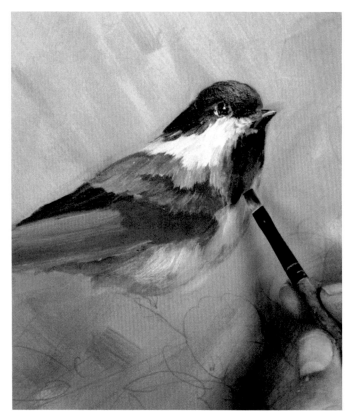

Step 27 Mottle the brush with Burnt Umber and tiny touch black and add some to the neck. Lighten with touch white and add additional tone to vary the color.

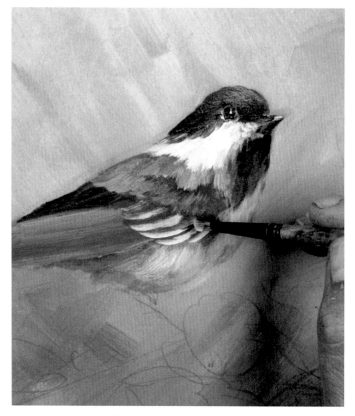

Step 28 Edge the brush with some white and using just the corner of the brush, add the smaller wing coverts to the bird.

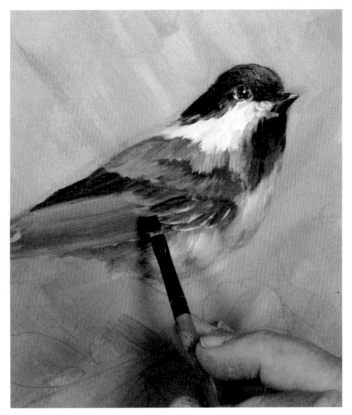

Step 29 Mottle the brush with some of the umbers and negative paint out some of the extra white on the wing coverts we just applied.

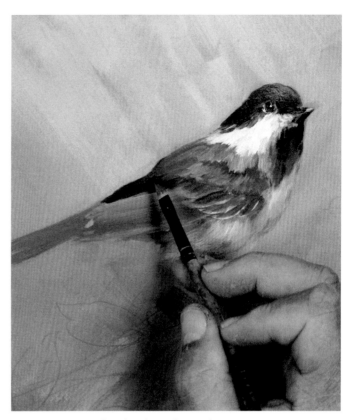

Step 30 Mottle the brush with some Burnt Umber and add darker tones to the back of the wing. Pull up and into the mantle area to vary the tones.

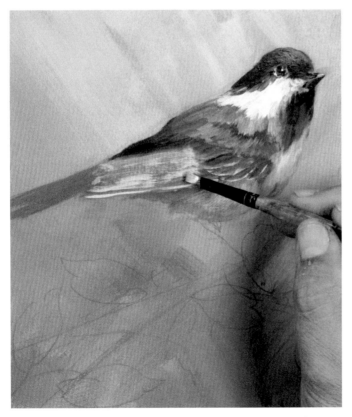

Step 31 Lighten the greys from step 10 with some white and then drag across the flight feathers to add some white interest.

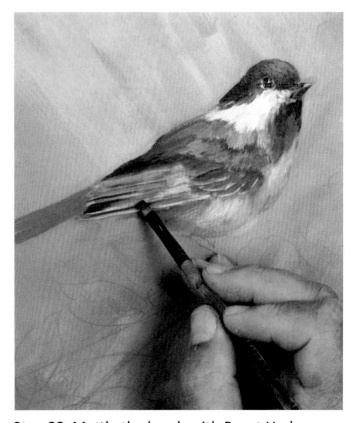

Step 32 Mottle the brush with Burnt Umber and negative paint out some of the white to make the individual feathers of the wing. Use the chisel of the # 4 fusion flat.

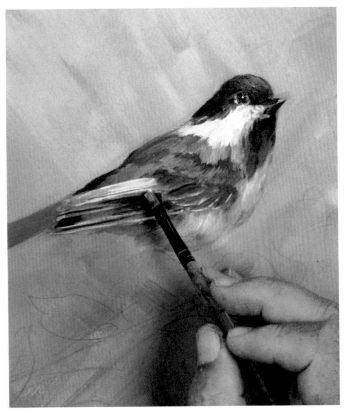

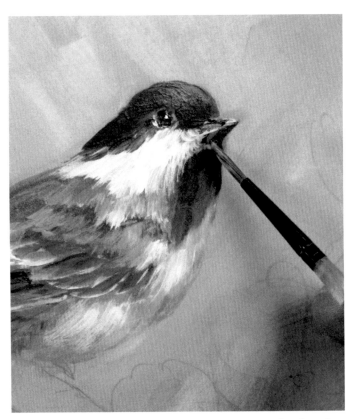

Step 33 Corner the brush with some white and restate some of the light edges to the wing feathers. If you get too much, negative paint again with the umbers.

Step 34 Add some additional greys to the beak for more interest. I repeat the tones several times to get the "life" and interest to the birds.

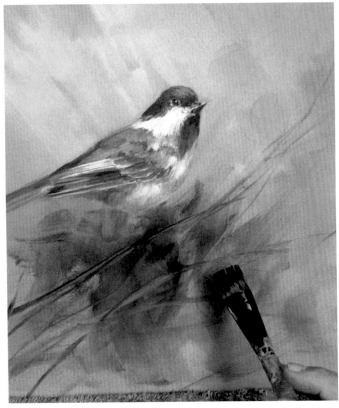

Step 35 Mottle the brush with some Pine Green and touch Burnt Sienna. Use the chisel of the large brush to add some stem movements to the design.

Step 36 Mottle the brush with some Burnt Sienna, Naphthol Red Light, Yellow Oxide, then lighten with some white.

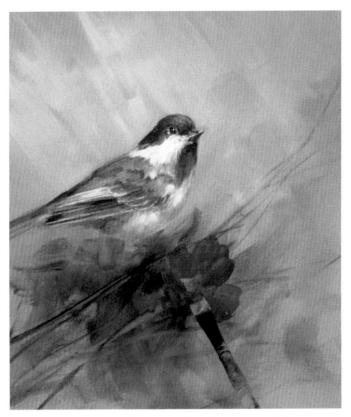

Step 37 Begin to base in the flowers with some various tones. Change the tones often for interest in the blossoms.

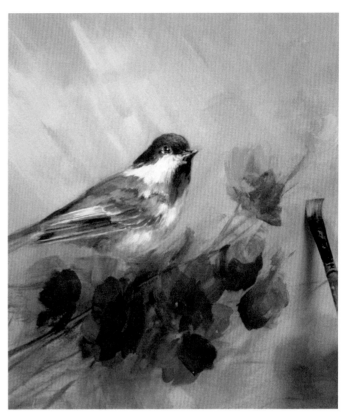

Step 38 Soften the tones in the back with more white so they fade into the background. Notice how bright they are around the bird. We will soften this with white later.

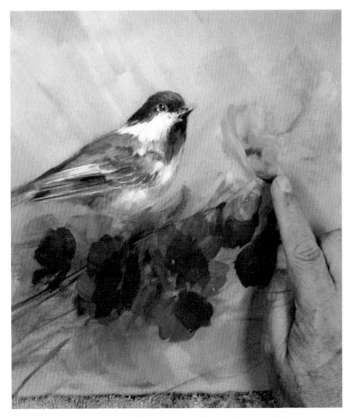

Step 39 Use your finger and push the blossoms into the background to soften the back petals.

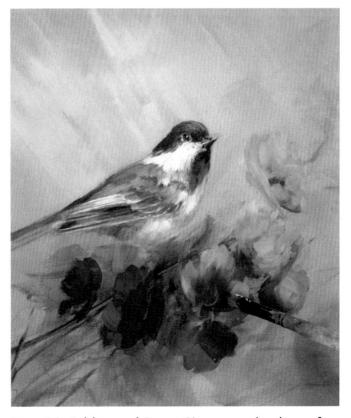

Step 40 Add toned Burnt Sienna and colors of the Chickadee into the front blossoms. This will create some of the harmony. Lighten the petals with touch white.

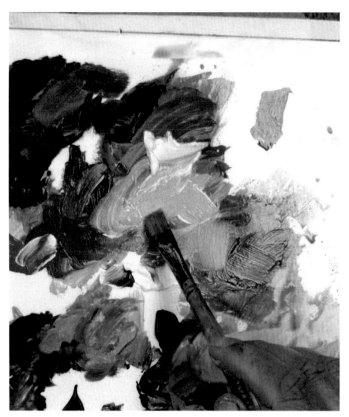

Step 41 Here you can see the colors for the blossoms. Lots! Mottle the color lighter with white as we get ready to make the lighter petals.

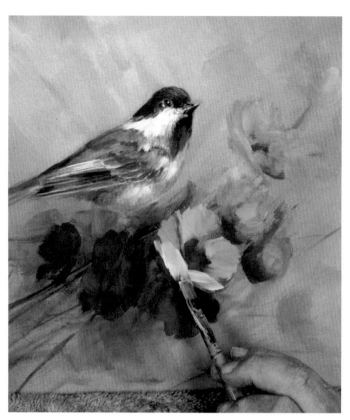

Step 42 Make the petals in the front of the blossom lighter with more white and then vary the tones as you go around the back of the blossom.

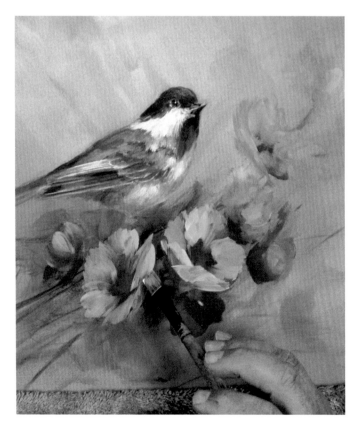

Step 43 I turn the blossoms by making the front petals a little shorter than the back ones. Here I stroke across the front of the petals for a different look.

Step 44 Switch to the #4 fusion flat and then sliding the brush on your palette to pick up just a corner of white which we will use to detail the petals.

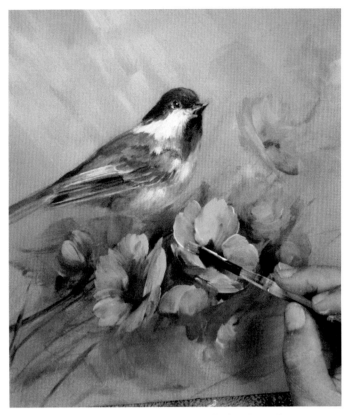

Step 45 Use just the corner of the brush to "draw" around the petals giving the front petals edges interest that will cause them to advance.

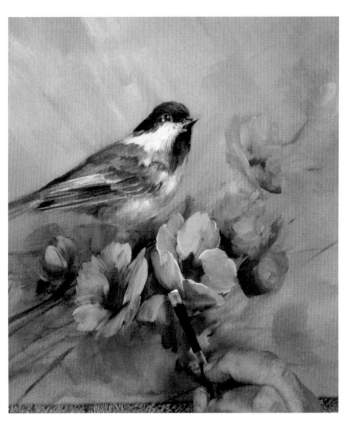

Step 46 Pull down with the cornered brush to make the petals in the front.

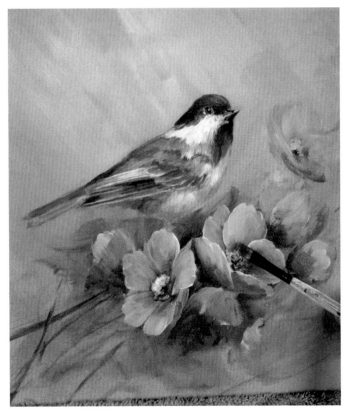

Step 47 Mottle the brush with darker tones and restate the shadows around the centers. Then tap in the centers with some Yellow Oxide and white on the corner of the brush.

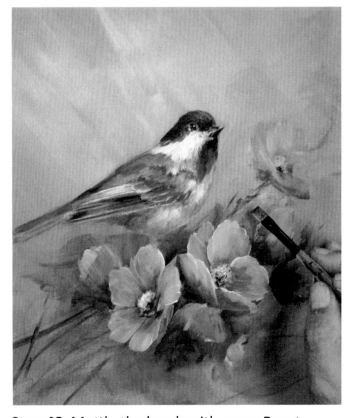

Step 48 Mottle the brush with some Burnt Sienna and using just the chisel, add some smaller stem movements to the blossoms.

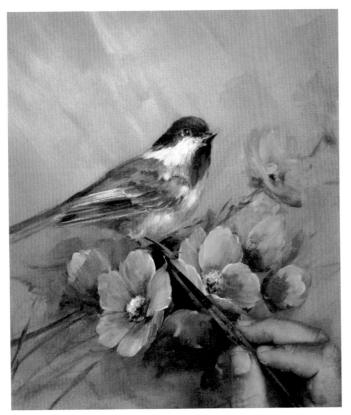

Step 49 Add the legs of the Chickadee with some of the greys from the wing. Use the tip of the # 4 round. Add some shadow and lights, but keep understated and soft.

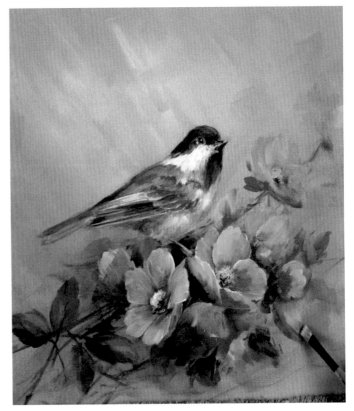

Step 50 Mottle the brush with Pine Green and touch Burnt Sienna and add the leaf shapes around the blossoms. Sometimes add touch blue and black. Lighten with yellows.

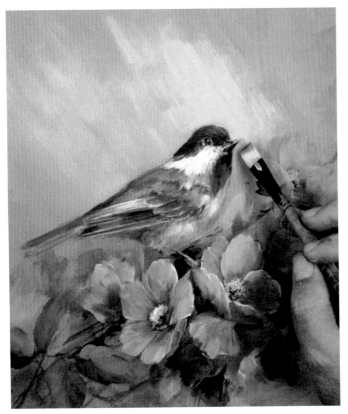

Step 51 Mottle the brush with some of the blues from the background and cleanup and reinforce the blue colors in the sky which push the Chickadee forward.

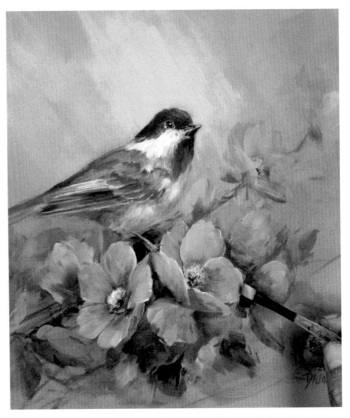

Step 52 Finally add a few touches of the blues to the blossoms which gives harmony to the blossoms and background. Enjoy!

Enlarge Pattern
127% to Original Size

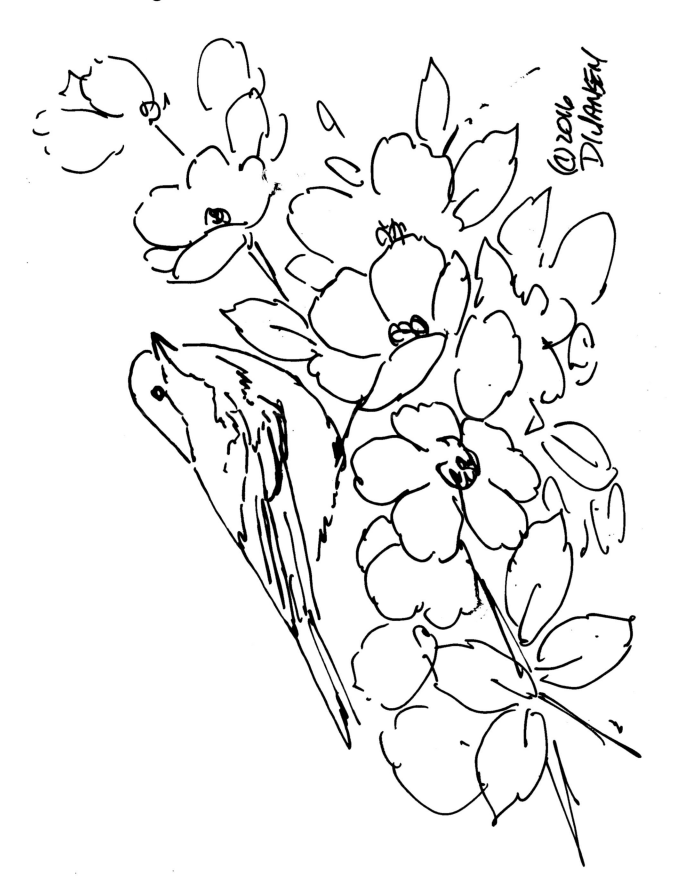

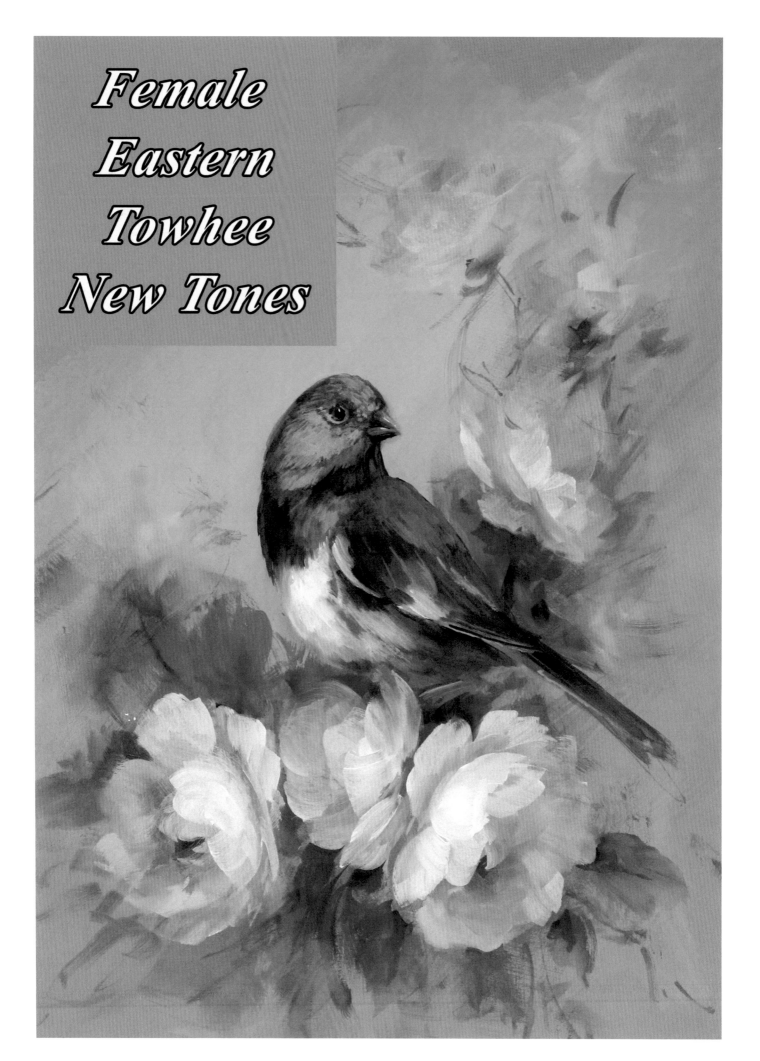

Female
Eastern
Towhee
New Tones

Female Eastern Towhee- New Tones

One of the reasons I wanted to paint the female Eastern Towhee was that I thought it would be fun to try to capture her beautiful tones in a painting. She actually changes color a little as she turns in the light. Her feathers reflect light through a wider band of hues than many other types of birds. So how do we paint that?

To help me visualize the colors, I placed them out on my palette before I started to paint. The photo shows me doing this. I set the brighter oranges on top (Naphthol Red Light + Hansa Yellow). That makes an orange. The oranges shift down to the Burnt Sienna tone you see on the left.

Those oranges are then darkened with Burnt Umber. Also, I cool the Burnt Umber for the shadow area. Red Violet drops the temperature very quickly. Phthalo Blue or Ultramarine Blue give the appearance of cooling the tone while adding contrast to the area because the blues are a compliment to the oranges.

All those tones are added to the whites and greys. Those tones are essential to make the light shines and highlights. The shines that soften the oranges need to be warm or cool and in harmony with the base orange tone.
A mixing adventure- let's give it a try!

Paint It Simply Palette
Base Color- Lt. Grey, White + touch Black and Yellow Oxide

Palette Colors

Paint It Simply Colors
Naphthol Red Light
Red Violet
Carbon Black
Phthalo Blue
Hansa Yellow
Titanium White

Additional Palette Colors
Pine Green
Burnt Sienna
Yellow Oxide

Wood Surface
11 X 14 Wood or canvas panel

How to See a Rose- Basic Form- From our Mastering Roses Series

Step 1- Determine the Type of Rose.
This step you casually base in the area the rose will occupy. You should have an idea of the type of rose. Casual or stroke. Move the color in a circular motion for a round rose.

Step 2- Determine the Size and Placement.
Next determine the size and gaze of the rose. I usually do this by starting the 3 circles. Inside throat, bowl and area for the reaching petals. I keep this soften using my finger.

Step 3- Light Source and Shadow.
I next refine or determine the shadow side of the rose. This tells the light source. Cool and darken one side of the rose so you can see the light and shadows. Soften the shadows or incorporate into rose.

Step 4- Determine Warm and Cool Areas.
Warm the color and lighten it so you can begin to apply the light colored areas. This usually is the most forward part of the rose. Soften the color as you go around the rose to the backside.

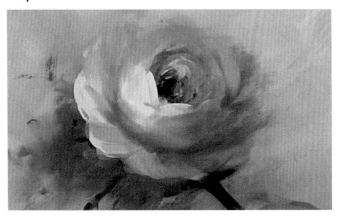

Step 5- Define the 3 Circles with Color.
Add the area for the reaching petals. This now clearly defines the 3 circles of the rose. Throat, bowl and reaching petals. Keep soft.

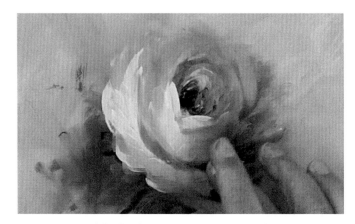

Step 6- Establish the Movement and Petals.
Use your finger or a soft brush to move the color in the circular motion for the bowl and in and out for the reaching petals. The rose is now ready to decorate with desired petals.

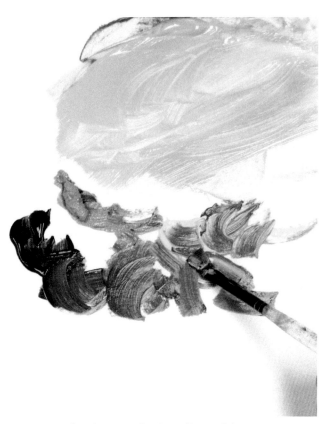

Step 1 Like the other lessons mottle a blue with some Ultramarine Blue and white. Apply over the light grey surface of the background leaving just a few streaks. 3/4 inch brush.

Step 2 Mottle the # 4 fusion flat with some Burnt Sienna, both yellows and a touch of white. Vary all these tones as we work to base in the female Towhee.

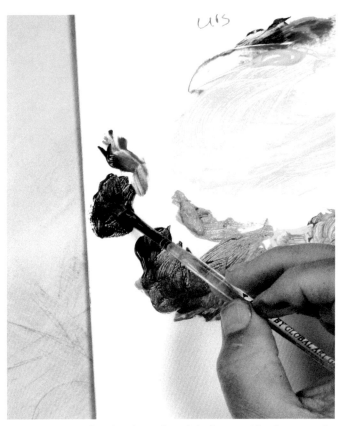

Step 3 Base in her head with some contour following strokes of the various Burnt Sienna tones. Leave a space for the eye.

Step 4 Mottle the brush with Burnt Umber and touch Ultramarine Blue to darken and cool the tone.

65

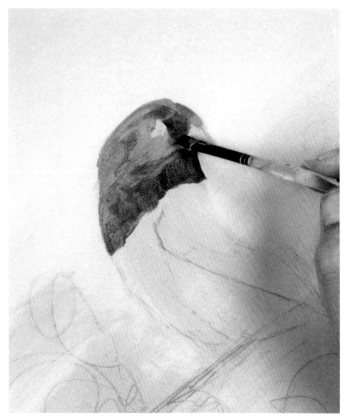

Step 5 Add some darker tones to the inside neck and between the beak and the eye. Use small contour following strokes. We will then add this tone to other areas. See step 7.

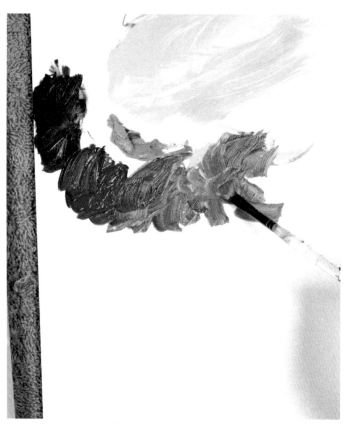

Step 6 Mottle the tone lighter and brighter with some Hansa Yellow and Naphthol Red Light. This is used to vary the Burnt Sienna base tone for the bird. Darker tones are Umbers.

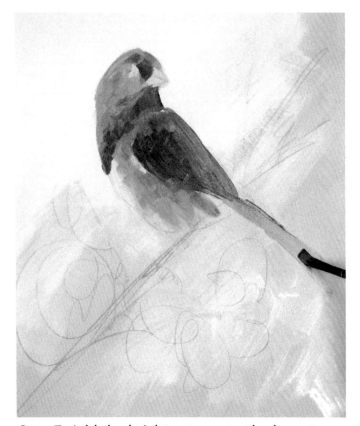

Step 7 Add the brighter tones to the breast area. Burnt Sienna tones to the head, wings and tail. Darker tones from step 5 are added to neck, front of wing and top of breast.

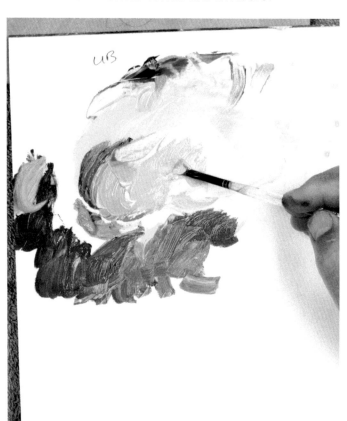

Step 8 Mottle the bird body color with some Ultramarine Blue and then lighten with touch white and Yellow Oxide to warm. This will be a warm yellowish grey color.

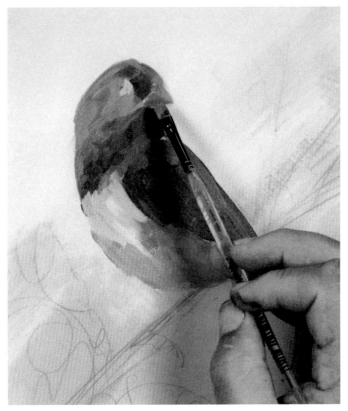

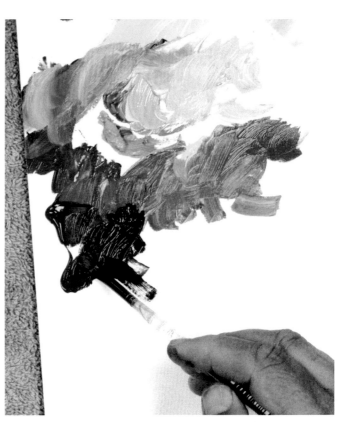

Step 9 Add this grey to the top of the breast as an undertone, then vary the grey with a little Burnt Sienna and add lighter tone to top of beak and darker to lower part of beak. Chisel edge.

Step 10 Mottle the Burnt Sienna with some Burnt Umber and tiny touch black. The secret to making a beautiful bird is the vary these tones!

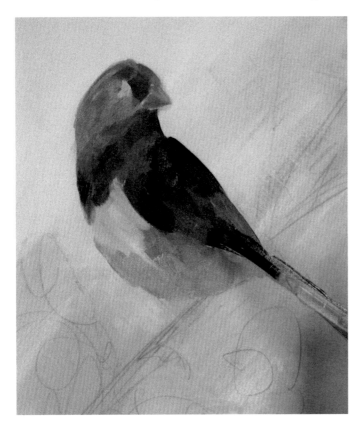

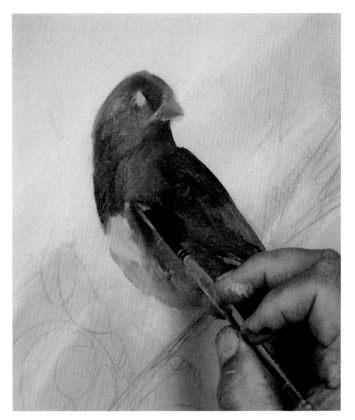

Step 11 Add the darker tones to the top of the wing and then down through the wing, changing to tones to more Burnt Sienna for interest.

Step 12 Lighten the tone with some orange (Naphthol Red Light + yellows) and add to the top of the wing. Spend time mottling the body with these tones. It gives more interest.

67

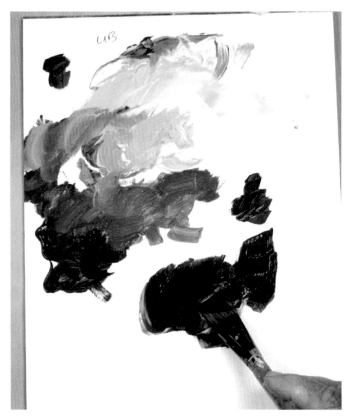

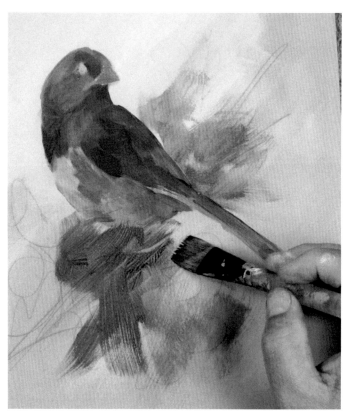

Step 13 Mottle the Pine Green with some Burnt Sienna on the large 3/4 inch brush. Sometimes add a touch Ultramarine Blue to change the tone.

Step 14 Casually add the green tones under the bird dragging into the background. Soften the outside edges and build more color in the center.

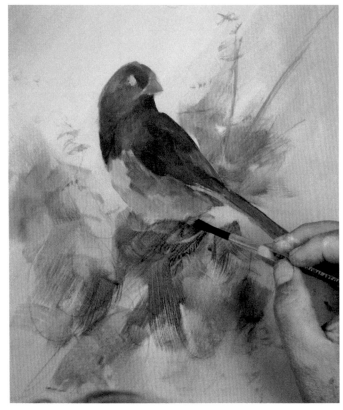

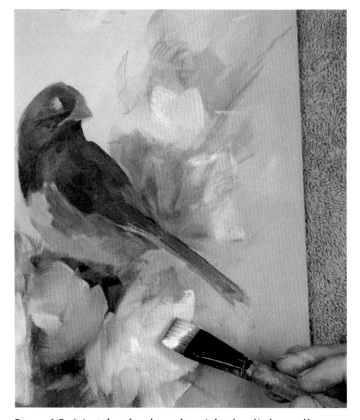

Step 15 Use the chisel of the smaller fusion flat to add some stem movement and some darker tones under the bird. These darker tone "set" her down into the leaves.

Step 16 Mottle the brush with the light yellow-ish grey tones we used on the breast. Use the 3/4 inch brush and casually base in the areas for the roses, making outside ones softer.

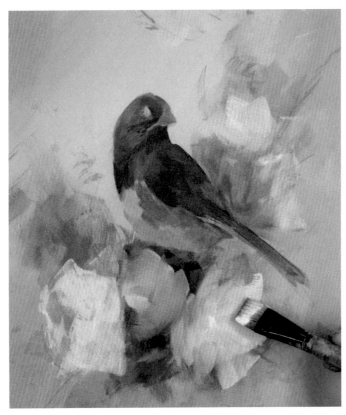

Step 17 Lighten the greys with more white and add some additional light color in the center areas of the rose around her.

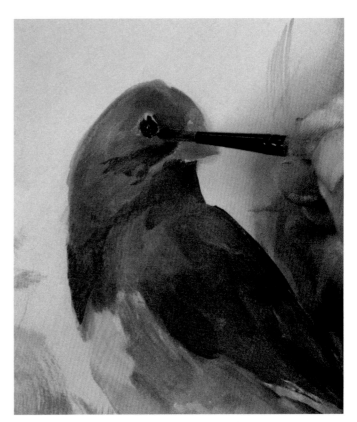

Step 18 Mottle the # 4 round with Burnt Sienna and add the eye. Then darken with some black and add a smaller touch to the front of the eye, leaving some of the Sienna showing.

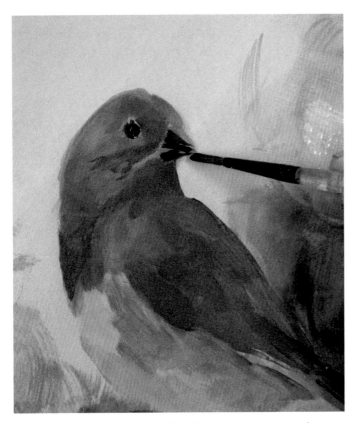

Step 19 Add some of the Burnt Sienna to the top of the beak and then some black to the bottom of the beak. Do not cover up all the greys.

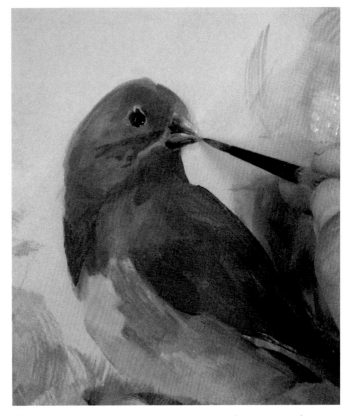

Step 20 Lighten Burnt Sienna with some white and add to the beak, lighter on top and just a little for interest on the bottom.

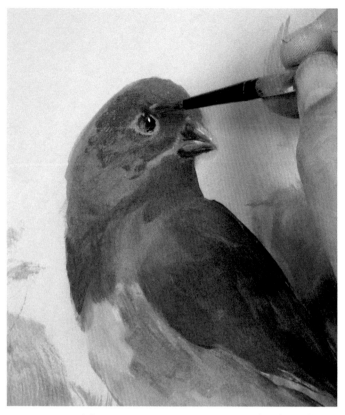

Step 21 Add some Burnt Sienna on the brush and add strokes to the head. Now we will add smaller touches of various tones to her to add more interest.

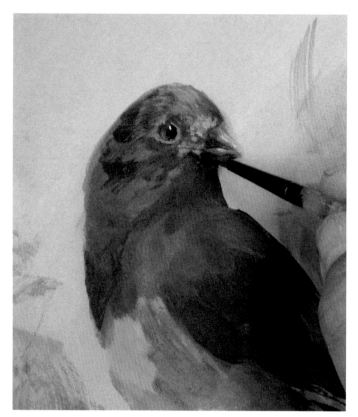

Step 22 Darken the last tone with Burnt Umber and add strokes. Then lighten Burnt Sienna with a little white and add some lighter tones around the top of her head.

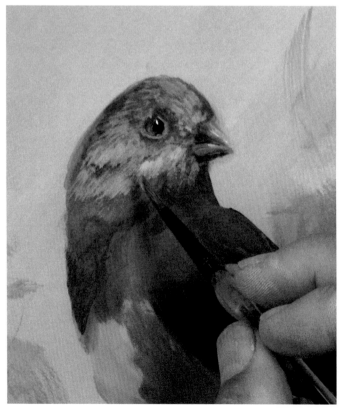

Step 23 Continue working down the front of her head with the light tones. Work back and forth with the tones and small contour following strokes to suggest feathers.

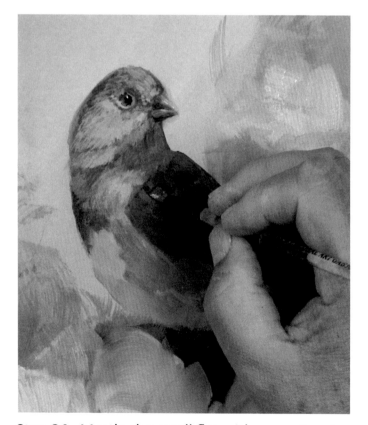

Step 24 Mottle the small flat with some Burnt Sienna tones and restate them into the wing and mantle to vary the color.

Step 25 Mottle the Burnt Sienna with some Ultramarine Blue to grey the color and then lighten with white.

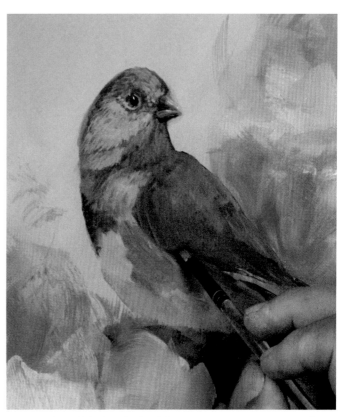

Step 26 Add this light blue grey over some of the Burnt Sienna tones in the top mantle of the wing to vary the tones even further.

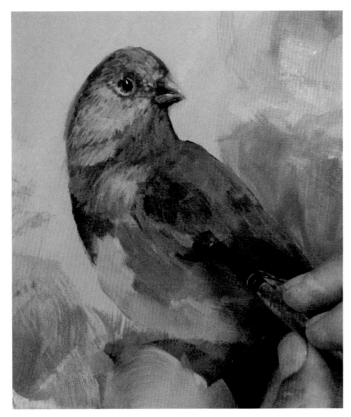

Step 27 Mottle again with some sienna and yellow and add into the wing with various sizes of strokes.

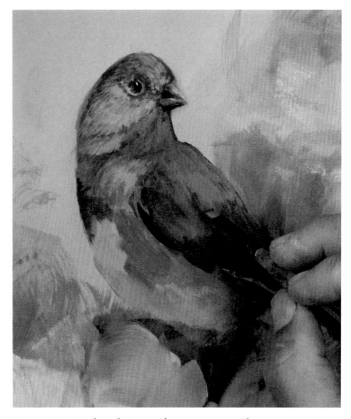

Step 28 Go back into the greys and repeat. As you can see, to get all this variation, especially in this colored bird, I repeat tones many times. As I repeat I work in smaller areas.

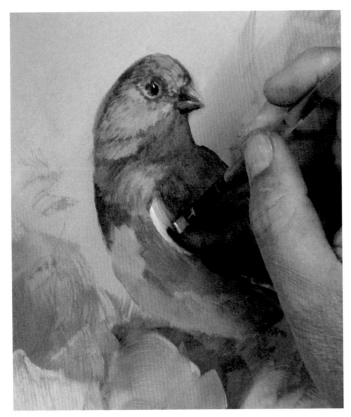

Step 29 Mottle the brush with some white and grey and using the chisel, add the front edges of the wing. Add a few strokes to the breast area which you can see in the next step.

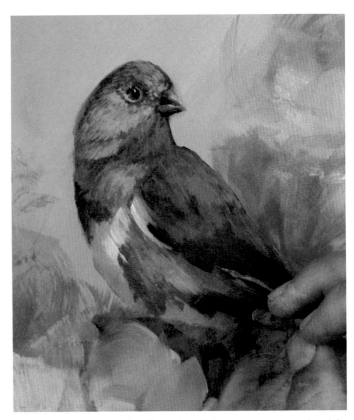

Step 30 Mottle the brush with oranges and add some brighter tones to the lower breast area. Add additional yellows and add that color inside the oranges to create highlights.

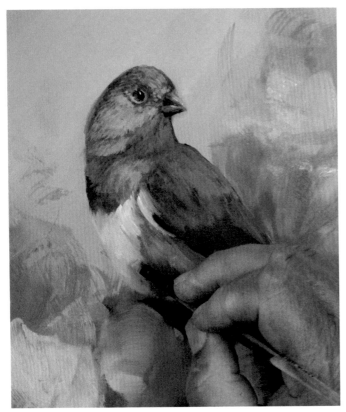

Step 31 Mottle the brush with some lights and add light strokes to the breast again, build more color. Work back and forth between the oranges and whites to build the breast.

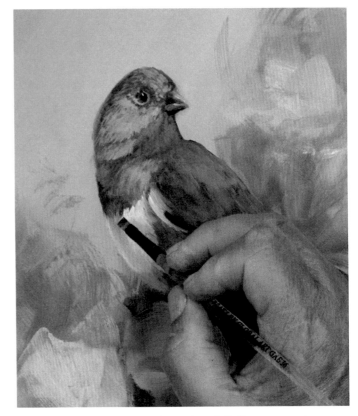

Step 32 Here I am using the # 2 flat to make some smaller darker Burnt Umber strokes at the top of the white breast. Incorporate the color into the white, but do not blend.

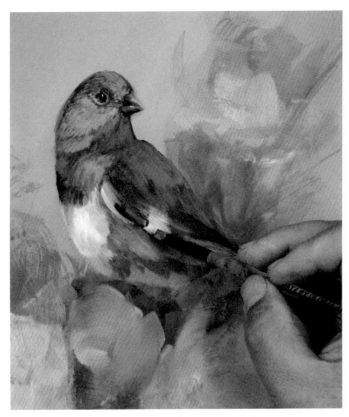

Step 33 Mottle the brush again with some whites and add the white areas to the wing. I am using the #2 flat. Vary the color with oranges.

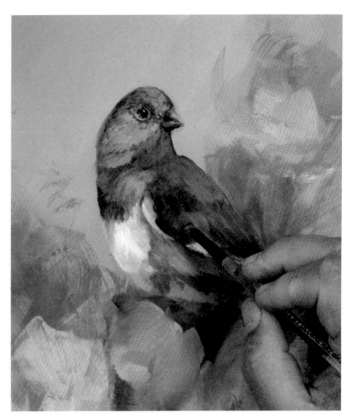

Step 34 Pull light oranges down toward the light band to create the movement of the covert feathers.

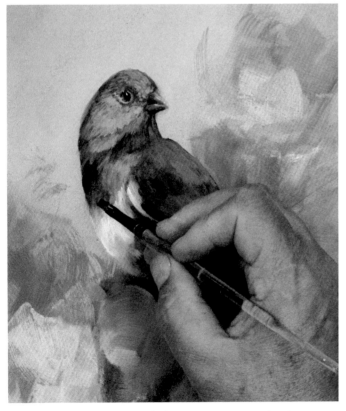

Step 35 Add some of those tones to the breast. Remember to always carry the colors in the bird. Work the tones, several times, each time getting a little smaller.

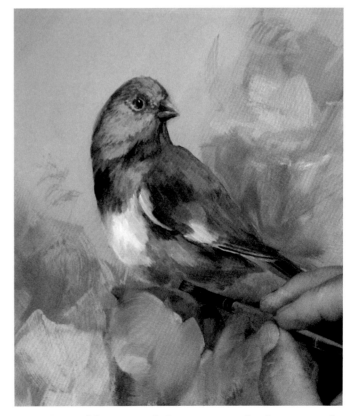

Step 36 Add some of the tone to the bottom of the bird to help with the roundness of her body. Notice the variation of the tones. This is the key to interest.

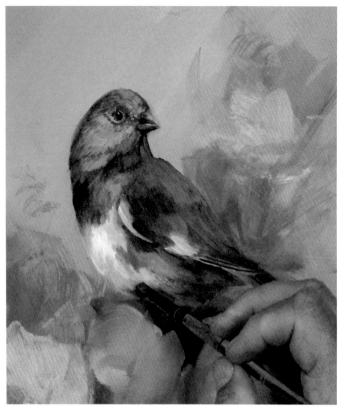

Step 37 Mottle the brush with the lights again and add to the center area of the breast and work down towards the tail slowly darkening the tone.

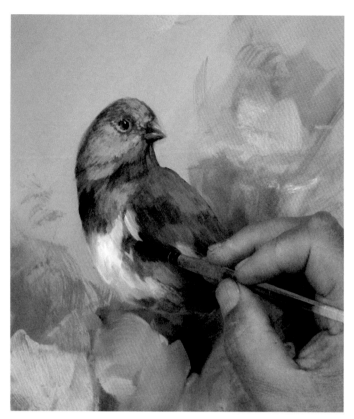

Step 38 Add shadow tone (Burnt Umber) under the wing now as a shadow which will lift the wing off of the body.

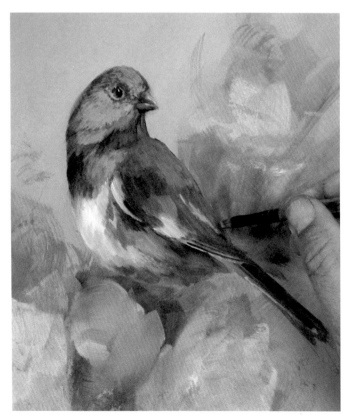

Step 39 Add some soft toned whites to the back of her wings which represent the white color bands on her wings. Use the chisel of the brush to make the small strokes.

Step 40 Mottle the Burnt Sienna with oranges and lights on the palette with the # 10 flat brush. We will use this on the roses.

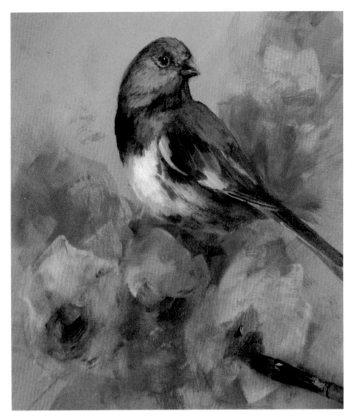

Step 41 Begin casually applying this color over the roses. This will carry the bird colors into the roses. Darken the centers with a little more color, lighten as you get to the background.

Step 42 Mottle some of the Burnt Sienna into the blue we used earlier to grey the color. Do not over mix. Let some of the grey be warm (sienna) and some cool (blue).

Step 43 Lightly apply greys over the roses to soften them into the background. This softens the sienna colors. Lighten the color with white and build the front of the roses.

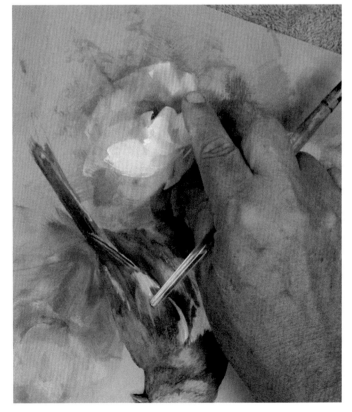

Step 44 Soften the colors into the background with your finger. Leave more contrast petals in the center area building up the center of the rose.

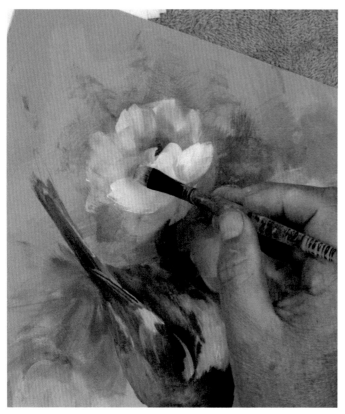

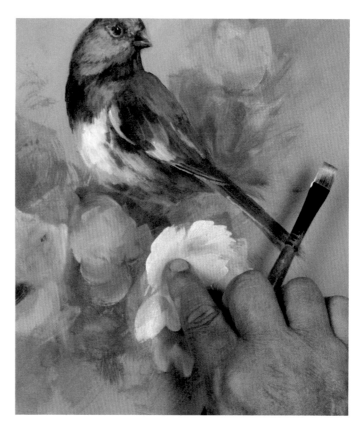

Step 45 Mottle the brush with soft greys, not as much white and soften the back edges of the roses into the background.

Step 46 Add the front reaching petals of the rose and then push the color in and out to create movement for the rose. Keep soft. See rose painting examples in front of this lesson.

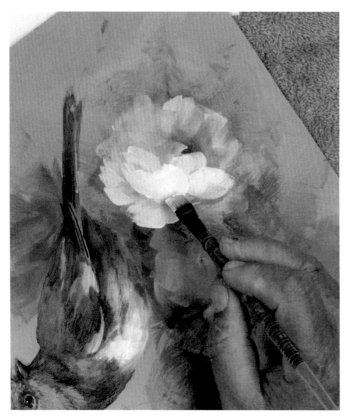

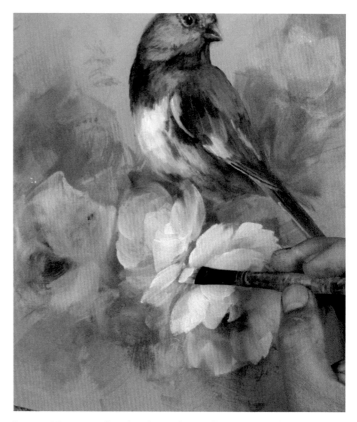

Step 47 Mottle the brush with more white and build the front of the rose. Use more white and curve the strokes so that the front of the rose curves or rounds making the bowl.

Step 48 Mottle the brush with more white and begin the reaching petals of the rose. Pull the petals in towards the bowl. Have found edges in the front and lost edges in the back.

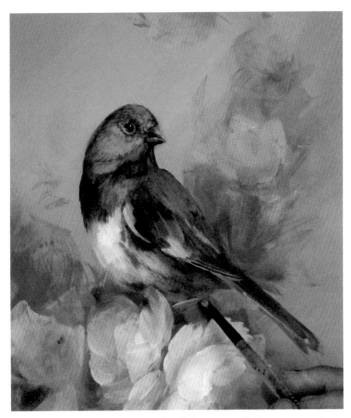

Step 49 Use the chisel of the small flat to make the legs of the female Towhee. Check some of the final details on her and make sure she has some nice found edges to bring her forward.

Step 50 Add some final petals to the fronts of the other roses. Keep the colors mostly in the center to keep the roses round.

Step 51 Mottle the brush with the light blues from the sky and add this to the roses on the back side and shadow side. This cool color will add harmony between roses and background.

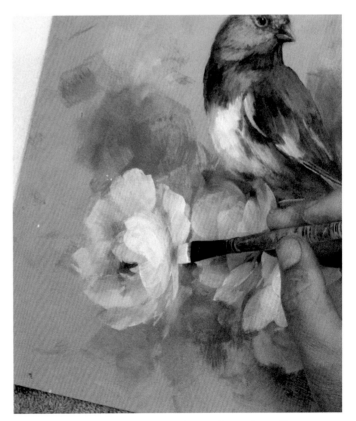

Step 52 Use the warm whites (touch Yellow Oxide) in the front of the roses to apply some final lights. Keep side petals lost.

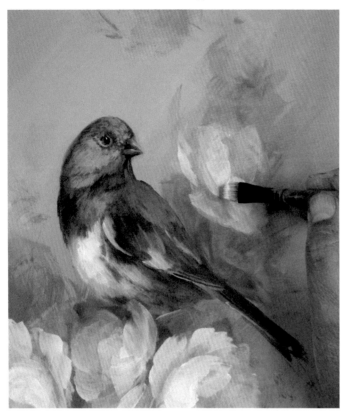

Step 53 Add some soft whites to the fronts of the roses in back. Keep the color a little greyer and do not make as many found edges so the rose recedes behind the female Towhee.

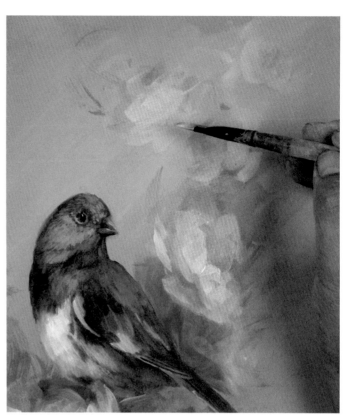

Step 54 Add some suggestions of back roses with the small brush and soft greys. Add some soft Burnt Sienna to the centers.

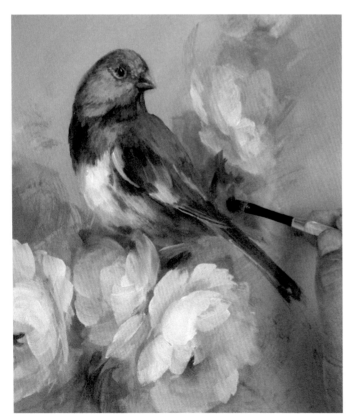

Step 55 Mottle the brush with Pine Green, Burnt Sienna and Burnt Umber. Add some stems and darker green/ browns to the leaves for additional interest.

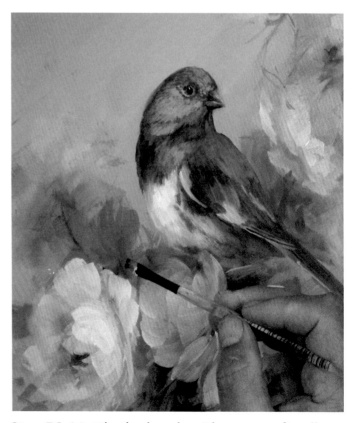

Step 56 Mottle the brush with some soft yellow greens and build some soft leaf shapes around her to finish. Keep soft. Enjoy!

©2016
D/WAWSON

Blue Warbler Learning Blues

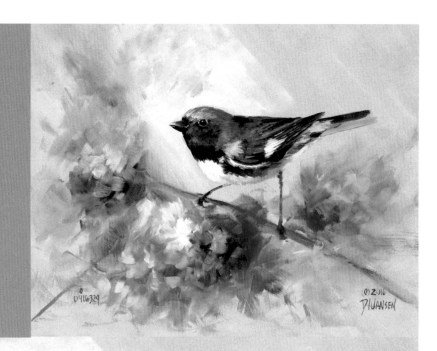

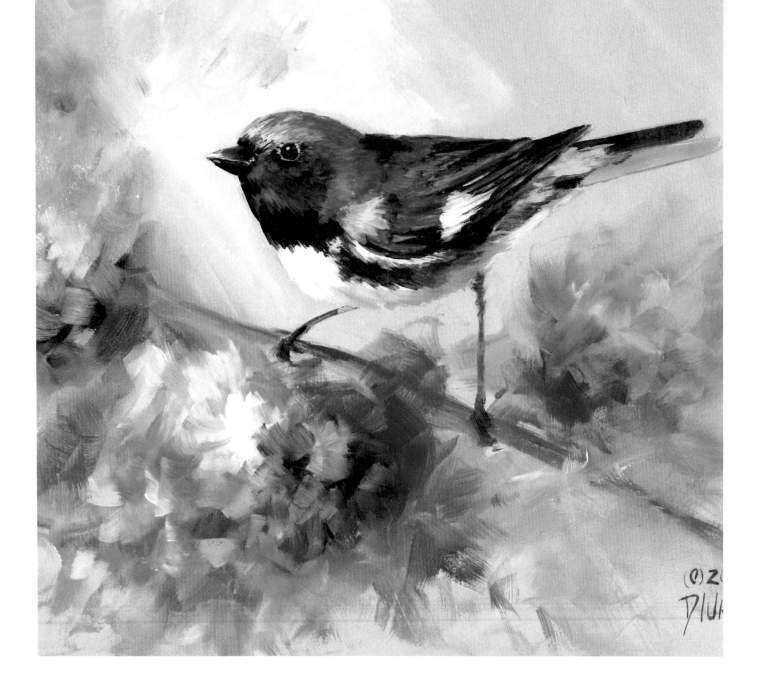

Blue Warbler- Learning Blues

Time to play with blue tones! Blues are very important because they are in many color mixes and help control the temperature in the painting. In the Paint It Simply lessons, we use Phthalo Blue. Phthalo Blue is a powerful mixing blue that leans to the yellow or blue-green side. We can shift Phthalo Blue to the blue-violet side by adding Red Violet.

For this lesson, we will focus on the working properties of Ultramarine Blue. In comparison to Phthalo Blue, it is a weaker mixing blue and greys very quickly when combined with other colors. However, it is an old, traditional pigment that is used by many artists. I believe many

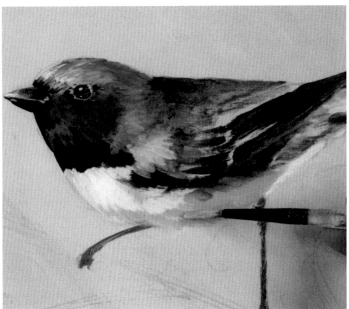

painters do not understand the benefits of Phthalo Blue. If you have worked through the Paint It Simply lessons, you will notice a huge difference as we return to Ultramarine Blue.

Ultramarine Blue will give you a historical perspective to blue. In this lesson, you will see the difference between it and Phthalo Blue. In some areas, we will use the two blues together. As you brush mix through the steps, watch what is happening to the blues. This year I have trained my eye to see subtle differences in blues and this lesson is a great way practice! Let's give it a try!

Paint It Simply Palette
Base Color- Lt. Grey, White + touch
Black and Yellow Oxide

Palette Colors

Paint It Simply Colors
Naphthol Red Light
Red Violet
Carbon Black
Phthalo Blue
Hansa Yellow
Titanium White

Additional Palette Colors
Pine Green
Burnt Sienna
Yellow Oxide

Wood Surface
11 X 14 Wood or canvas panel

Step 1 Mottle a light warm grey from black, white and touch Yellow Oxide. I based the board with grey made from black and white.

Step 2 Add some streaks of the lighter warmer grey over the background and then use a paper towel to remove the excess like we did in the other lessons.

Step 3 Mottle some Ultramarine Blue with white to lighten. We will adjust the tones of the blue with some Phthalo Blue as well.

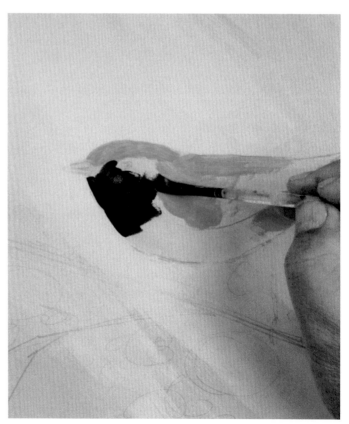

Step 4 Begin by basing in the top part of his body with the Ultramarine Blue and white. Darken the Ultramarine with a touch of black and bade the neck area.

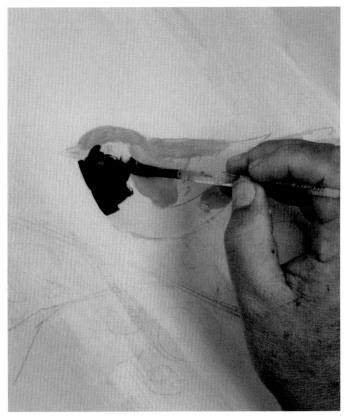

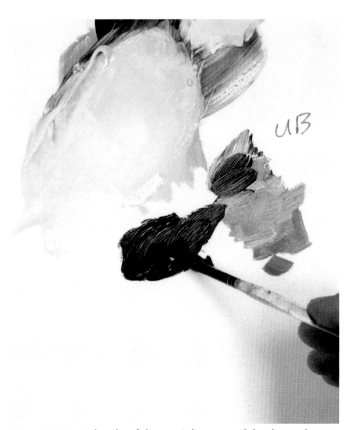

Step 5 Carry the color up and around the eye area leaving a small space for the eye. I am using the # 4 fusion flat and short contour following strokes.

Step 6 Mottle the blue with more black and then soften with tiny touch white which will grey the color slightly.

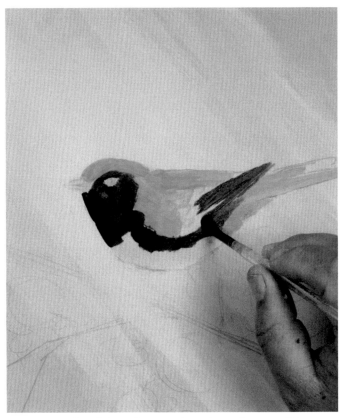

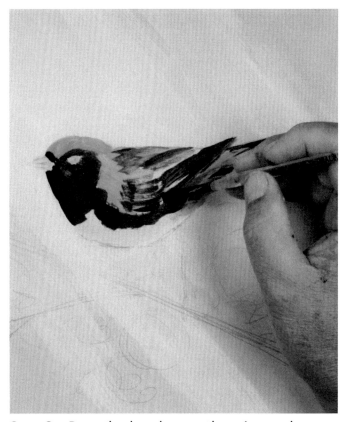

Step 7 Add this color under the wing and into the flight feathers of the wind.

Step 8 Drag the brush over the wing and coverts of the wing leaving some areas of broken color. Almost like a "dry brushing" of the paint over the coverts.

83

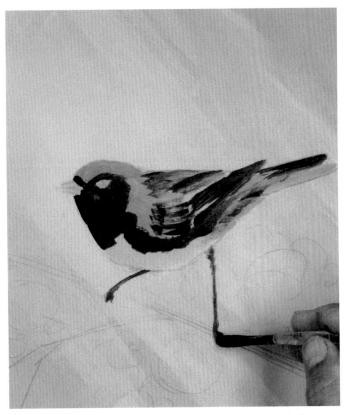

Step 9 Use the chisel of the brush to add the legs of the Warbler. Just suggest the feet. No need to get perfect with the shapes.

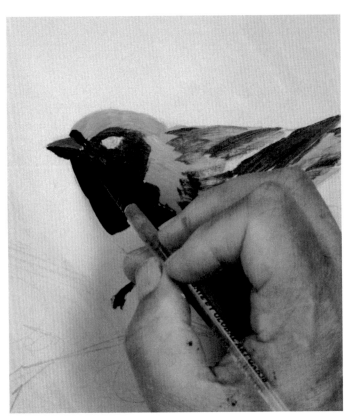

Step 10 Add black to the bottom of the beak, then lighten with a touch of white to make a grey and add the top of the beak.

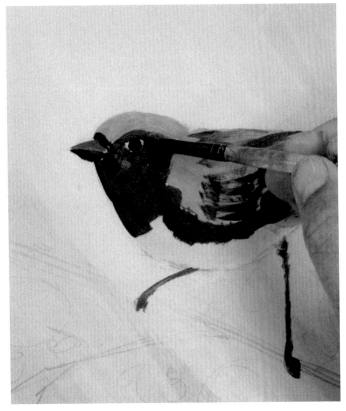

Step 11 Use the corner of the brush to tap in the eye with black. Leave a little white around the eye for the eye ring.

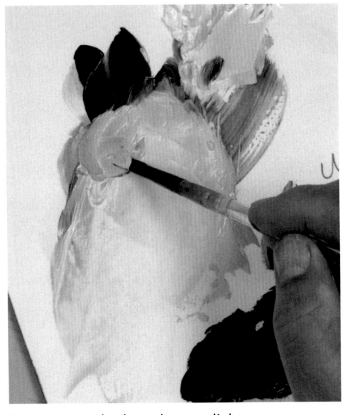

Step 12 Mottle the color to a light warm grey. Similar to the grey we used in the background.

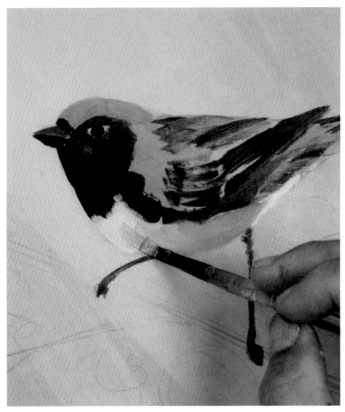

Step 13 Add this color to the breast area of the bird. Notice how the color is just a little darker than the background so you can see it.

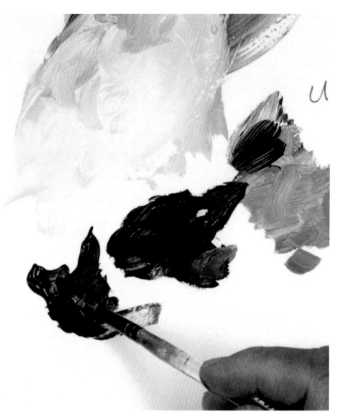

Step 14 Mottle a warm brown with Burnt Sienna and black. A little more on the brown side.

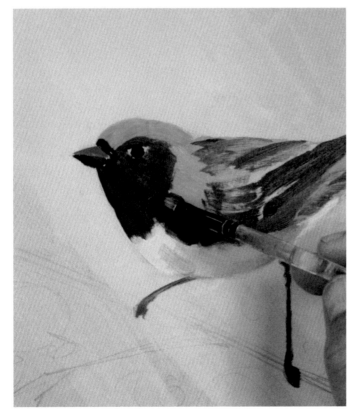

Step 15 Using the brown, add some to the black areas of the warbler to warm up and add a different tone to the black areas for interest.

Step 16 Mottle different blues with Ultramarine Blue + touch Phthalo Blue, black and white. Do not over mix.

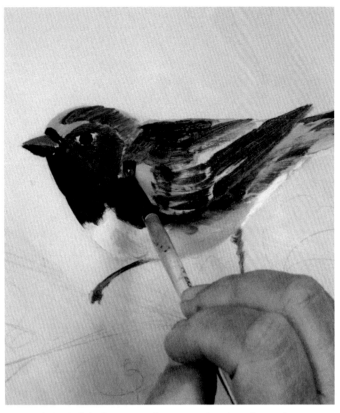

Step 17 Add these colors to the back and between some of the black color areas on the warbler.

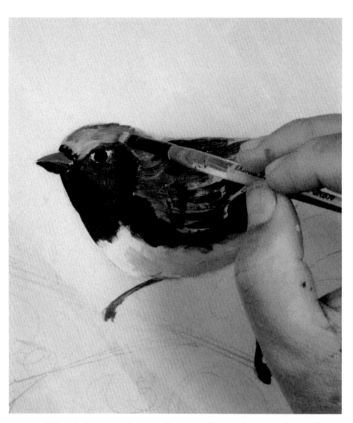

Step 18 Lighten the color with white and add some lighter contour following strokes to the top of his head. Use small shorter strokes.

Step 19 Lets vary the tone now with a touch of Red Violet and white. Mottle on the brush.

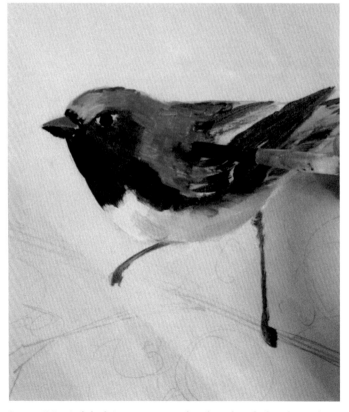

Step 20 Add this tone to the back of the head and along the mantle of the Warbler to vary the tone and color.

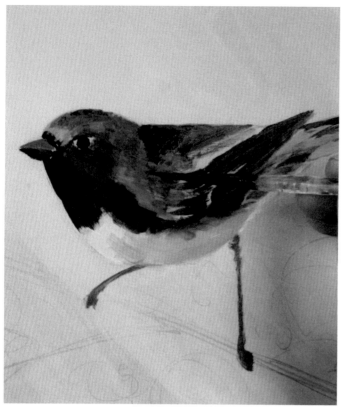

Step 21 Mottle the #4 round with some blue and black and restate some of the darker blue tones over the lighter blue violet we just applied.

Step 22 Mottle the blues with more white to lighten the tone. Again, do not over mix, we are painting for variation.

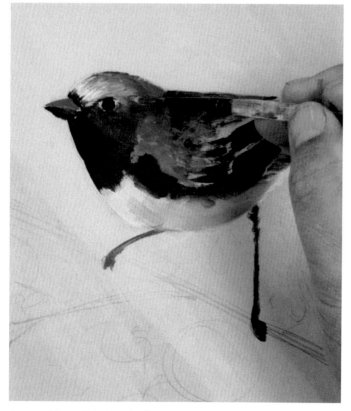

Step 23 Add this lighter tone to the front of his head and then along the eye towards the back of the head using contour strokes.

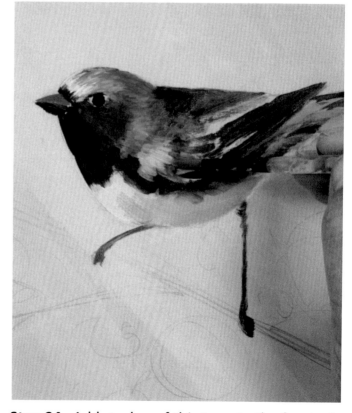

Step 24 Add strokes of this tone to the front of the wing using more medium sized strokes to suggest some larger feathers.

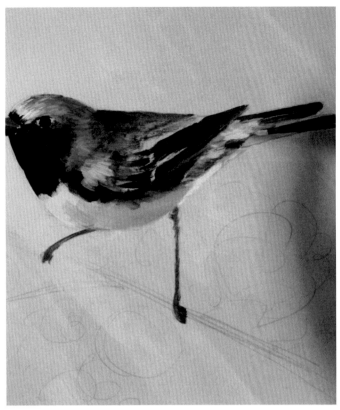

Step 25 Add lighter tones of the blue to the tail covert or covering feathers. Vary the lights and the tones and keep the strokes smaller.

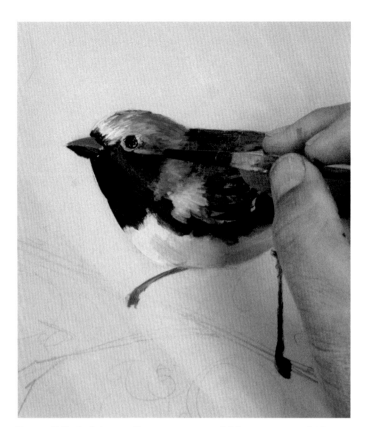

Step 26 Add medium tones of blue around the eye. Add a stroke of Burnt Sienna in the eye which will add some warmer tones to the eye and give more interest.

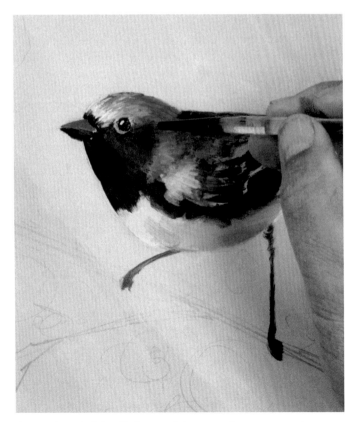

Step 27 Add a lighter shine to the eye and eye ring. Pull some light strokes down the head contouring the strokes into the darker bands.

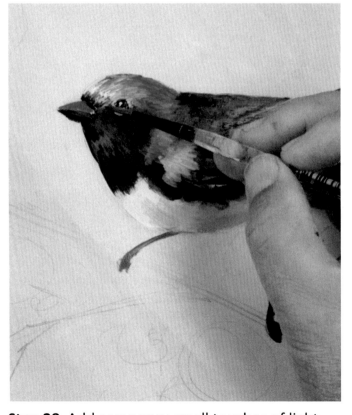

Step 28 Add some very small touches of light blue around the eye and between the eye and the beak. Theses are the smallest feathers on the bird.

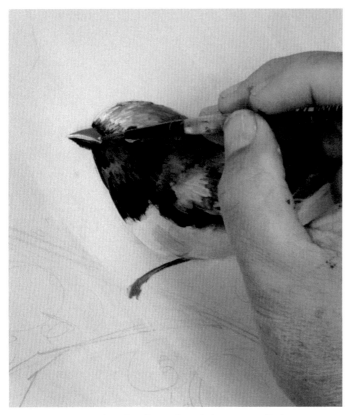

Step 29 Mottle the brush with some light grey and add some strokes where the upper and lower beak come together.

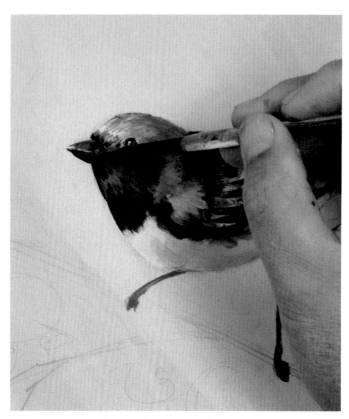

Step 30 Mottle the brush with Burnt Sienna and add this to the top of the beak. Paint out some of the grey color making a thinner line between the upper and lower beaks.

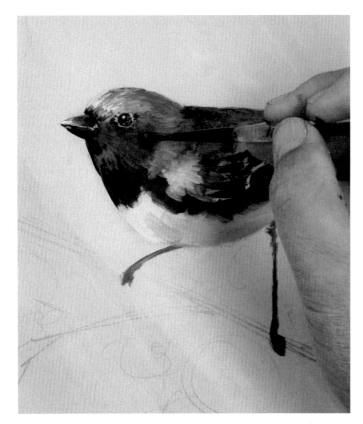

Step 31 Add some grey shines to the tip of the beak and then mottle the brush with the Burnt Sienna and restate the color on the cheek.

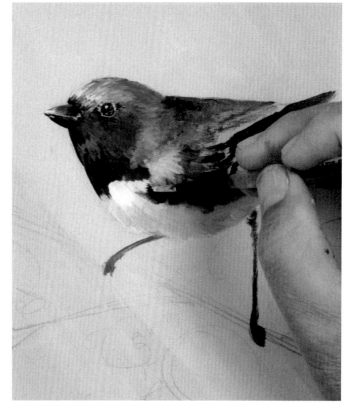

Step 32 Mottle the brush with some white and add some lighter strokes to the breast area, carrying the color up and into the neck area a little. Incorporate the neck and breast.

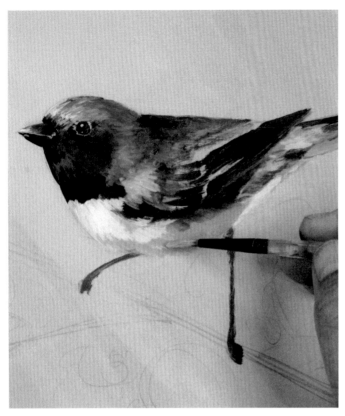

Step 33 Mottle the brush with greys and then add shadows to the white breast area below the wing.

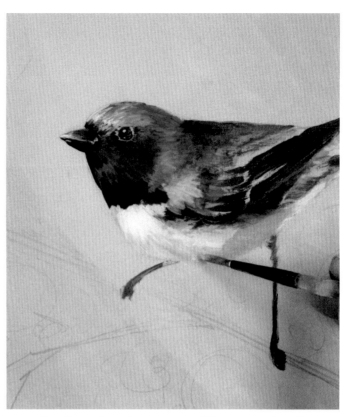

Step 34 Mottle with more white to make the grey a little lighter and then add some feather strokes to the shadow breast area with just applied.

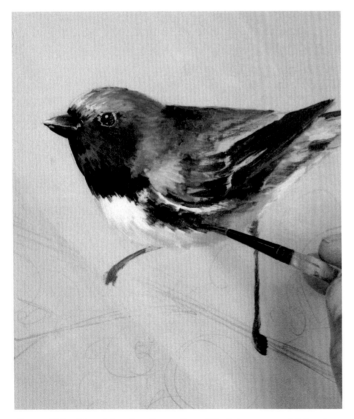

Step 35 Mottle the brush with blues and black and add some smaller strokes under the wing and down into the breast. Notice I left a white band under the wing.

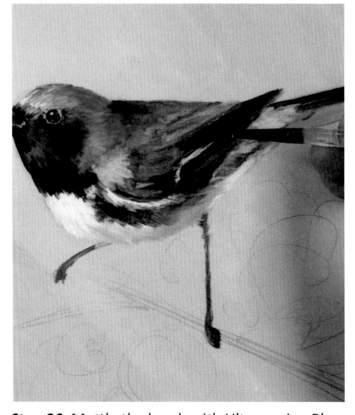

Step 36 Mottle the brush with Ultramarine Blue and touch Phthalo Blue and add this to the top of the wing to vary the blue colored coverts.

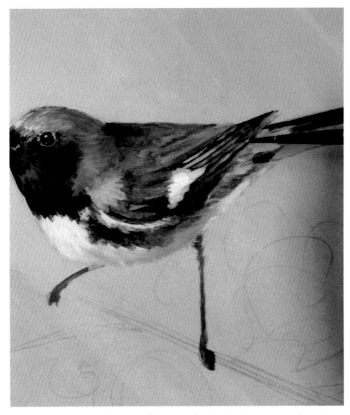

Step 37 Mottle the blue a little lighter and using the tip of the round add the light wing feathers to the wing. These are the longer flight feathers.

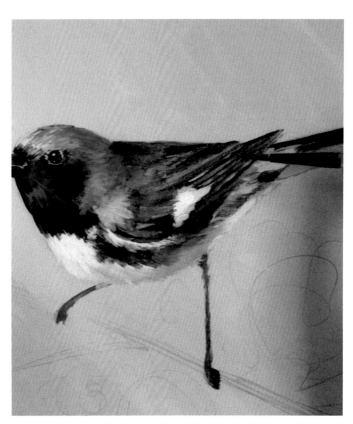

Step 38 Mottle the color a little darker and then paint out some of the white to make the color thinner and more delicate for the wing.

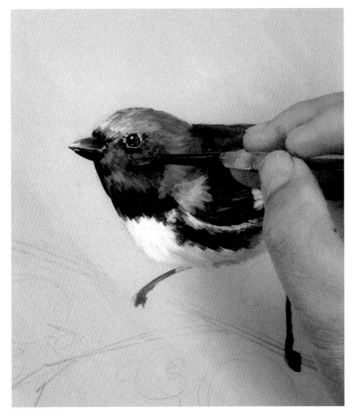

Step 39 Mottle the brush with medium blues and go over some of the Burnt Sienna area of the cheek with some blue to set the warm brown into the cheek.

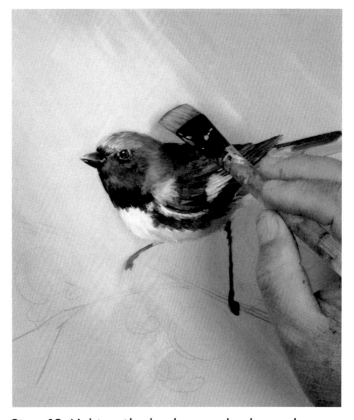

Step 40 Lighten the background color and cleanup around the head of the warbler. This will bring him forward by creating more found clean edges.

91

Step 41 Mottle the brush with Burnt Sienna. This is the smaller # 4 Fusion Flat.

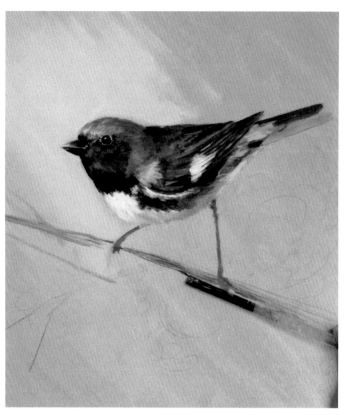

Step 42 Holding the brush very flat, drag over the surface to make the stems. Notice the skipping across the surface because the brush is held very flat.

Step 43 Mottle the 3/4 inch brush with Pine Green, Burnt Sienna and white to lighten.

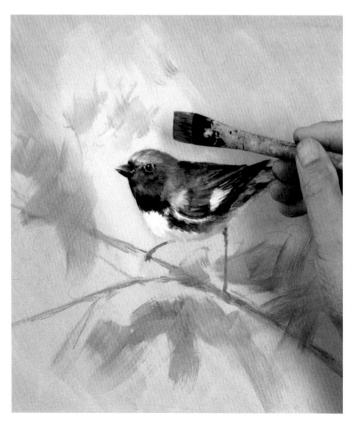

Step 44 Casually drag this over and around the bird and let the color soften as it goes away from the bird. Soften into the background.

Step 45 I use my fingers to soften the greens into the background.

Step 46 Mottle the blues with Red Violet and then lighten with some white to make various blue and red violets colors.

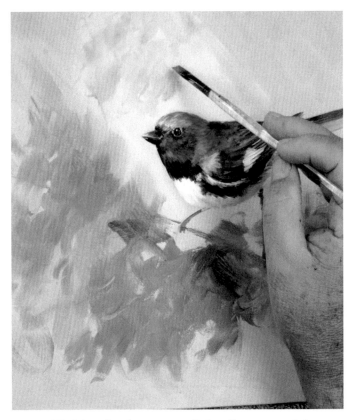

Step 47 Mottle the area of the flowers with some red violets and blue violets we just made. Notice how soft they are against the background keep the colors light and soft.

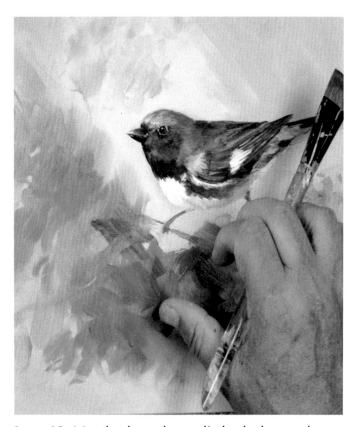

Step 48 Mottle the colors a little darker and make smaller strokes in the center areas of the colors with just applied. Soften the darker colors into the first colors with your finger.

93

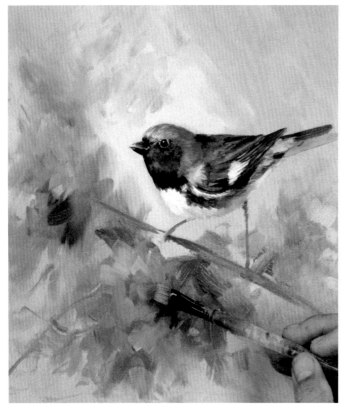

Step 49 Vary the tones. Here I made a light blue from Phthalo Blue and white and added some strokes of this color that add more interest to the blue and red violets.

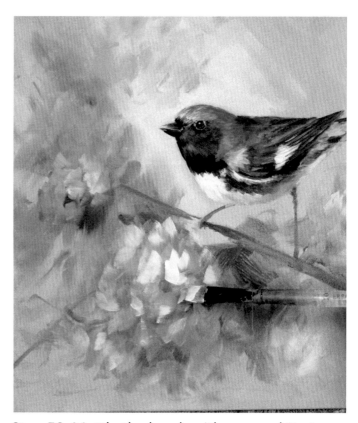

Step 50 Mottle the brush with more white to make lighter tones and add some strokes to the flowers. Keep the thicker white strokes in the centers of each flower group.

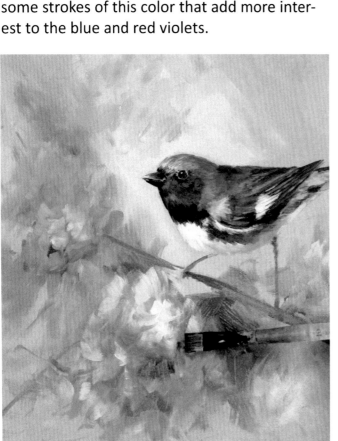

Step 51 Mottle the brush with red violets and add some shadow strokes. I see these as form shadows which gives roundness to the flowers, not individual shadow strokes.

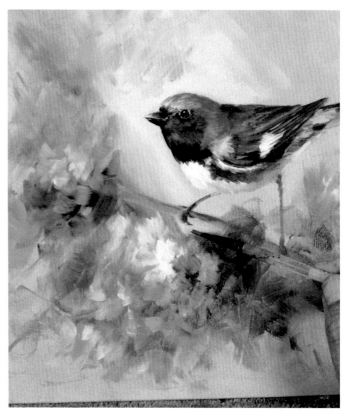

Step 52 Add final darks. Add suggestions of feet and leaves. Add a little soft white to finish. Enjoy!

94

Enlarge Pattern
127% to Original Size

©2016 DKJANSEN

Wilson's Warbler- A Study in Yellow

With this lesson we will move from the orange spectrum to the yellow spectrum. It can be difficult to accurately depict warm and cool yellow tones. For example, if you cool yellow with blue, you mix green. If you warm yellow with red, you mix orange. Yellow can change very quickly so we must carefully study this tonal range of colors. These beautiful little birds are the perfect subjects to help us learn a whole new range of tones.

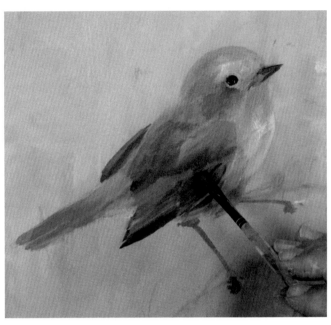

Hansa Yellow, the brightest yellow on our palette, is very sensitive to color shifts. A slight addition of another color is enough change its tone. To strengthen the its character, we will add the powerful mixing pigment Yellow Oxide.

In the Paint It Simply lessons I show you how to mix a toned yellow similar to Yellow Oxide from Hansa Yellow. We can make the color, but it is difficult to emulate the mixing properties. Yellow Oxide doesn't color shift as quickly as Hansa Yellow. When we combine the two in some areas, the tones are easier to create and a wider variety of warms and cools can be mixed.

As you go through this lesson, look for the temperature differences between the mixes. Train your eye to see slight variations that come from using "just a little". Watch how the different blues respond to the yellows. Ultramarine can cool yellow and not make it as green as Phthalo. Why? Ultramarine leans red, which is the compliment of green. Mixing fun! Let's give it a try!

Paint It Simply Palette
Base Color- Lt. Grey, White + touch
Black and Yellow Oxide

Palette Colors

Paint It Simply Colors
Naphthol Red Light
Red Violet
Carbon Black
Phthalo Blue
Hansa Yellow
Titanium White

Additional Palette Colors
Pine Green
Burnt Sienna
Yellow Oxide

Wood Surface
11 X 14 Wood or canvas panel

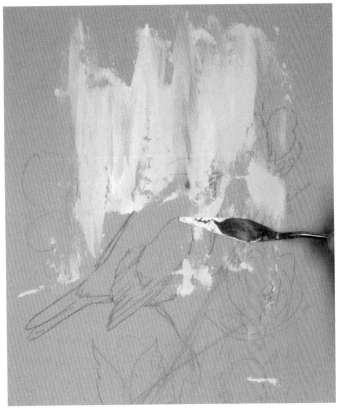

Step 1 Mottle Phthalo Blue with some white to lighten and then using the palette knife drag over the background which was based medium grey color + medium white.

Step 2 Mottle a medium grey color which is white + touch black + tiny touch Yellow Oxide to warm.

Step 3 Drag the medium grey color over the blue to soften them into the background and then use a paper towel to remove the excess off your design or sketch.

Step 4 I hold the knife very flat and push into the background to soften the movement. Push up and down this creates unique movement that is also softer.

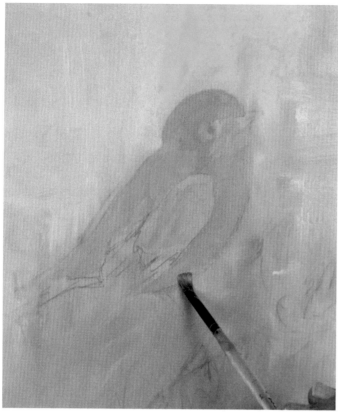

Step 5 Mottle some Yellow Oxide with touch Hansa and tiny touch Naphthol Red Light. Begin to base in the body with some shape following strokes.

Step 6 Mottle the yellow with more Hansa and a tiny touch of Carbon Black which will make the color a little green.

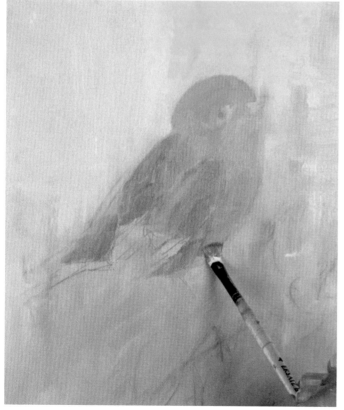

Step 7 Using the # 4 fusion flat brush some of this tone over the back and wings of the warbler. Use contour following strokes.

Step 8 Mottle the yellow with a touch of Burnt Sienna which will darken and also warm the yellow tone.

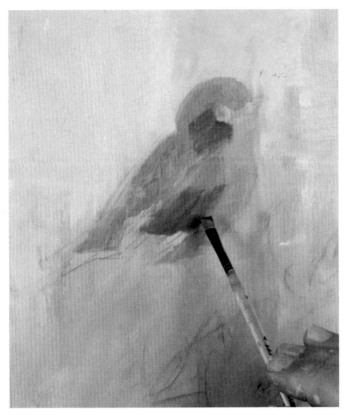

Step 9 Add some to the head behind the eye and to the wings. Notice how the warbler is beginning to have some tonal variation for interest. Leave open around the eye ring.

Step 10 Mottle the last yellow tone with some Burnt Umber, Burnt Sienna and tiny touch Pine Green. The Pine Green will grey down the tone. Lighten with a little white.

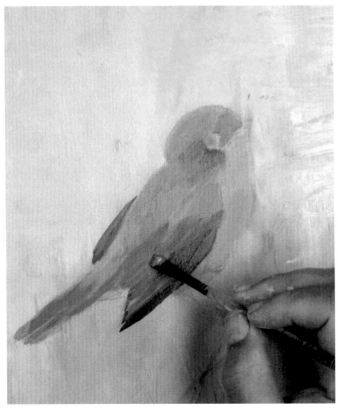

Step 11 Brush this tone over the wing tips and then lighten a touch more and add the lower strokes for the wings. Add the beak using the chisel with this tone.

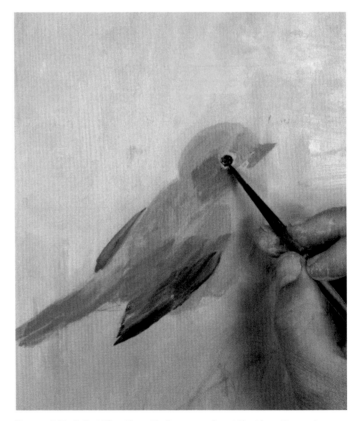

Step 12 Mottle the # 4 round with the Burnt Sienna and add a touch to the eye in the back. Darken the color with black for the front of the eye. Burnt Sienna + yellow legs.

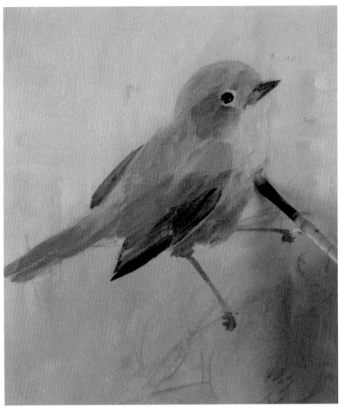

Step 13 Mottle the brush with more Hansa Yellow to brighten the tone and brush over the neck and top breast area to brighten the warbler. Add Burnt Sienna to the beak.

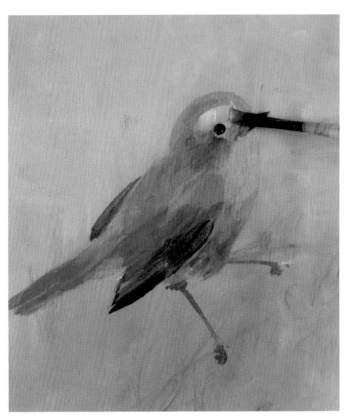

Step 14 Add some contour following strokes of brighter yellow above the eye of the warbler leaving a small space for the eye ring.

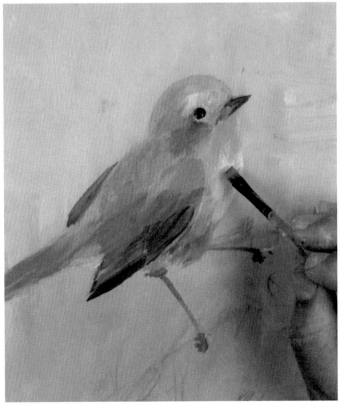

Step 15 Darken the tone with a mottle of Burnt Sienna and add darker tones under the beak of the warbler.

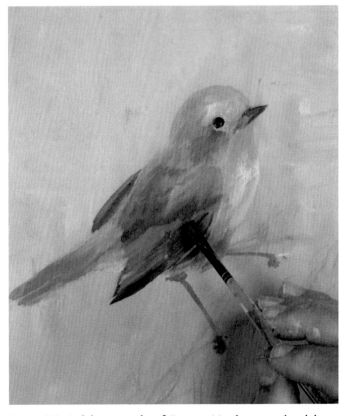

Step 16 Add a touch of Burnt Umber and add some of this tone to the wings suggesting the covers and flight feather movement.

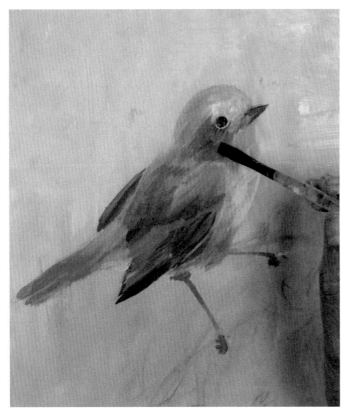

Step 17 Add some of the tone to the shadow portion of the head behind the eye as shown above.

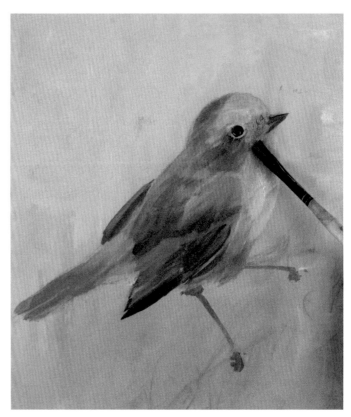

Step 18 Mottle the tone with some additional Burnt Sienna which will make it a touch redder and add to the area between the beak and eye.

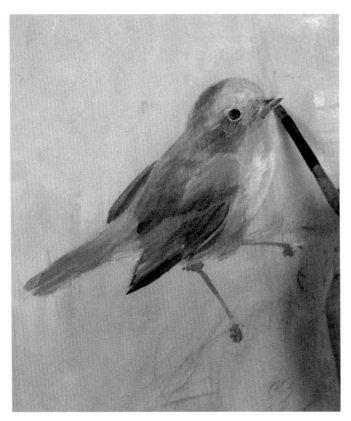

Step 19 Mottle some white with touch Carbon Black and Burnt Sienna to warm, this will be a greyish tone. Add this to the beak between the upper and lower portions.

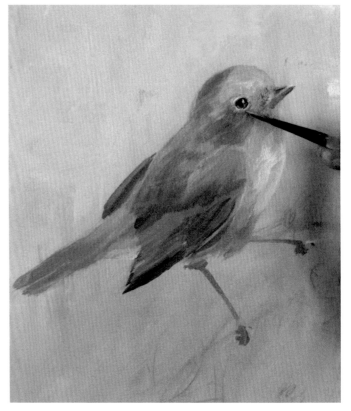

Step 20 Using the tip of the # 4 round add a grey shine to the eye and then some very light Hansa Yellow and touch white eye ring.

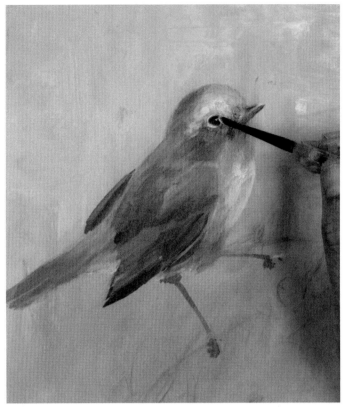

Step 21 Lighten the color with more white and add some shines to the eye ring and then add a tiny shine to the front of the eye.

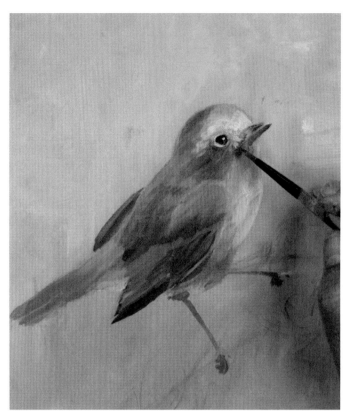

Step 22 Tap some of the light eye ring color into the area between the eye and the beak. Also make some smaller contour following strokes on the top of his head for interest.

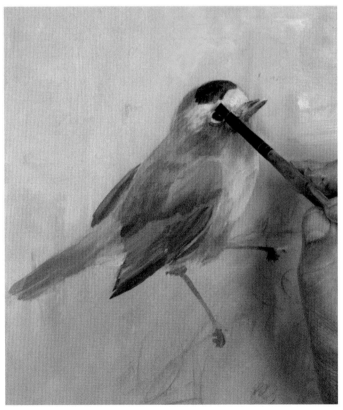

Step 23 Mottle the small flat with black then soften with Burnt Sienna and yellow. Add the color spot to the top of his head, with shape following strokes.

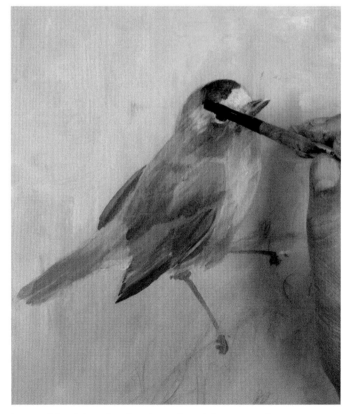

Step 24 Mottle the brush with more Burnt Sienna and yellow and add some lighter touches to the color spot and work into the yellow areas a little.

103

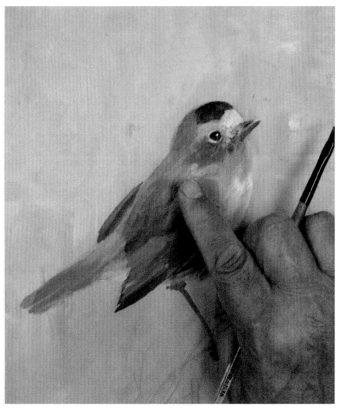

Step 25 Use your finger to soften some of the tones into the warbler. We do this so we can make some small feather strokes and they don't have to compete with all the tones.

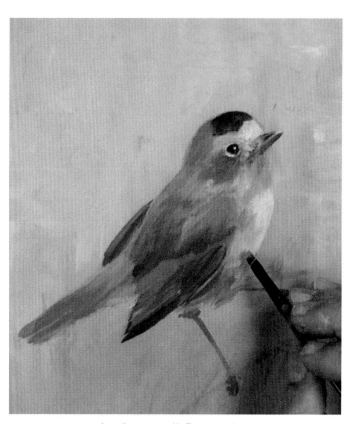

Step 26 Mottle the small flat with some Burnt Sienna and Yellow Oxide and add darker shadow and warm tones under the wing.

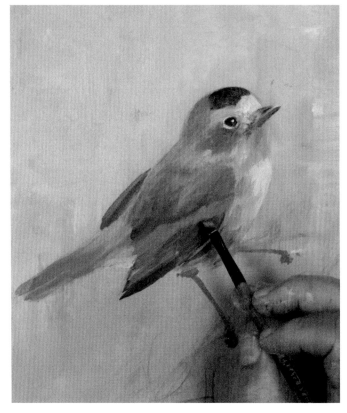

Step 27 Add some of the browns into the wing where we will paint the converts to vary the tone again.

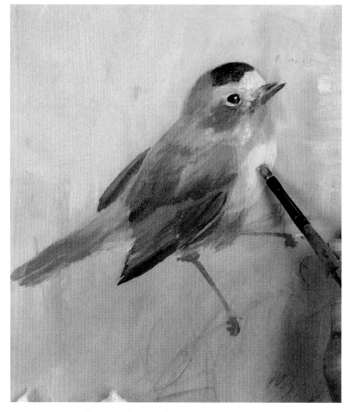

Step 28 Lighten the color with Hansa and white and add some additional tones to the top of the breast.

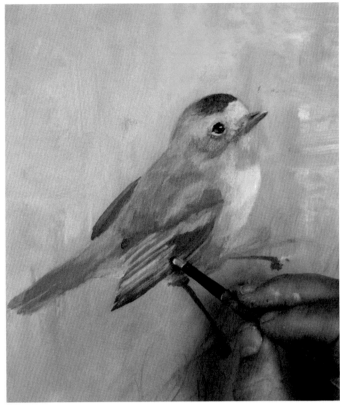

Step 29 Mottle white with touch Burnt Sienna and yellow to make a light tan color. Using the chisel of the small flat, add the light between the long flight feathers on the wing.

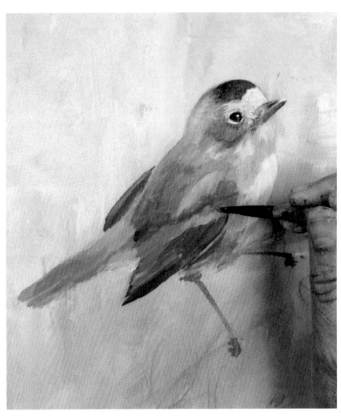

Step 30 Mottle the brush with some Burnt Umber and Burnt Sienna and paint out some of the light tan to incorporate the colors into the wing. Notice I also carry above flight feathers.

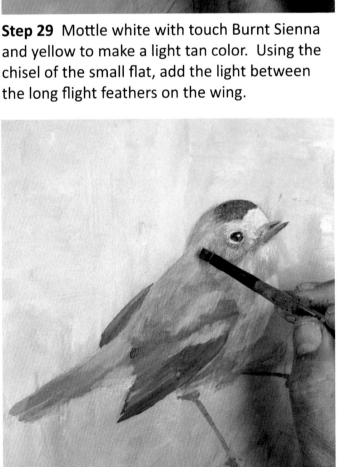

Step 31 Add light tan tones to the yellow areas on the warbler. This will vary the tones and soften the yellow look of him. Varying tones adds interest. We need to do this!

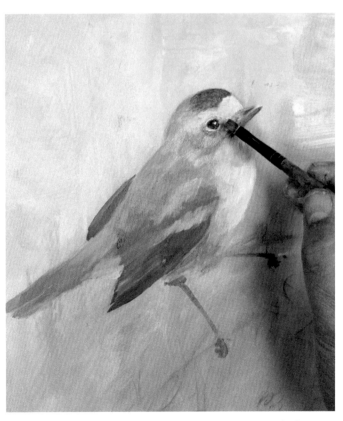

Step 32 Soften some of the tones around the eye with the small flat and the tan color. Go over the edges of the color spot to soften it into the head of the warbler.

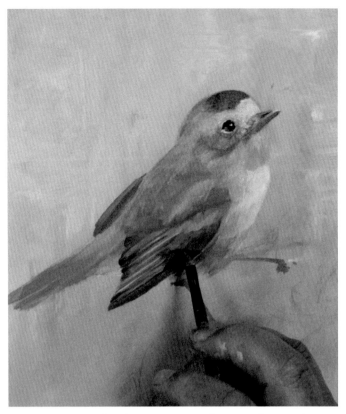

Step 33 Mottle the Burnt Umber with touch Pine Green and then lighten slightly with touch white. This is a nice brownish green tone we can now add for interest.

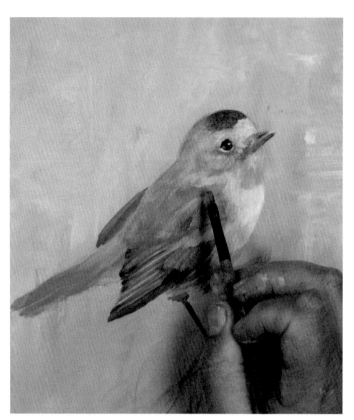

Step 34 Lighten the tone a little more with some white and add along his mantle and back area. Variation of tones.

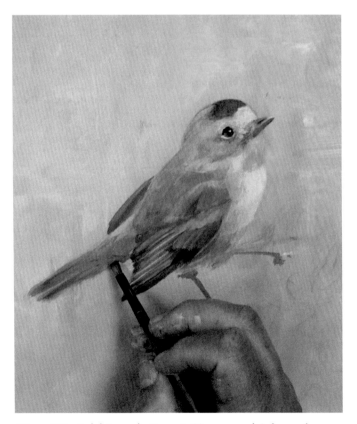

Step 35 Add touch Burnt Sienna which makes the tone a little orange and add to the tail. Soften with yellows.

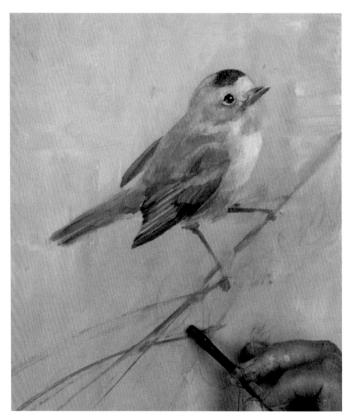

Step 36 Mottle the brush with Burnt Sienna, yellows and touch Pine Green and using the chisel, begin to make the stems under the warbler.

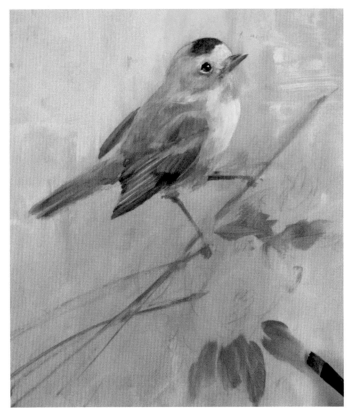

Step 37 Using a larger flat, mottle Pine Green with touch Burnt Umber and Burnt Sienna and begin to add some leaf shapes. Keep casual and transparent.

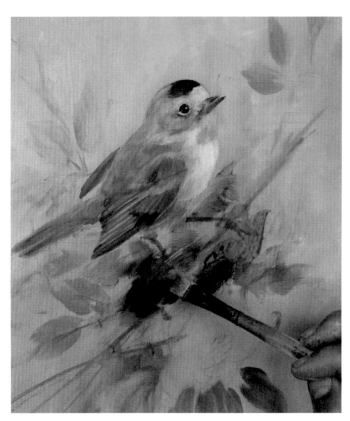

Step 38 Mottle the greens darker with more Pine Green and touch black and add as shadow leaves under the feet of the warbler.

Step 39 Mottle Burnt Sienna, touch Naphthol Red Light and Yellow Oxide. Lighten with white.

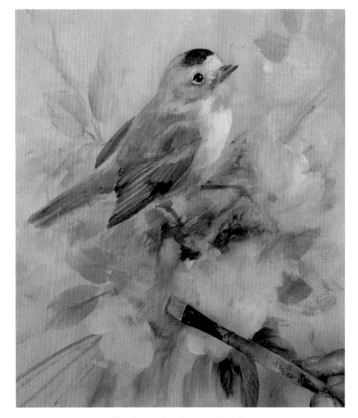

Step 40 Casually brush through the areas we will apply the flowers. Keep the edges soft and lost and vary the amount of Burnt Sienna and red to vary the color.

107

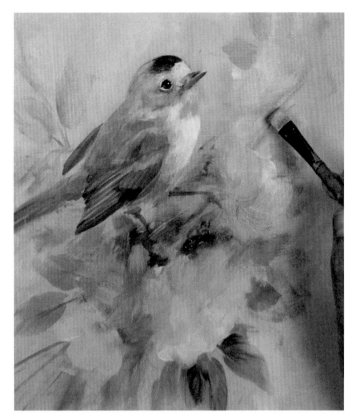

Step 41 Mottle the color with additional Naphthol Red Light and add reddish tones to the flowers to add interest. Just casual strokes.

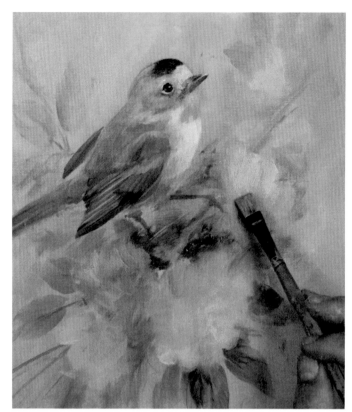

Step 42 Mottle the brush with Yellow Oxide and touch Hansa and add to the roses to vary the color. Add just a little to keep soft in the roses in the back.

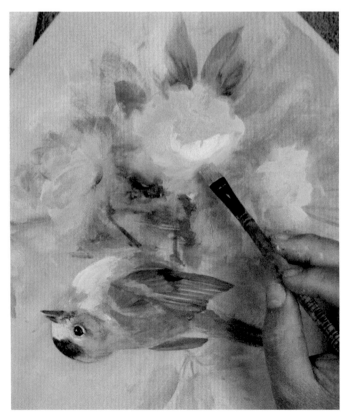

Step 43 Lighten the yellow tone with white and begin to build the light front of the roses.

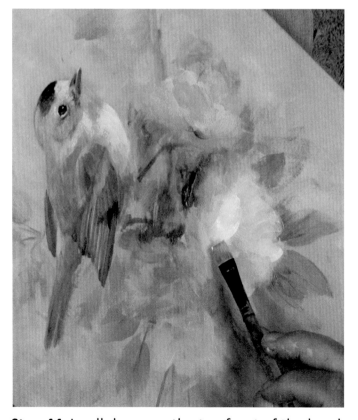

Step 44 I pull down on the top front of the bowl and then curve the stroke to make the round bottom of the bow. The roses are soft, we paint for movement of color, not specific petals.

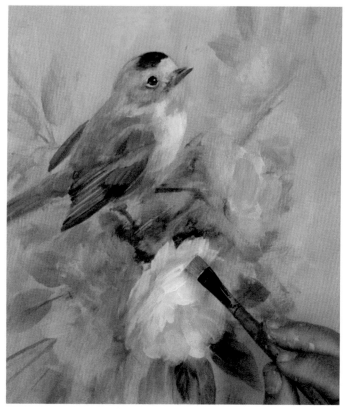

Step 45 Add some of the light to the other roses and then build the center rose again. This one controls how light we make the others. Pull some strokes in towards the bowl.

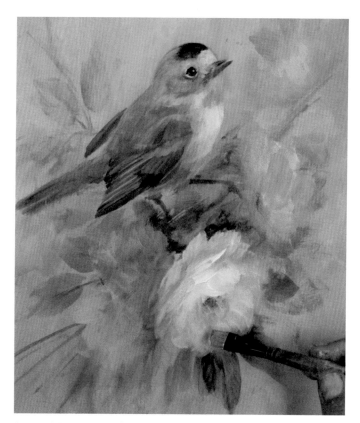

Step 46 Using the corner of the brush and some Red + Burnt Sienna, darken the center of the rose which will give it a little more contrast. Not too much or you will distract from the warbler.

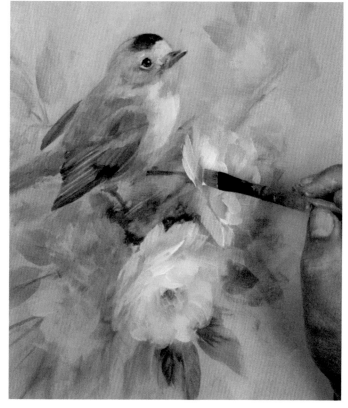

Step 47 Using the light color, add some petals to the other roses. We just need to suggest a few petals, do not paint too many. Pull in towards the center to make the petals.

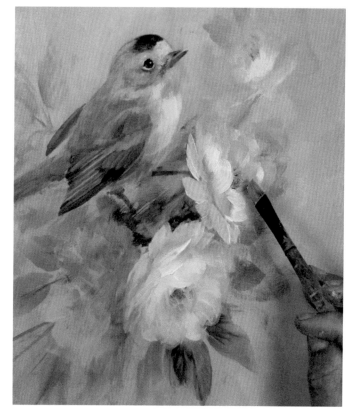

Step 48 Corner the brush with the red and orange like the first rose and add a little dark to the center.

109

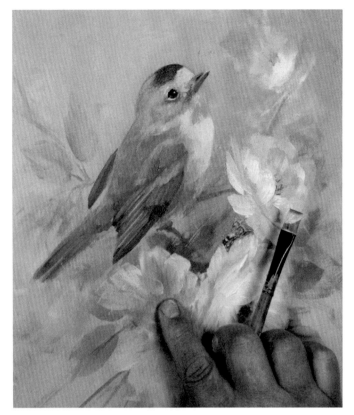

Step 49 Add some lights to the other roses and soften that light into the roses with your finger. Do not make detailed petals on these roses as it would be distracting. Keep soft.

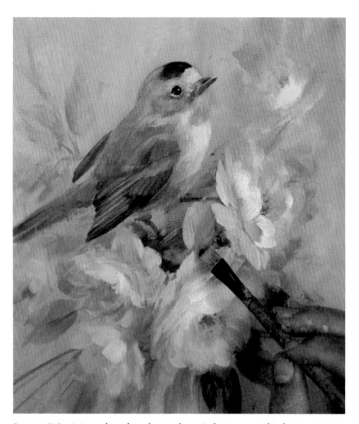

Step 50 Mottle the brush with some light yellow greens using yellows and Pine Green. Add some leaf shapes in the center of the design.

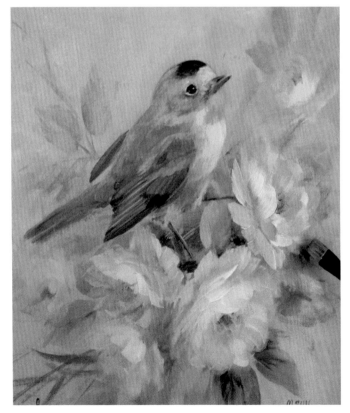

Step 51 Mottle with some Phthalo Blue and white. This is the background color. Add some light blue to the bottom sides of the roses to cool and harmonize with the background.

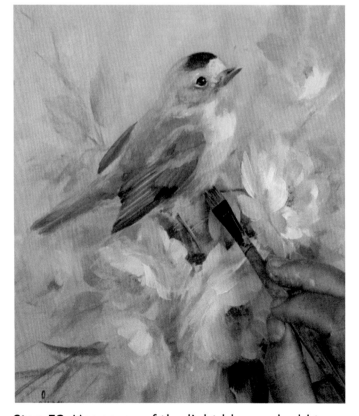

Step 52 Use some of the light blue and add to the breast, tail and wings of the warbler to add harmony with the background. Enjoy!

Enlarge Pattern
127% to Original Size

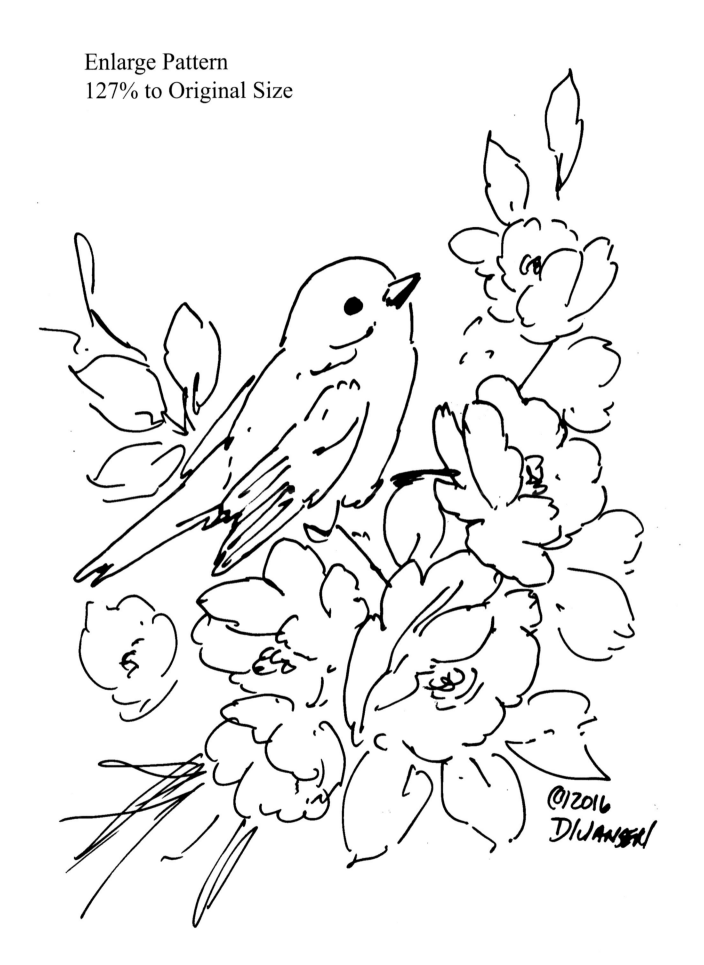

©2016
DWANSON

Little Vireo Casual Neutral Tones

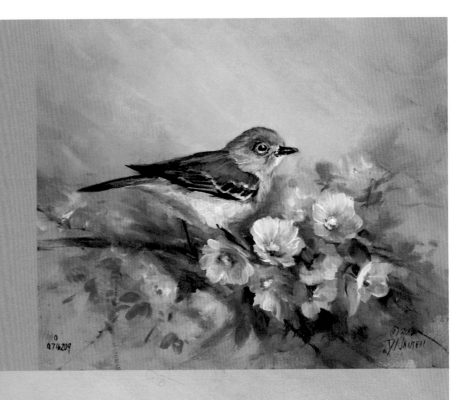

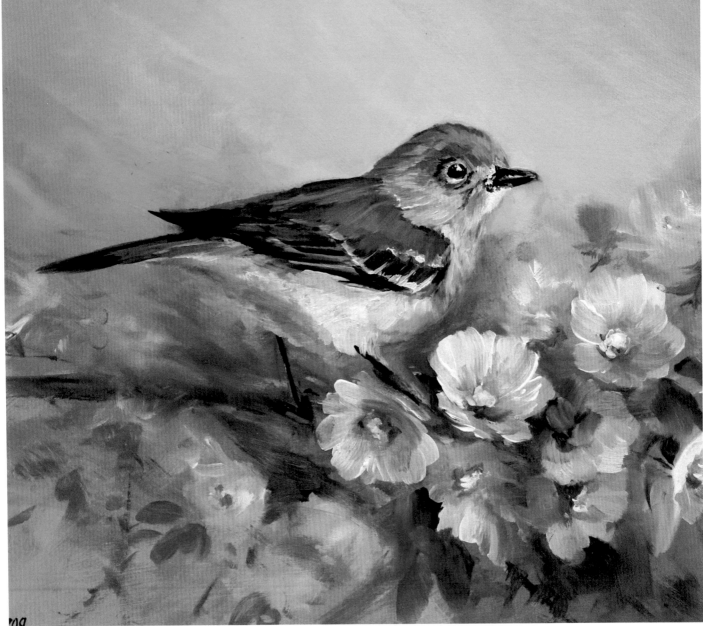

Little Vireo- Casual Neutral Tones

Many people tell me that my birds have more life this year than in earlier paintings. What are you doing differently? I add more variation to the tones and their temperature. There are so many techniques that you can use to mottle tones and capture images. It is impossible to show it all in one book! By creating this series of lessons I have tried to take you on a journey through techniques and tones to improve your skills. Now we will head into the next set of lessons that is a little more complicated because of neutral tones.

Previously, we looked at different color hues and practiced varying the tones and their temperatures. With this lesson we will paint a little vireo that has a wide variety of undertones. Look for the undertones in this step photo.

Neutral tones can be difficult to see because they don't lean close to a specific color hue. Many birds, especially the females, have a lot of neutral tones for camouflage.

Now we will key off a neutral and then vary that tone by making it warmer and cooler. We can change it to slight hues of yellow, blue and green. We will tie all the tones together with a neutral and then add subtle shifts in color. Hopefully the previous lessons prepared your eye to see changes and this Vireo will get you ready for the next lesson. Let's give it a try!

Paint It Simply Palette
Base Color- Medium White, White + touch Black and Yellow Oxide

Palette Colors

Paint It Simply Colors
Naphthol Red Light
Red Violet
Carbon Black
Phthalo Blue
Hansa Yellow
Titanium White

Additional Palette Colors
Pine Green
Burnt Sienna
Yellow Oxide

Wood Surface
11 X 14 Wood or canvas panel

Step 1 Mottle the brush with some Phthalo Blue and some white and add to the background around the Vireo. Vary the color. Board is based medium white.

Step 2 Use a paper towel to remove the excess color from the Vireo so you can see your sketch.

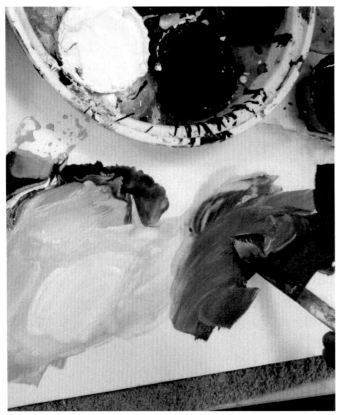

Step 3 Mottle the Pine Green with some Burnt Sienna and touch Yellow Oxide to make some very toned greens.

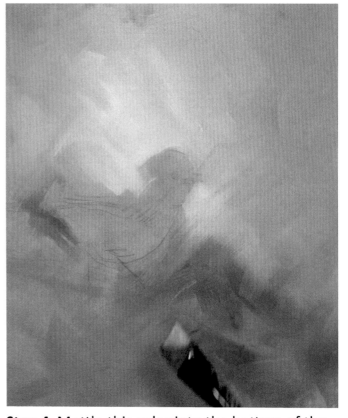

Step 4 Mottle this color into the bottom of the design below the Vireo. This will be the base for the leaves and green areas.

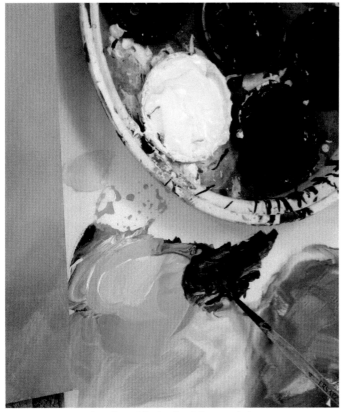

Step 5 Mottle the Phthalo Blue with some Burnt Sienna which will darken and tone.

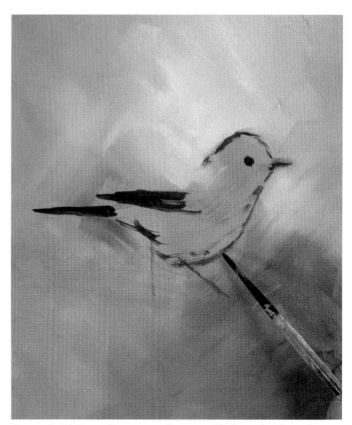

Step 6 Using the round, we will brush sketch to define some of the areas of the Vireo. I use this technique sometimes to give a different look to the birds.

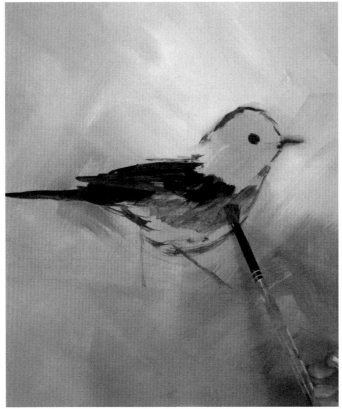

Step 7 Vary the color with additional blue to darken and add to the wings. Brush some thin browns over the body of the Vireo. Tap in the eye and beak with dark color.

Step 8 Mottle the color with some blue from the sky and lighten with touch white. This will make a medium toned blue grey.

115

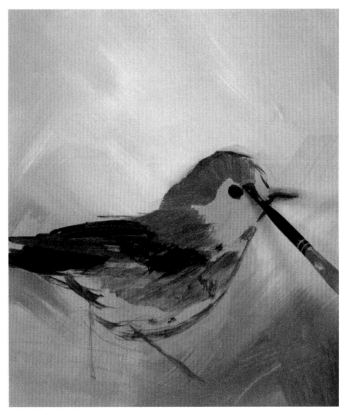

Step 9 Use small contour following strokes. Leave a small space around the eye for the eye ring.

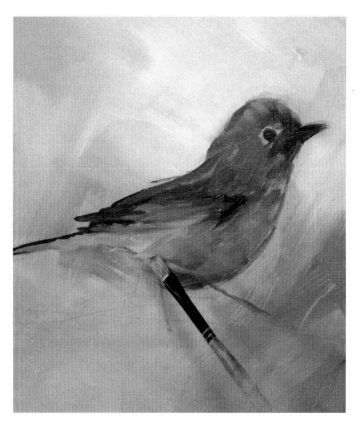

Step 10 Mottle the Burnt Sienna lighter with some white and add to the tail area to begin to build with color. Add some Yellow Oxide to the breast area.

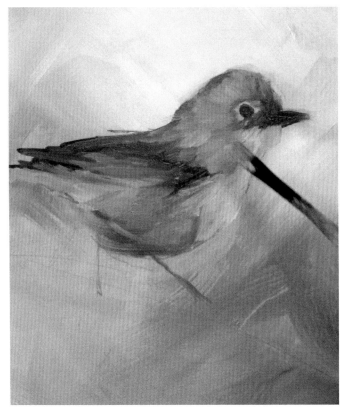

Step 11 Mottle the color a little lighter with some white and add to the neck of the Vireo to begin the tonal changes that add more interest.

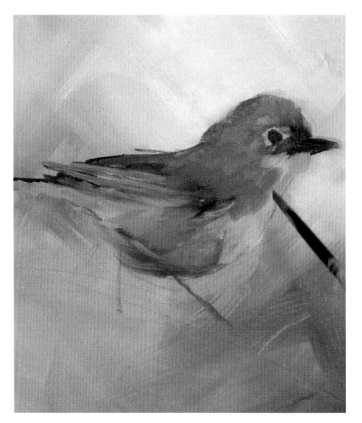

Step 12 Mottle the color a little darker with Yellow Oxide and Burnt Sienna and add some strokes to the neck area to vary the color.

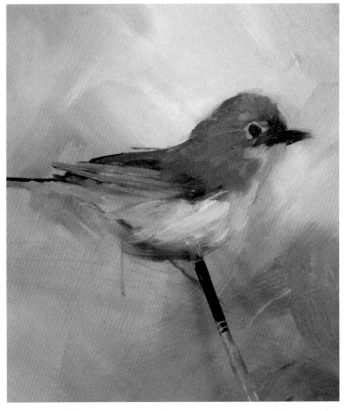

Step 13 Lighten the color with more white and add to the breast area to build it with more color. Use the point of the round and this color to lighten up around the eye ring.

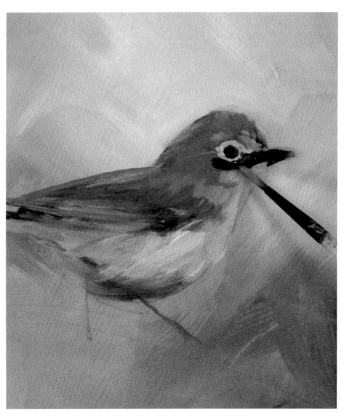

Step 14 Mottle the brush with Phthalo Blue and Burnt Sienna. Use this color to add the shadow between the beak and the eye.

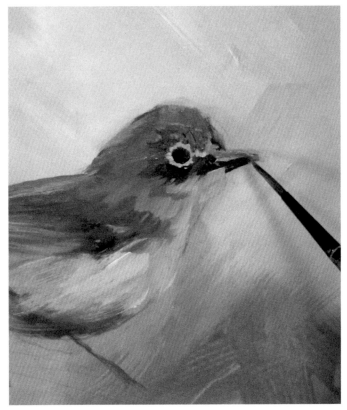

Step 15 Lighten the color with white to make a lighter grey and add a light stroke to the upper part of the beak and add some strokes between the beak and eye.

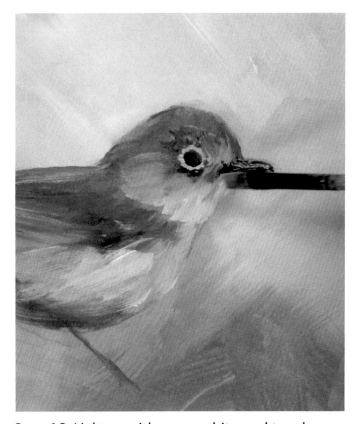

Step 16 Lighten with more white and touch Yellow Oxide and using small flat, add some strokes to the neck working the color up towards the beak.

117

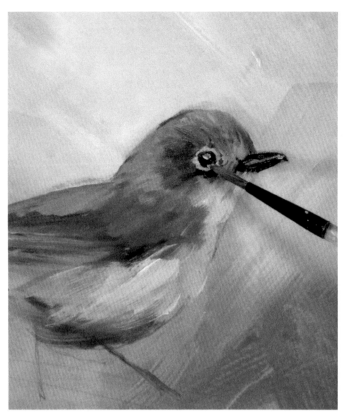

Step 17 I darkened the front of the eye again with some black, and then added small highlights to the eye ring and a touch to the eye.

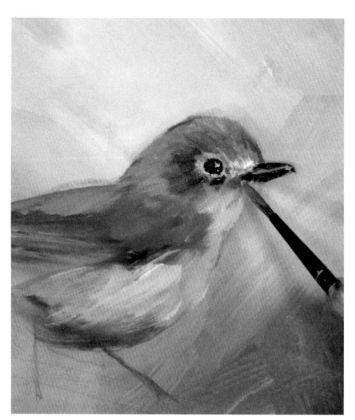

Step 18 Mottle the brush with some additional white and then add some smaller touches between the beak and the eye. Like earlier lessons these are the smallest feathers.

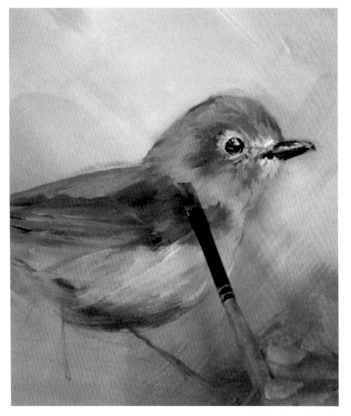

Step 19 Mottle the small flat with warmer tan and grey and pull some light feathers down over the top of the wing and mantle.

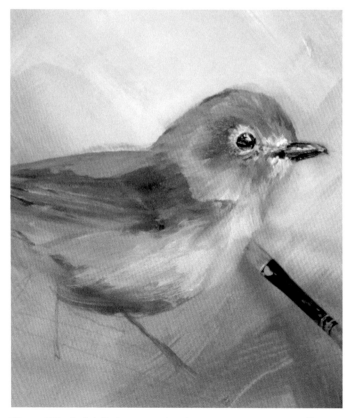

Step 20 Add lights to the breast area as well. Vary the colors, now you can see all the tones in the bird which gives him lots of interest.

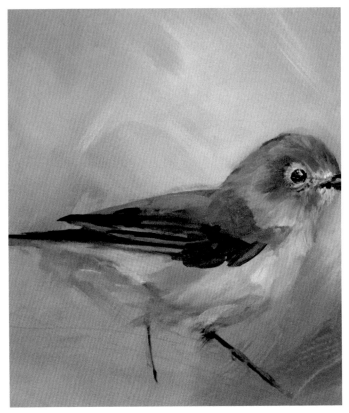

Step 21 Now it is time to work the wing again. Like I said in the earlier lessons, it is this back and forth of the tones that make all the difference in the birds.

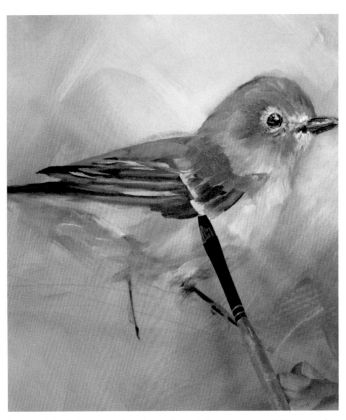

Step 22 Mottle the brush with some white and add additional strokes of white to the feather tips and flight feathers. Then mottle with darks and negative paint to the tips.

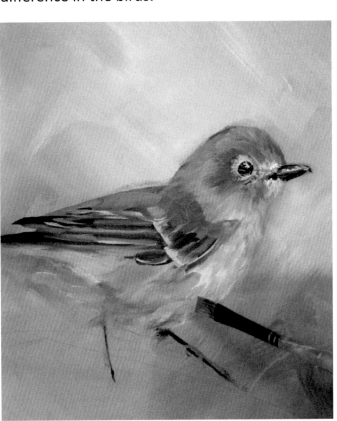

Step 23 Mottle the brush with some Yellow Oxide and touch Burnt Sienna and blue to tone and restate the shadows under the wing.

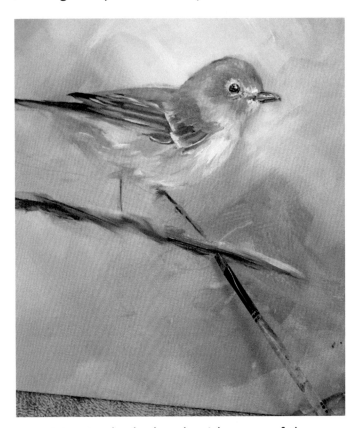

Step 24 Mottle the brush with some of the greys from the bird and drag to make the stems and twigs between the flowers. Add darker and lighter tones for interest.

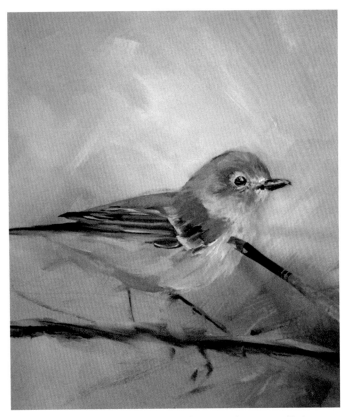

Step 25 Mottle the small flat with more light yellow and add smaller feathers using shape following strokes down the front of the breast.

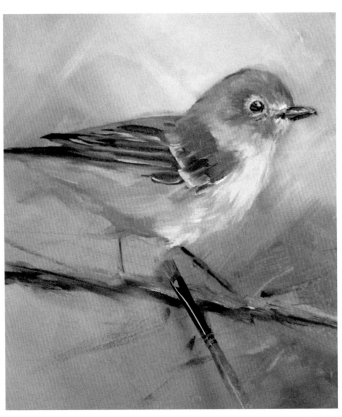

Step 26 Drag some of the white color over the top of the leg to incorporate the legs into the body.

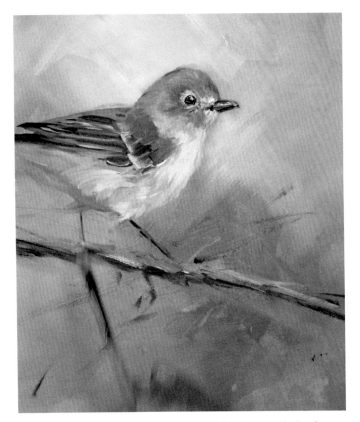

Step 27 Add some additional lights and darks to the branch, but keep it softer than the colors we used on the bird.

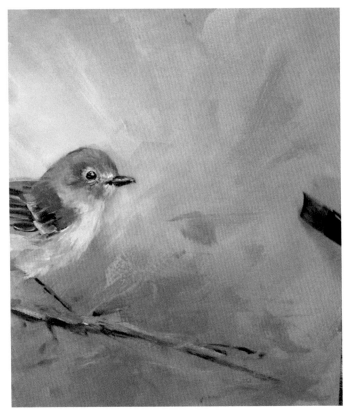

Step 28 Mottle the brush with soft yellow greens. Mottle with Pine Green, Yellow Oxide and then soften with the blues and greys of the background. Brush into the background.

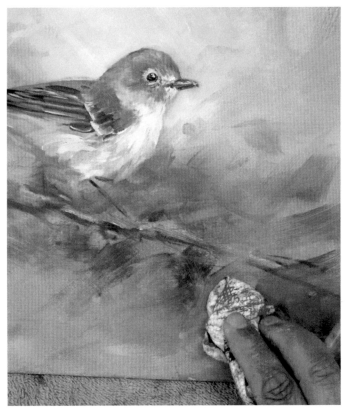

Step 29 Add additional darks to the bottom of the design and then soften them into the background with a paper towel. This adds some movement, but also keeps them soft.

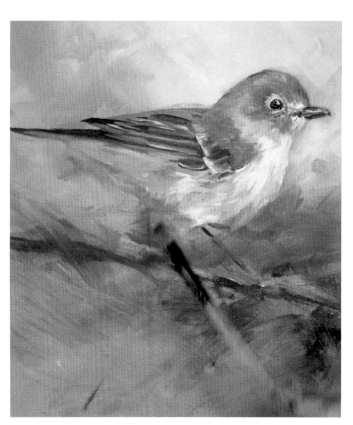

Step 30 Brush some green movement around the bottom of the bird for interest.

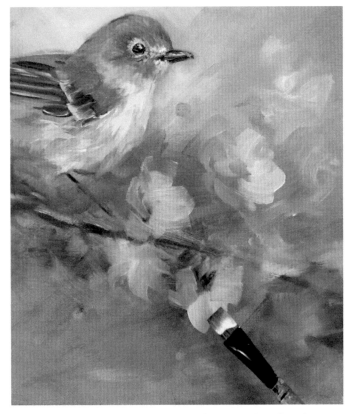

Step 31 Using a #10 fusion flat, add soft white in the areas that we will paint the flowers. Do not make petals at this time.

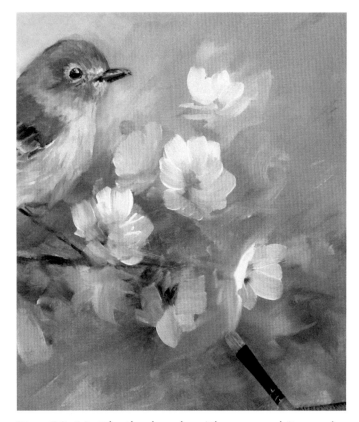

Step 32 Mottle the brush with more white and for the flowers that are closer to the Vireo, we need to now begin to shape some petals with casual strokes.

121

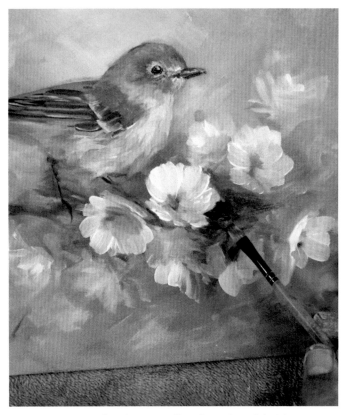

Step 33 Mottle the smaller brush with Pine Green and touch blue and black to darken. Add darker tones around the flowers to increase the contrast.

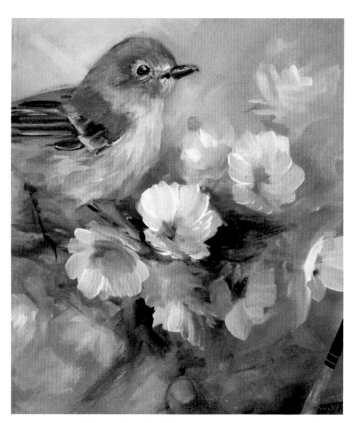

Step 34 Soften the darker greens and the colors go out into the background so the darkest tones are around the center flowers.

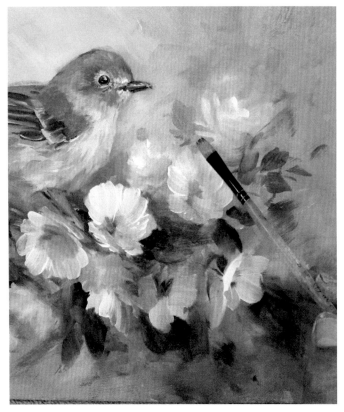

Step 35 Add soft suggestive petals to the flowers on the outside of the design. Use soft greens and begin to shape smaller leaves.

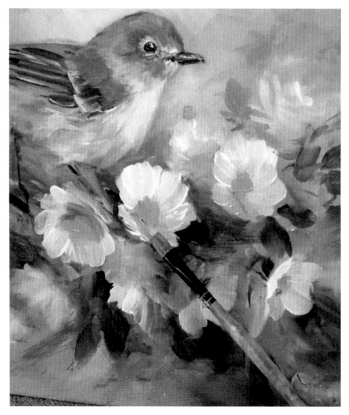

Step 36 Mottle the brush with Yellow Oxide and tap in the centers of flowers and soften the color as you go out into the background.

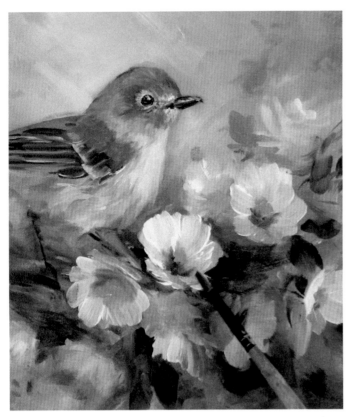

Step 37 Corner the brush in Burnt Sienna and then shadow the lower portion of the centers in the centers.

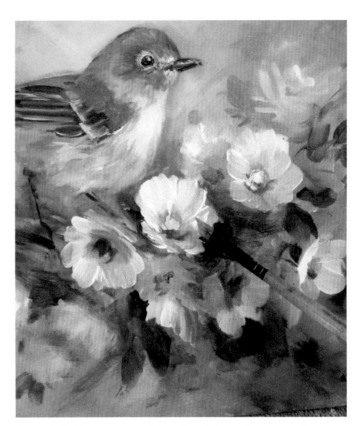

Step 38 Corner the brush with yellows and white and add the highlights to the centers of the flowers near the center of the design. Soften as you go out.

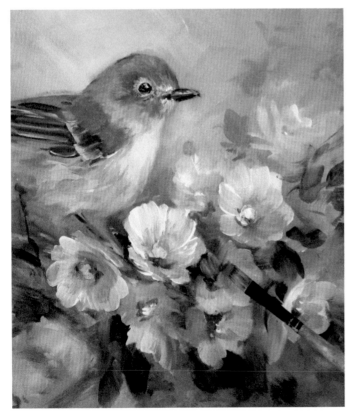

Step 39 Mottle the brush with darker greens and begin to shape a few leaves between the center flowers.

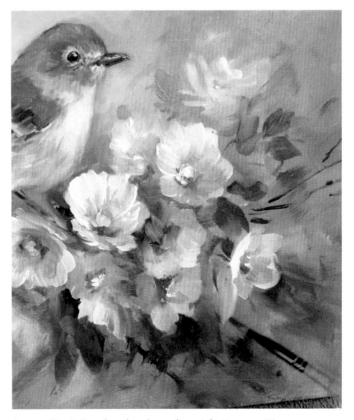

Step 40 Mottle the brush with Burnt Sienna, and tone with touch Pine Green and blue. Add some movement to the lower corner of the design.

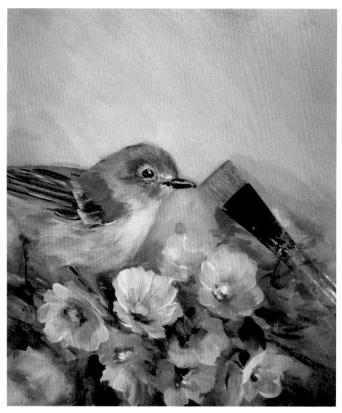

Step 41 Mottle the 3/4 inch brush with soft sky color and clean up around the head of the Vireo to bring him forward.

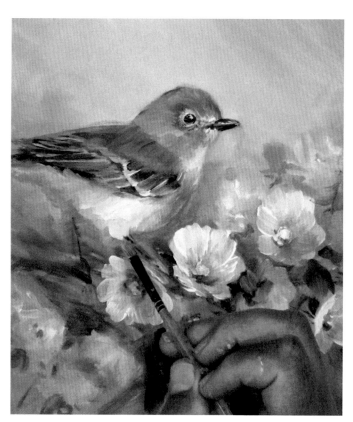

Step 42 Clean up some of the greens between the Vireo and the flowers, and then mottle with white and add the thigh of the Vireo over the leg.

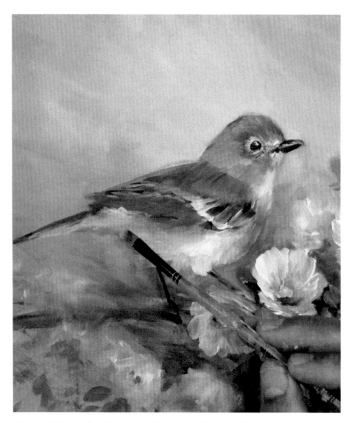

Step 43 Add light colors to the tail of the Vireo

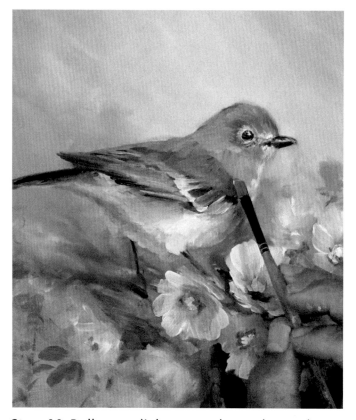

Step 44 Pull some light greys down the neck and over some of the other areas to add feather interest.

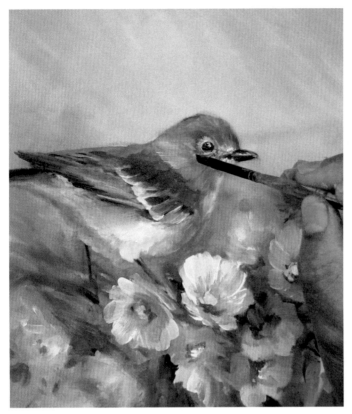

Step 45 Add light strokes to the back of the head pulling toward the eye.

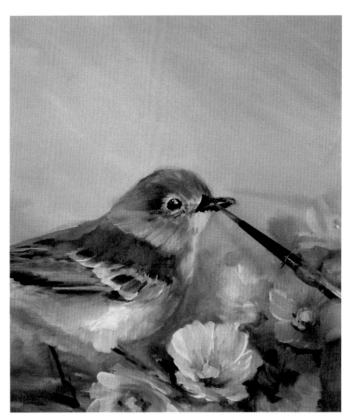

Step 46 Darken some of the beak with the tip of the round and some black to shape the beak. This increases the contrast.

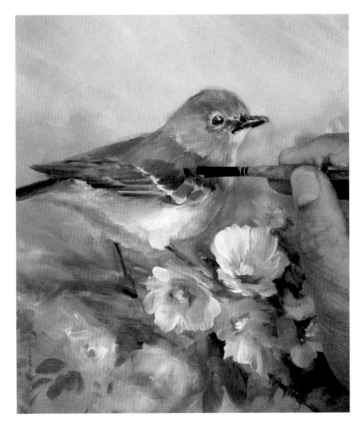

Step 47 Add medium greys to the mantle and top of the wing. Let the greys slightly streak to suggest feathers. Use short strokes pulling over the darks of the coverts.

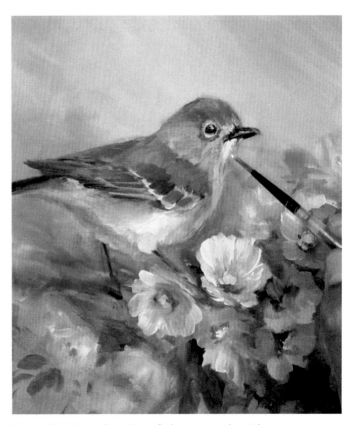

Step 48 Use the tip of the round with some white to make smaller strokes under the beak which adds more interest.

Step 49 Add strokes of the light color to the neck feathers with the tip of the round. Stroke some of the feathers over the medium areas to suggest those feathers.

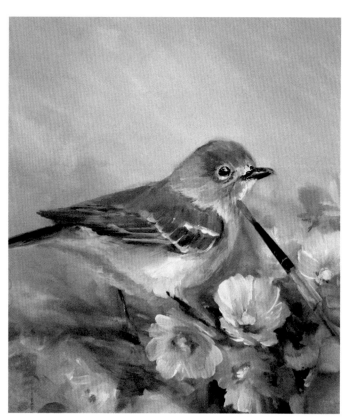

Step 50 Mottle medium greys and pull down to incorporate the light colors into the neck.

Step 51 I use the corner of the flat and greys to add additional interest around the eye.

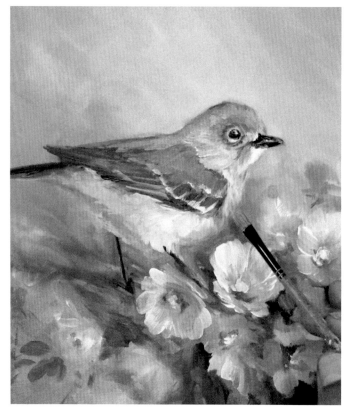

Step 52 Finally add some of the light greys to the breast area as final highlights Add a few of the greys to the blossoms for harmony to finish. Enjoy!

Enlarge Pattern
127% to Original Size

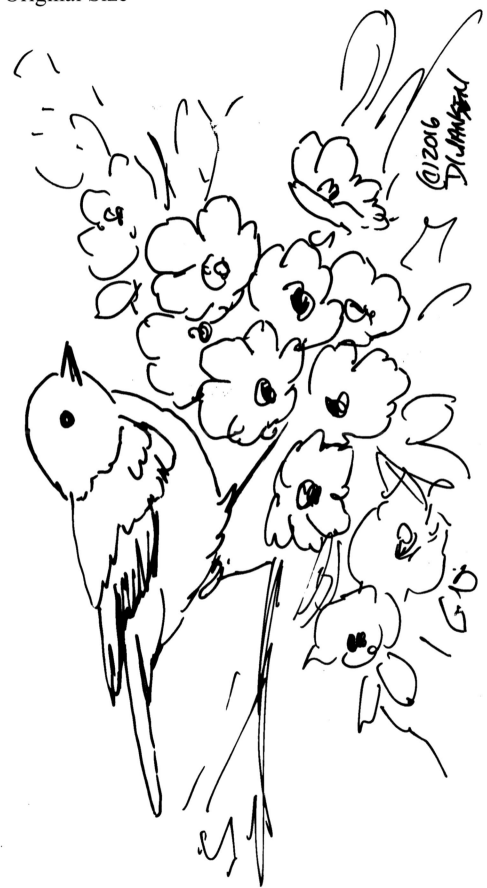

Bushtit- Complicated Neutrals

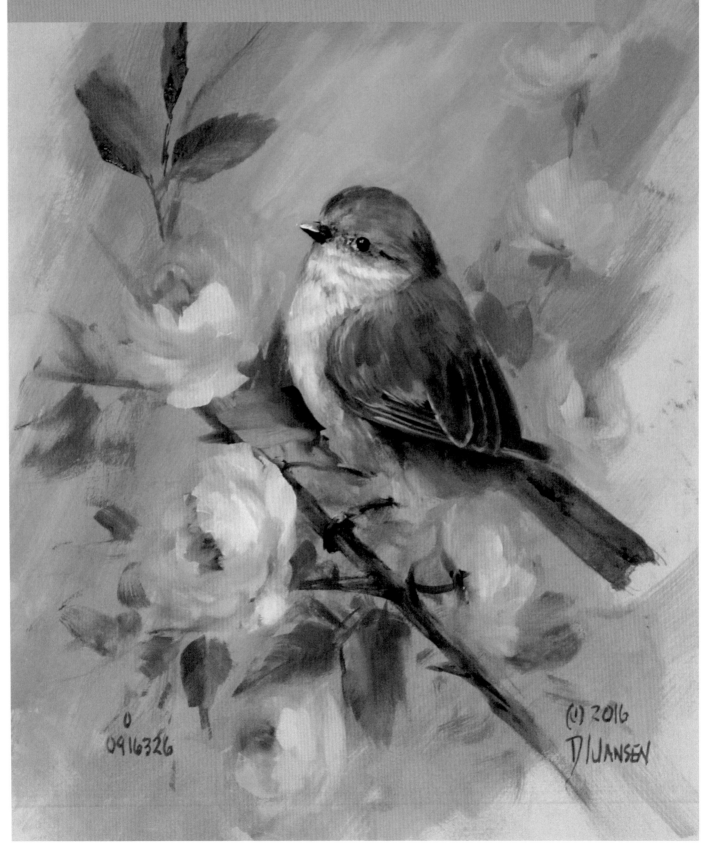

0
0916326

(c) 2016
D JANSEN

The Bushtit- Complicated Neutrals

I chose this lesson for the front cover of the book because understanding neutral tones is essential to painting realistic birds. Many species, including the bushtit, have a variety of neutral tones to help them blend in with nature. However, painting variation in neutral colors can be difficult. Years ago I did color work for the decoy carving industry. I spent most of my time teaching these incredible artists about the neutrals you find in game birds.

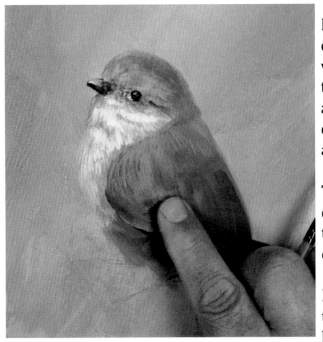

Brown is brown right? No, there are many kinds of browns. Every color on the standard 12 color wheel has a neutral variation. Essentially, before taking temperature into consideration, there are already 12 versions of brown. With warm and cool color shifts and subtle value changes, there are thousands of possible tones.

To mix and mottle those tones you need to develop a plan. I always thoughtfully approach the painting with a method for the technique and color choices.

Look at this little bird. There are warm yellow tones on the head which shift to the cool brown-blue tones of the wings and tail. Look closely to see the neutrals move to the red side and then the violet side in the mantle area. Practice planning the layers of tones to capture the essence of this beautiful bird. Let's give it a try!

Paint It Simply Palette
Base Color- Lt. Grey, White + touch
Black and Yellow Oxide

Palette Colors

Paint It Simply Colors
Naphthol Red Light
Red Violet
Carbon Black
Phthalo Blue
Hansa Yellow
Titanium White

Additional Palette Colors
Pine Green
Burnt Sienna
Yellow Oxide

Wood Surface
11 X 14 Wood or canvas panel

Step 1 Mottle the brush with Ultramarine Blue, white and touch Red Violet. Like in previous lessons, go over the background and wipe out with paper towel to see the sketch.

Step 2 Mottle the brush with Pine Green and soften with some reds to tone. Mix with the sky color to lighten and soften. Add some greens to the lower portion of the design.

Step 3 Mottle Burnt Sienna , Blue, and Burnt Umber to make a brownish grey then lighten with white and begin to base in the body and tail of the bushtit.

Step 4 Warm the brownish grey with Yellow Oxide and then some white to warm and lighten.

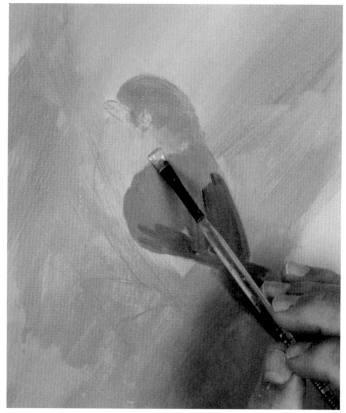

Step 5 Add a warmer tan to the top of the bushtit's head and then lighten the color again with more white and add the neck feathers.

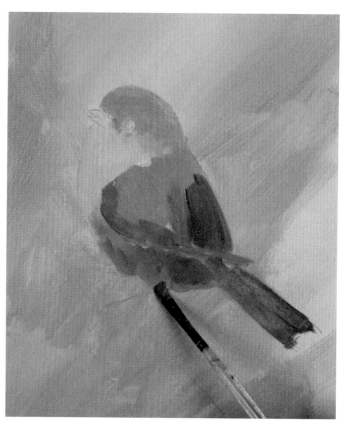

Step 6 Mottle the color darker with some Burnt Umber and a tiny touch of blue and then shadow the lower part of the body and tail.

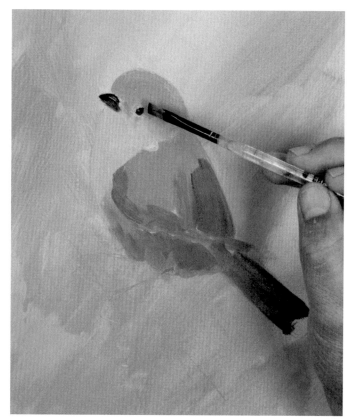

Step 7 Use the corner of the flat with Burnt Sienna and add the eye. Mottle the brush corner with black and add a touch of black to the front of the eye. Add these to the beak.

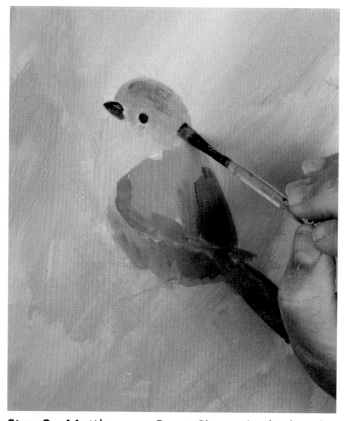

Step 8 Mottle some Burnt Sienna in the brush and soften with some tan color and brush over the top of his head to start the tone variation.

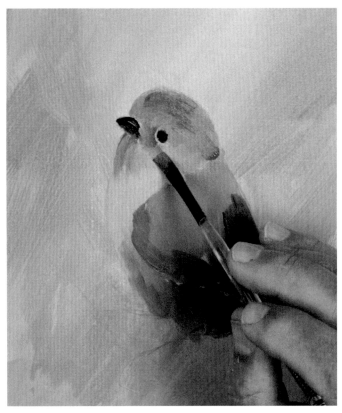

Step 9 Mottle some Yellow Oxide with the color to make more yellow and add this to the area around the beak. This will vary the tone.

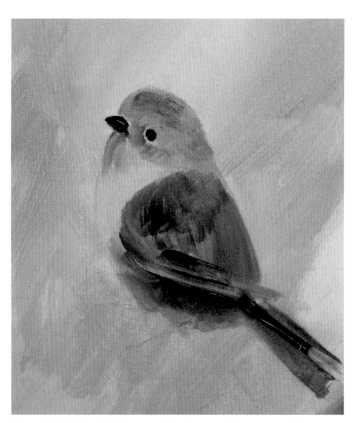

Step 10 Mottle Burnt Umber with some blue and then lighten slightly with touch white to make a grey and then add some darker tones to the wing and tail.

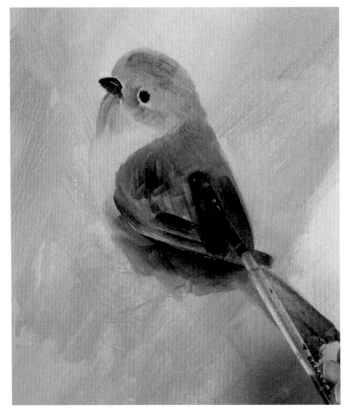

Step 11 Warm that tone with Burnt Sienna and touch Yellow Oxide and brush over the mantle of the back and into the wings a little.

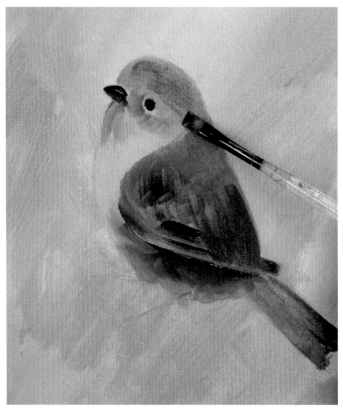

Step 12 Brush some of the brown tones on the head. The goal here is to vary the tones. Lightly drag over the area to add another tone, but not too much to eliminate the earlier tones.

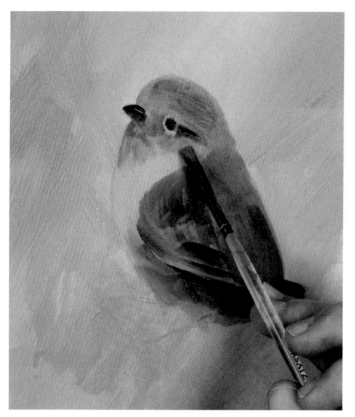

Step 13 Mottle the brush with Burnt Umber and Burnt Sienna and add the shadow behind the eye. Then soften with some tan tones.

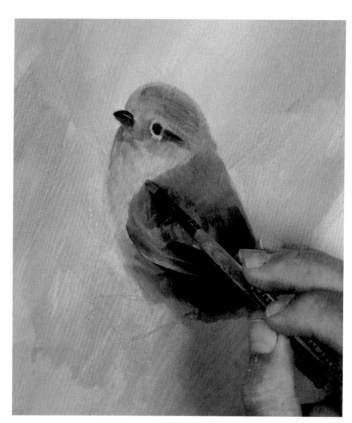

Step 14 Lighten the tone with additional yellow and white and lightly drag over the top of the wing and neck to vary the tones. Head down to the breast with touch more yellow.

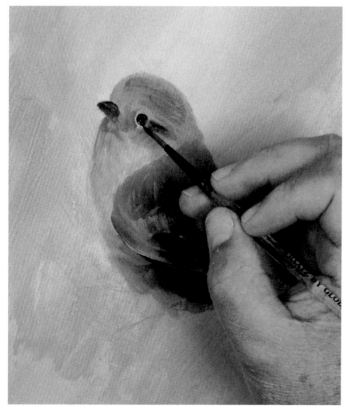

Step 15 Mottle the tip of the # 4 round brush with a light grey, and begin the eye ring. We will lighten later.

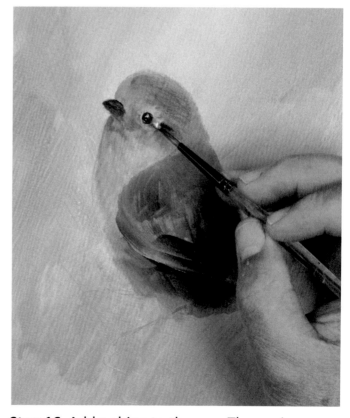

Step 16 Add a shine to the eye. Then using a light grey/ tan color go around the eye and lighten around the eye pulling out to contrast the eye.

133

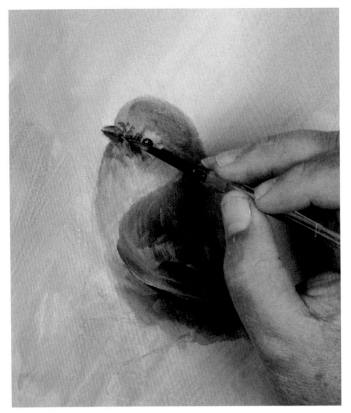

Step 17 Mottle the brush with Burnt Sienna and Burnt Umber and tap some darks between the eye and the beak. Use small strokes for the small feathers.

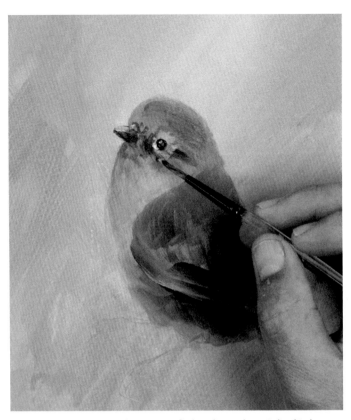

Step 18 Mottle the tip of the brush with light tan color and push into the shadows a little to soften and reduce the shadows.

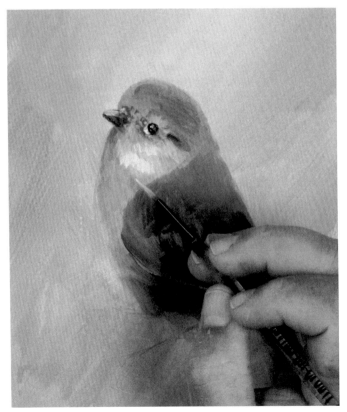

Step 19 Lighten the color with more Yellow Oxide and touch white and begin smaller sets of strokes to build the feathers. Vary the length of the strokes to suggest feathers.

134

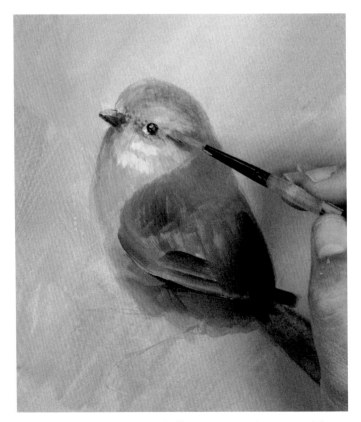

Step 20 Use contour following strokes to add feather strokes to the top of the head. Work this down towards the eye ring.

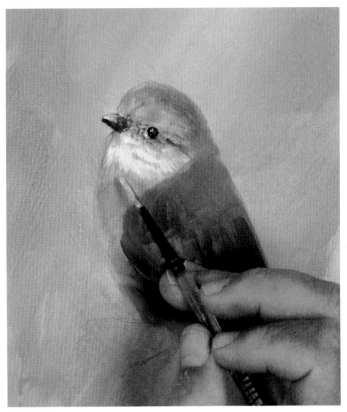

Step 21 Lighten the color with more white and add some smaller lighter strokes over the lights we applied earlier. Use contour strokes.

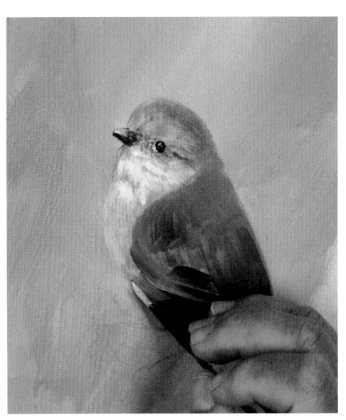

Step 22 Walk down the breast area with the light color. As you get to the shadows, lighten the pressure and make softer strokes.

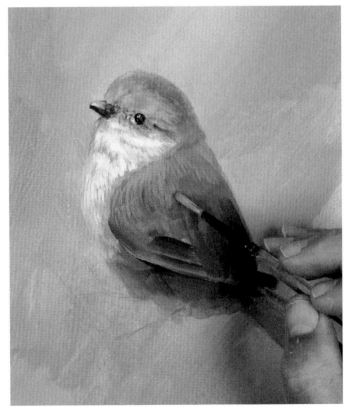

Step 23 Mottle the color with a little of the greys from the wing and add strokes to give the feathery look to the mantle and top of the wings.

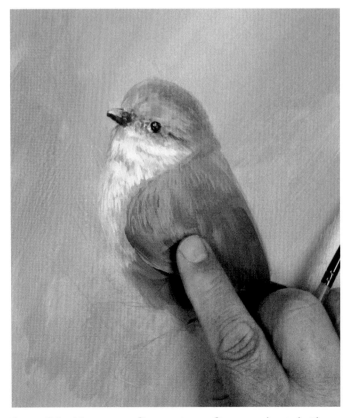

Step 24 Use your finger to soften and push the color into the previous tones. Notice how the tones modulate giving highs and lows which adds the interest we are looking for.

135

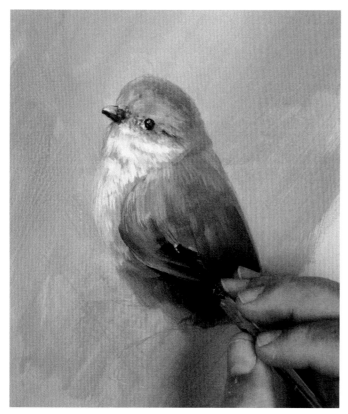

Step 25 Mottle the color with a little Burnt Sienna and Burnt Umber to make more brown and move through the wing again.

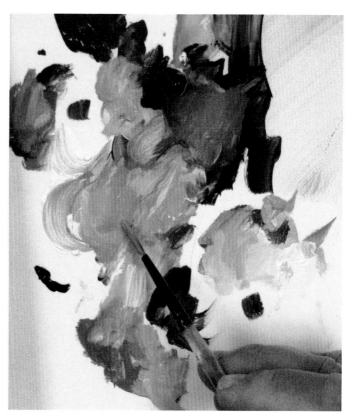

Step 26 Here you can see some of the color I am using on the palette. Notice the variations. We need to transfer this to the bird. Warm the grey with a little Yellow Oxide.

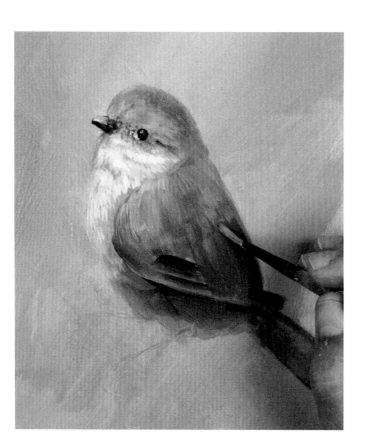

Step 27 Add a few strokes to the mantle of the bird to again add some warm tones that carry down the warmth from the top of the head.

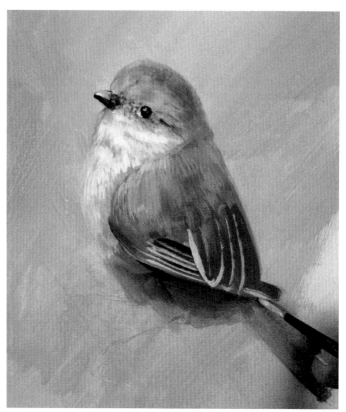

Step 28 Mottle the tone with more white to lighten. Add the edges of the flight feathers. On the one large feather in the center I also added a center vein line.

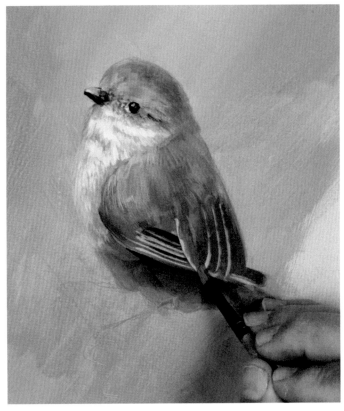

Step 29 Mottle the brush with some grey and brown and negative paint down the flight feathers to soften the edges of the white feathers.

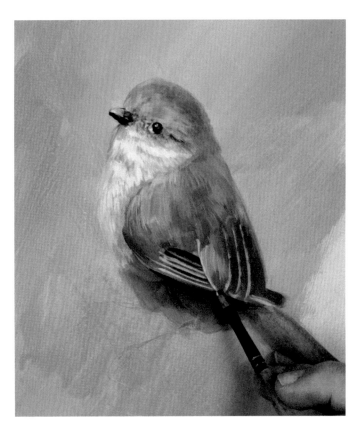

Step 30 Add lighter warmer tones we just used on the mantle down the center of the feather which helps lift it on top the others. Streak down the center.

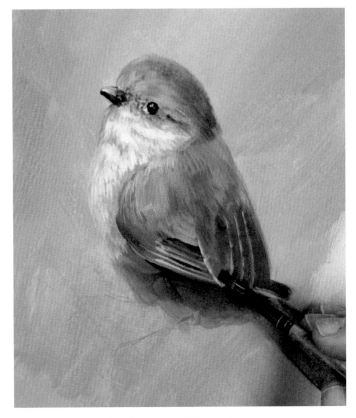

Step 31 Mottle the small flat with some darker values to soften and modulate the lighter tone we just added. Don't eliminate all the tone, just push it into the feather with some darks.

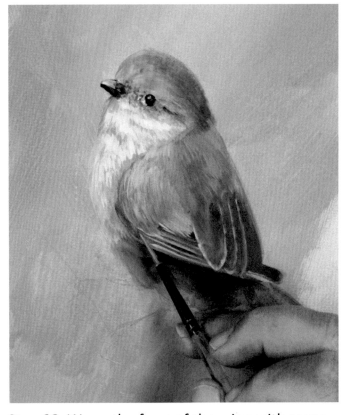

Step 32 Warm the from of the wing with some light Burnt Sienna tones. Vary the tones in the front of the wing.

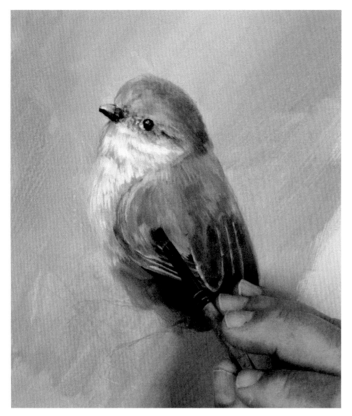

Step 33 I like to apply the light tone and then soften it into the feathers with some darks. This helps with the variations.

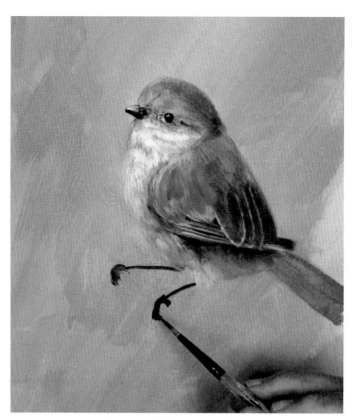

Step 34 Use the tip of the round and some darker greys from earlier to casually suggest the legs of the bushtit.

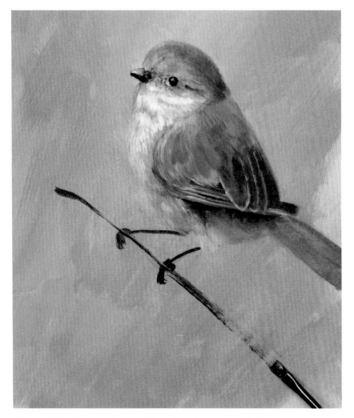

Step 35 Here I mottle the brush with some greys and Burnt Sienna and use the flat held very flat to drag over the surface and make the branch under the bushtit.

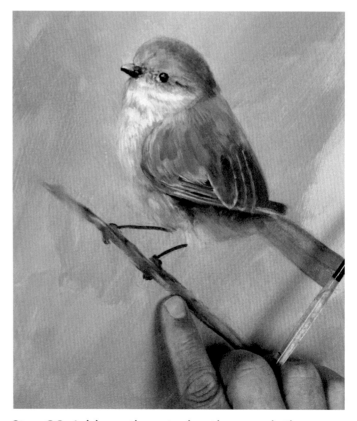

Step 36 Add another stroke, then push the colors into the slightly wet background to soften and blur the edges so it doesn't distract from the bird.

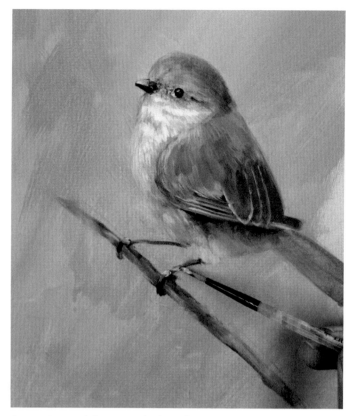

Step 37 Add some lights from his breast area to the legs to create a little more interest. Add a few strokes to the branch as well.

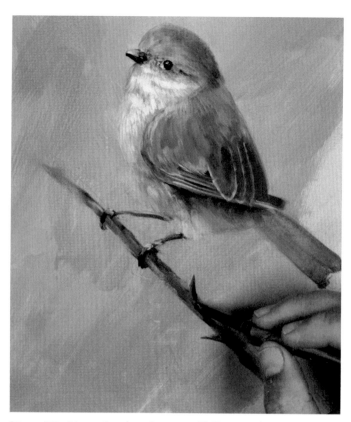

Step 38 Here I take the small flat and casually add thorns to the branch using a small triangle shape. I mottle the color with Burnt Sienna to make a little toned orange.

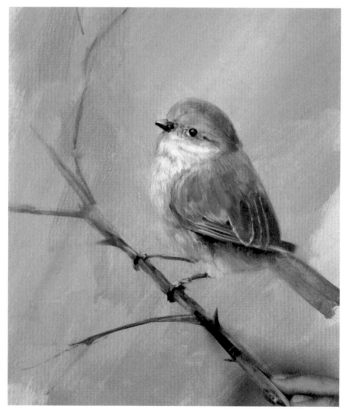

Step 39 Use that color to make some outer branches. Notice how they are more transparent and softer into the background.

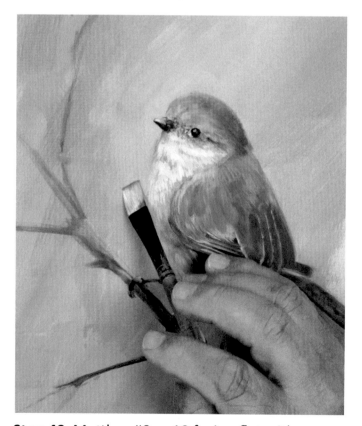

Step 40 Mottle a #8 or 10 fusion flat with some of the light blue light color and go around the top of the bushtit to clean up and bring him forward.

139

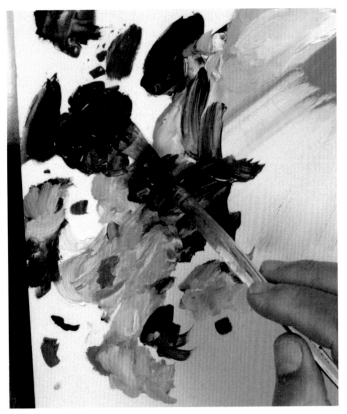

Step 41 Mottle the Pine Green with some Burnt Sienna to tone and then lighten with a touch Yellow Oxide and white.

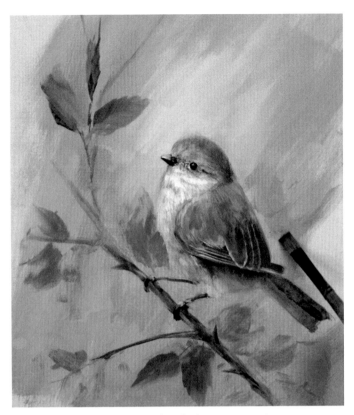

Step 42 Casually add leaf shapes to the composition. I stroke one side of the leaf then over to the other side after the color has almost run out. Pull to the center vein line.

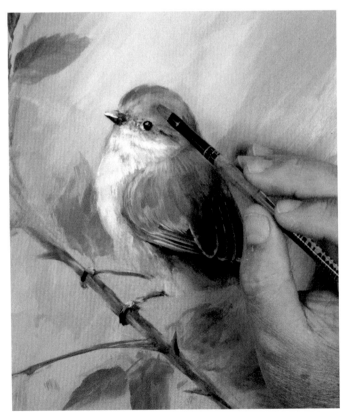

Step 43 Here I return to the bushtit to add some tones to the top of the head to create a little more contrast with the background and push him forward.

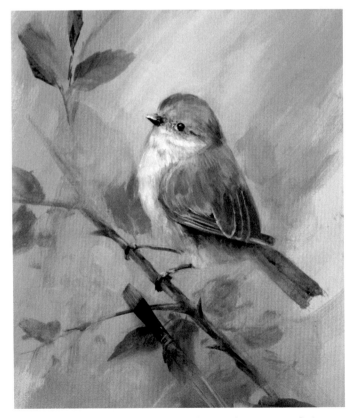

Step 44 Mottle Yellow Oxide with some of the light sky colors to soften it. Using the #8 or 10 fusion flat suggest the areas that we will paint the roses.

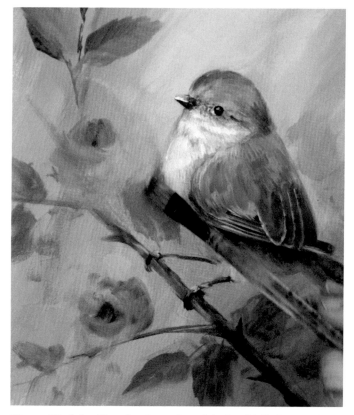

Step 45 Mottle the brush with Red Violet, Naphthol Red Light and Burnt Sienna. Using some transparent color softly suggest the centers to the roses.

Step 46 Mottle the brush with some of the base yellow, then lighten with additional white and touch more sky color to keep it soft. Build the color in the rose and soften the shadows.

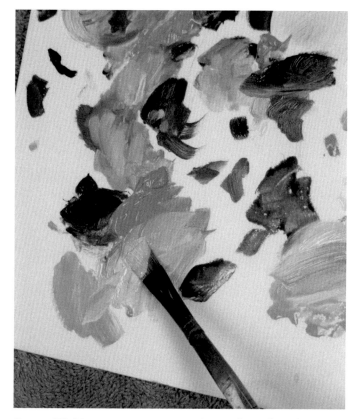

Step 47 Here you can see the colors for the roses. Mottle Yellow Oxide with more white and touch light blue sky color to keep soft.

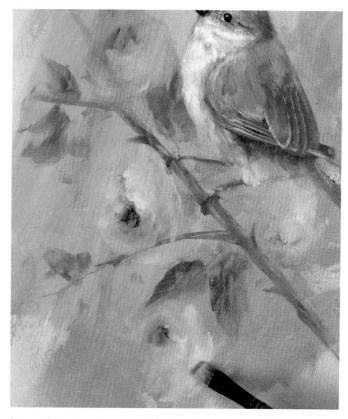

Step 48 Continue to build the roses with the light in the front. Use soft curved strokes and don't make petals until we build the movement first.

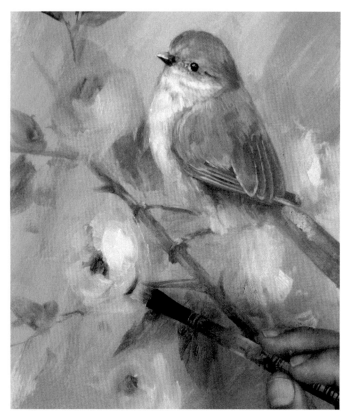

Step 49 Continue to build the color slowly making the roses more opaque in the front which makes them appear more round.

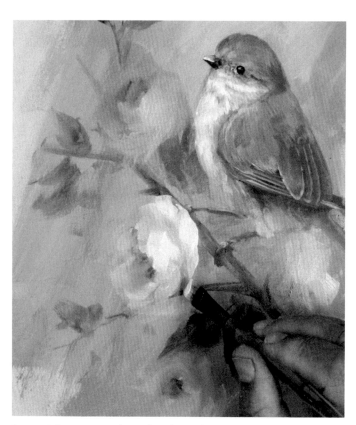

Step 50 Now edge the brush with more light color and casually. Notice how I leaves a little more of an edge near the bird to keep interest.

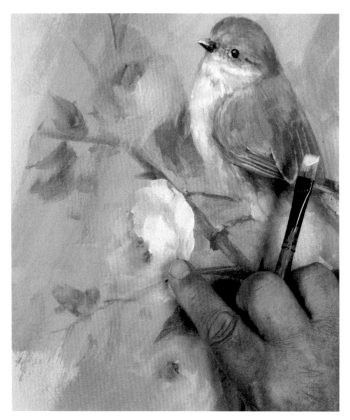

Step 51 Soften the outside of the rose with your finger, pushing the tone into the background to make the lost edge and recede the tone.

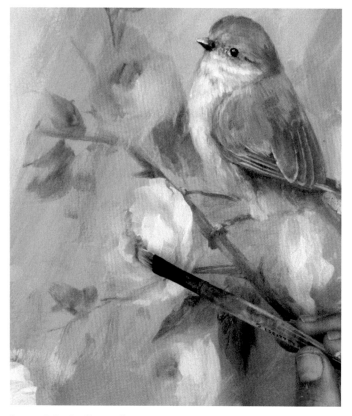

Step 52 Soften the movement in the center of the rose. The contrast in the roses shouldn't be more than the bushtit, and he is soft. Keep that in mind.

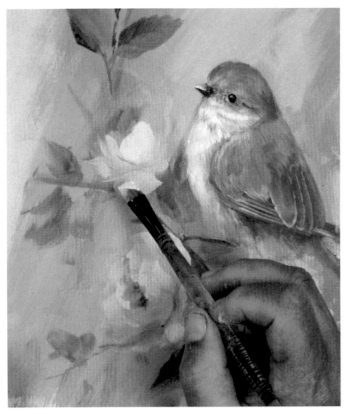

Step 53 Mottle the color with more white to lighten and build the from petals on the rose next to the bushtit. I pulled out for the petals. I vary directions to add some interest, but soft.

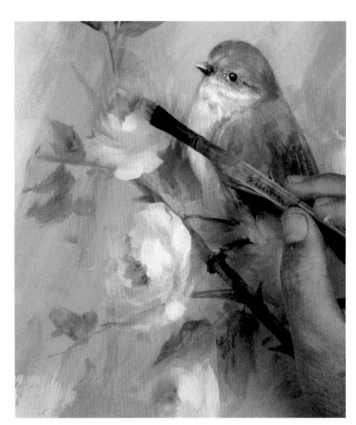

Step 54 Restate some of the soft reds into the center of the roses. Just paint for movement and keep the colors soft.

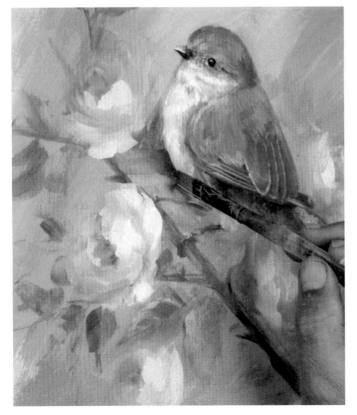

Step 55 Mottle the brush with darker greens and add next to the bushtit to darken and push the bushtit forward with contrast.

Step 56 Mottle the sky colors with additional white and even some light greens to harmonize the colors.

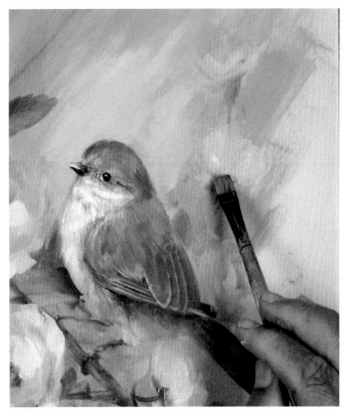

Step 57 Use this to suggest the back roses. Just a little more light and warm than the background. You should just see them.

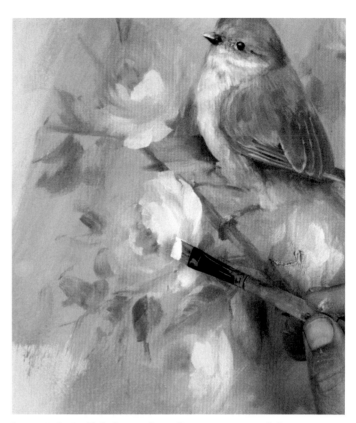

Step 58 Build the other front roses with more color, concentrating on showing some of the same light warm tones in the front of the rose as we used on the breast of the bird.

Step 59 Mottle the light blue sky with cool Red Violet and then lighten with white. This is a cool light for the shadow side.

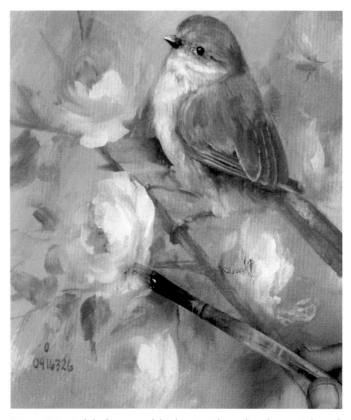

Step 60 Add the cool light to the shadow side of the roses. Soften the leaves and add a little to the bushtit to create harmony with the roses to finish. Enjoy!

Enlarge Pattern
127% to Original Size

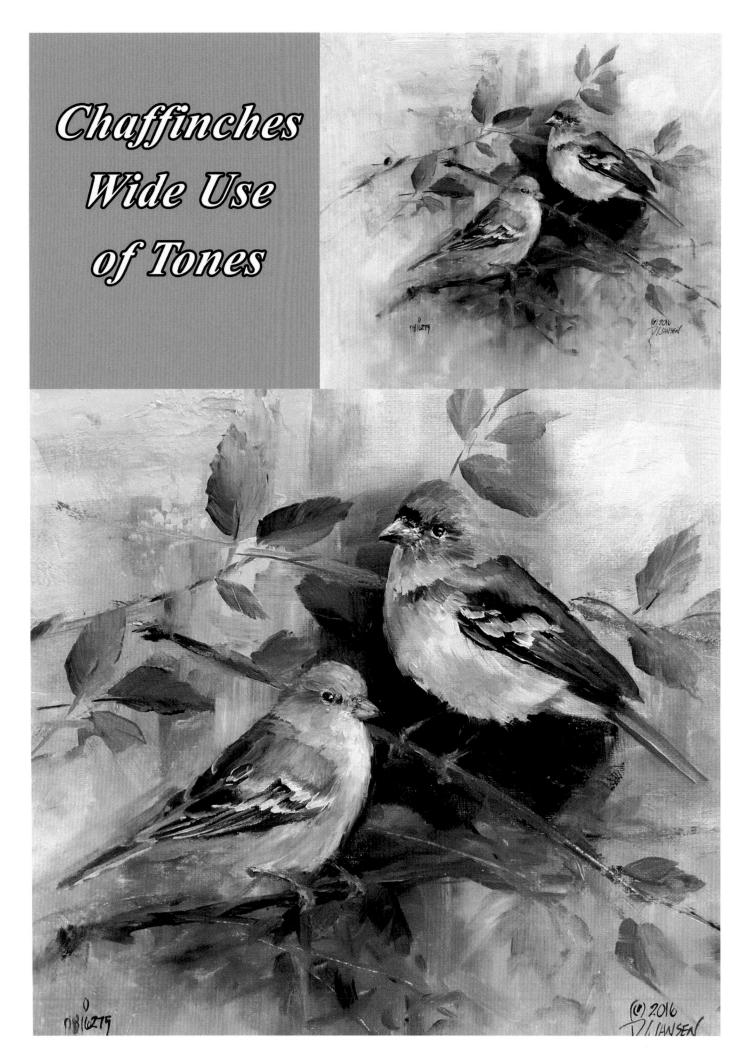

Chaffinches
Wide Use
of Tones

Chaffinches- Wide Use of Tones

Lastly, we will focus on a pair of Chaffinches. I have painted the male and the female separately in other paintings, but this one finally brings them together. This pair of Chaffinches is perfect for our last study of neutral tones. In nature, the male is often more colorful than the female. The male has the base tones of the female but is brighter with a broader spectrum of light and dark. What a wonderful painting experience!

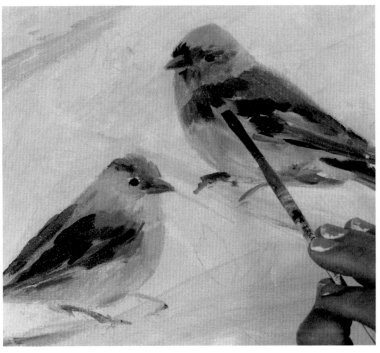

We will use the mixing strategies that we studied in the previous lessons. Both birds have warm browns and which must harmonize with the blue grey tones on the male's head and wings. These warm browns shift from the orange side to the blue side. There are greys tones that warm and cool. Adjust the intensity of orange so that male is more vibrant than the female. Mix light breast colors to work as common tone in both birds.

Then we increase the contrast between the pair with greens and add movement to the background. It is a fun way to add new and interesting compositions for our bird studies. Thank you for joining me in this book. I look forward to exploring new looks with you in the future. Let's give it a try!

Paint It Simply Palette
Base Color- Lt. Grey, White + touch Black and Yellow Oxide

Palette Colors

Paint It Simply Colors
Naphthol Red Light
Red Violet
Carbon Black
Phthalo Blue
Hansa Yellow
Titanium White

Additional Palette Colors
Pine Green
Burnt Sienna
Yellow Oxide

Wood Surface
14 X 18 Wood or canvas panel

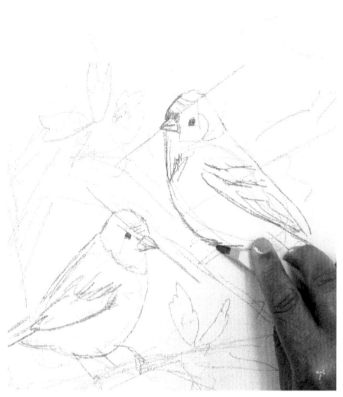

Step 1 Just like the earlier lessons, I like to sketch on the birds making them a little darker than normal so I can go over them with color and not lose the idea design.

Step 2 Mottle White with touch of Phthalo Blue, Burnt Sienna and Carbon Black to make a light blue grey. Use 3/4 inch brush.

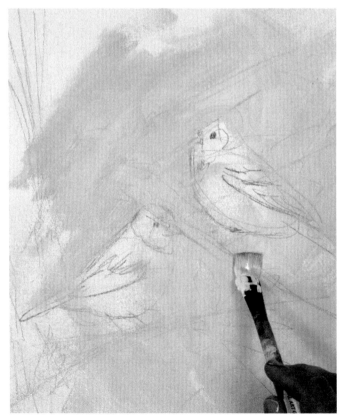

Step 3 Begin by adding the color around the birds and dragging off into the background.

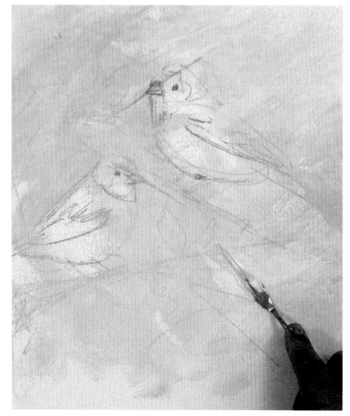

Step 4 I pick up additional white + background color. Using the palette knife very flat, begin to add some interest and soft color movement to the background. Hold knife flat!

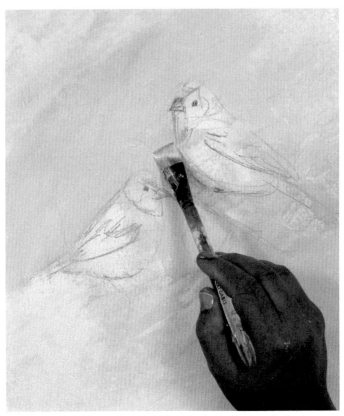

Step 5 Brush some of the color around the birds to fill in the canvas. Soften the color around them so they will come forward.

Step 6 Using the #4 fusion flat mottle Burnt Sienna with Yellow Oxide and Hansa Yellow to make a toned orange. Add a little of the greys from the background to vary color.

Step 7 Begin basing in the body of the male. Leave a little space for the eye and eye ring. Use short contour following strokes.

Step 8 Mottle the color with additional Black, Yellow Oxide and White to soften and lighten the color.

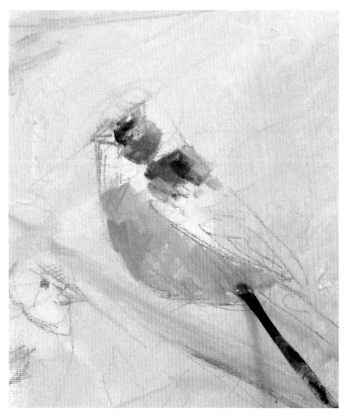

Step 9 Use this softer toned orange to base in the breast area of the male. Make more grey as you head to the tail of his body.

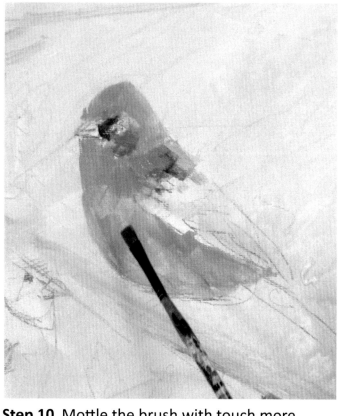

Step 10 Mottle the brush with touch more black and tiny touch blue to make light blue grey and add to the shoulder, head and under the wing on the body.

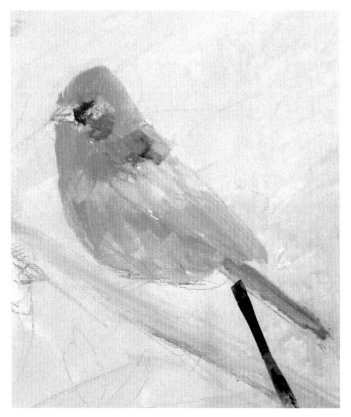

Step 11 Vary the grey and add long strokes for the tail. Vary with Yellow Oxide and Burnt Sienna.

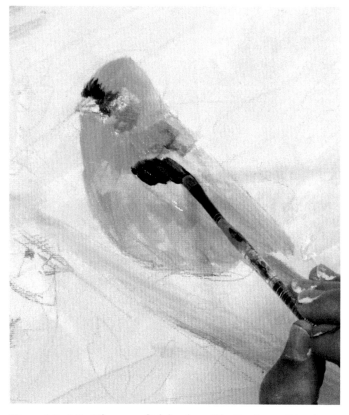

Step 12 Mottle a soft black with Carbon Black and touch soft greys to soften the color. Add this to the color band above the beak and shoulder of male.

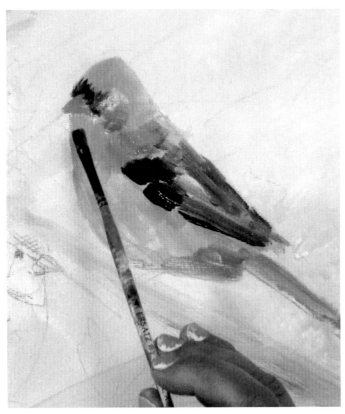

Step 13 Mottle the brush with the chest color then add additional Burnt Sienna and Yellow Oxide to darken. Add the color to the neck area of the male.

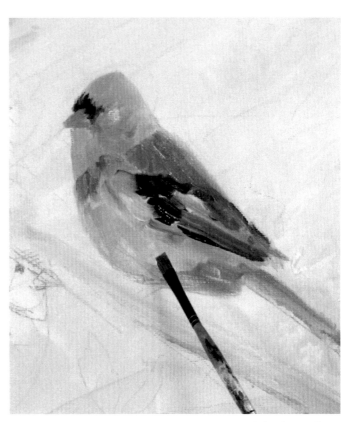

Step 14 Add more Burnt Sienna and darken the mantle and the transition area of the neck.

Step 15 Mottle a soft tan color with the oranges with a touch of black and white.

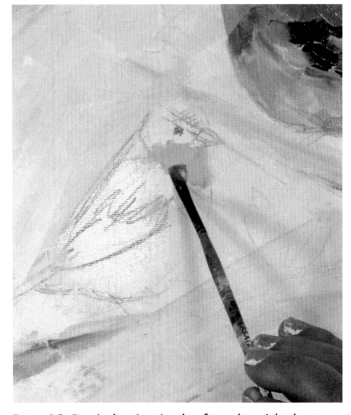

Step 16 Begin basing in the female with the tan color. Start at the neck. Use short contour following strokes.

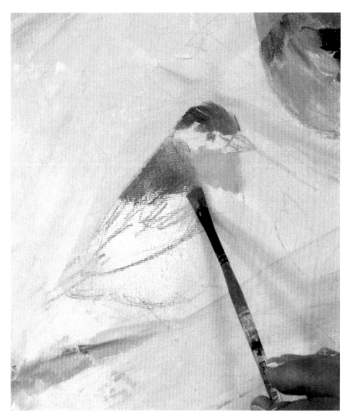

Step 17 Mottle the color a little darker with Burnt Sienna and tiny touch black to tone. This will make a softer light brown. Add to the mantle and top of her head.

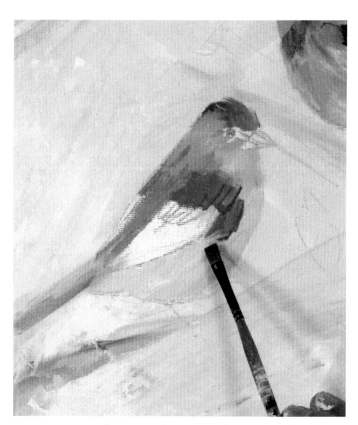

Step 18 Mottle same breast color as male and add to her chest. Mottle a little darker grey to the breast under the wing.

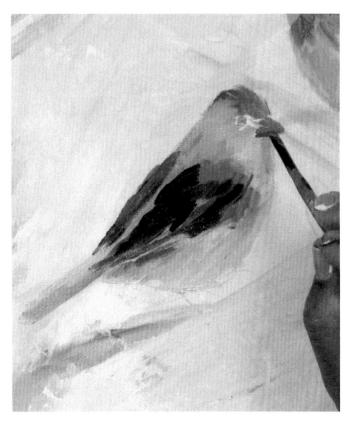

Step 19 Add darks under her wing and tail. Then add bands of darks in the wings with larger strokes to suggest flight feathers. Add darker brown to the beaks with corner of brush.

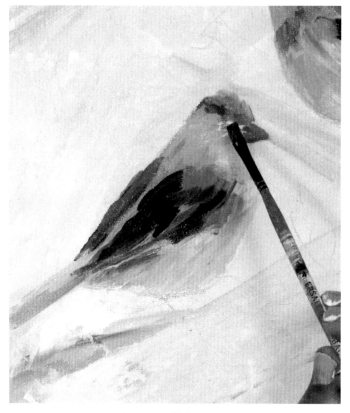

Step 20 Corner the small flat with the browns we used on the top of her head. Tap in some darks between the beak and the eye using the corner of the brush.

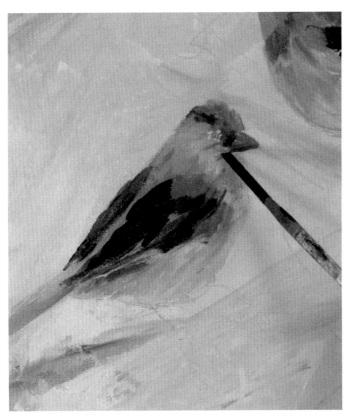

Step 21 Soften the darks down into the neck by stroking a few short strokes down her neck.

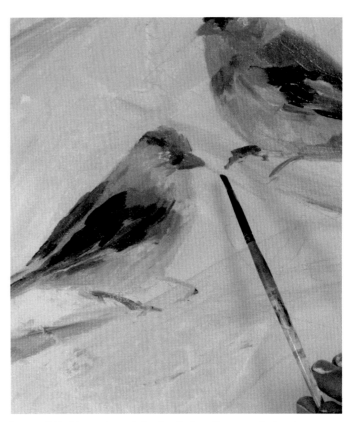

Step 22 Use the chisel of the flat and the brown to begin to suggest the legs of the Chaffinches. Using the round brush, base in the eye with Burnt Sienna and then darken with black.

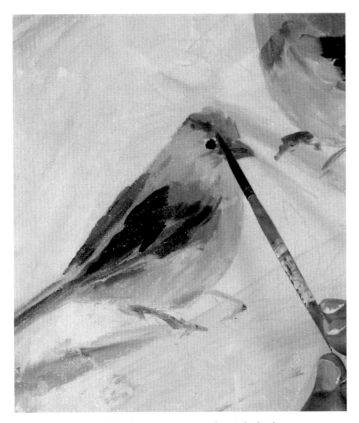

Step 23 Mottle the # 4 round with lighter tan colors and add smaller contour following strokes to the top of her head.

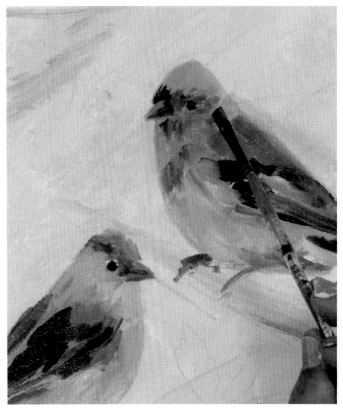

Step 24 Mottle the # 4 fusion flat with light grey and soften the color exchanges in his head. Use contour following strokes.

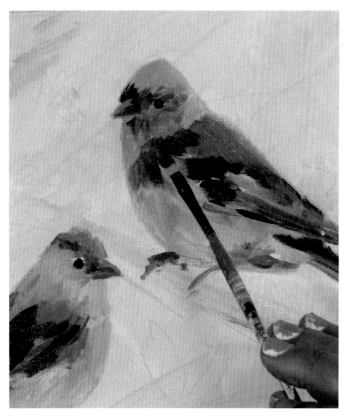

Step 25 Mottle the brush with Burnt Sienna and add short shadow strokes to the shoulder of him. Vary the length to look like feathers.

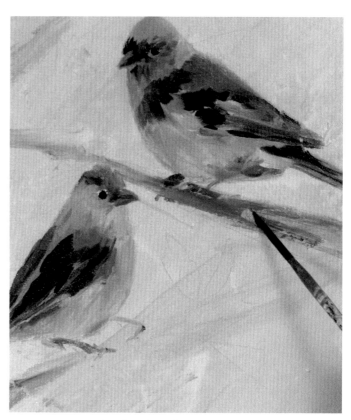

Step 26 Mottle the brush with browns from the birds and then add a tiny touch of Pine Green. Drag this over the surface to begin the branches they are sitting on.

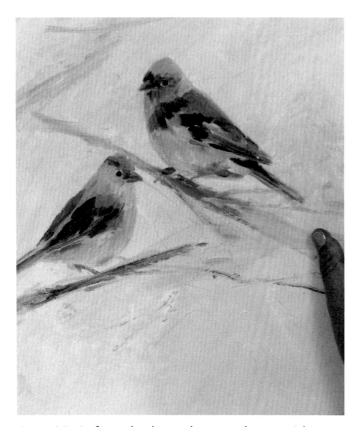

Step 27 Soften the branches on the outside edges with your fingers.

Step 28 Mottle the large 3/4 inch with yellows, Burnt Sienna and a touch Pine Green. Make sure you vary the tones, don't over mix.

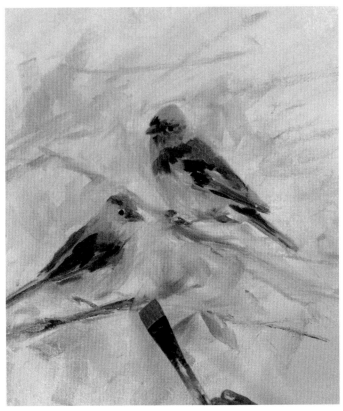

Step 29 Using light pressure, mottle the background around the birds with greens to suggest the movement of tree leaves.

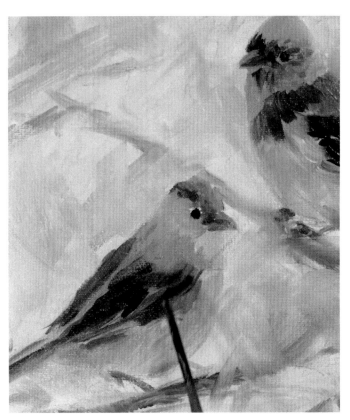

Step 30 Take some of the greys from the head of the male and add to the top shoulder of the wing on the female.

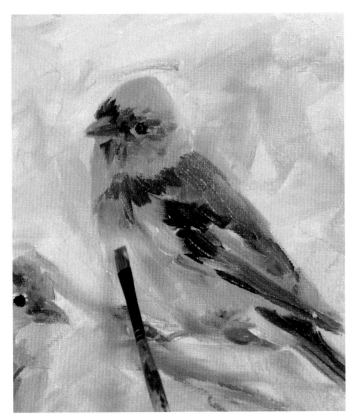

Step 31 Mottle the brush with the oranges and then lighten with white until the color is lighter than the breast. Add to the male with contour strokes.

Step 32 Mottle the light orange from the male with additional light tan color to soften the color.

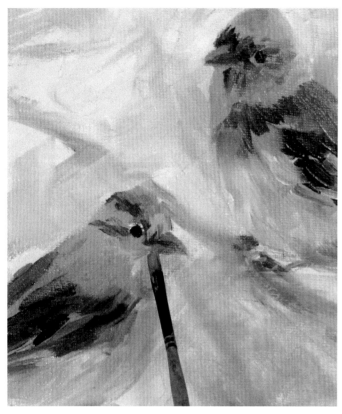

Step 33 Using this to soften the color exchanges between the areas of color on the female. Add additional lights under her beak.

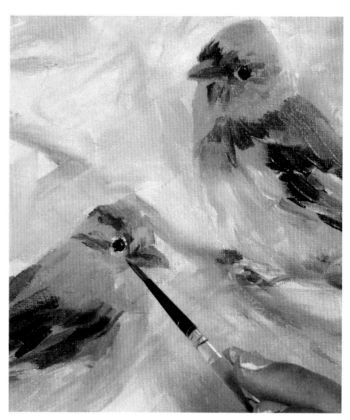

Step 34 Use the tip of the round to add smaller darker feathers and details between the eye and the beak.

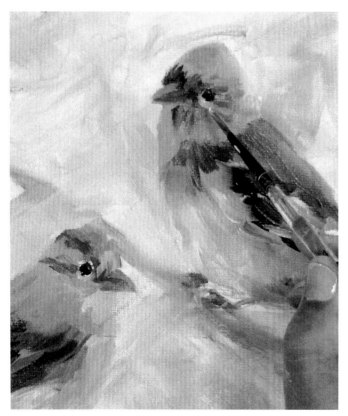

Step 35 Mottle the tip of the round with very light orange and begin to shape the eye ring on the male.

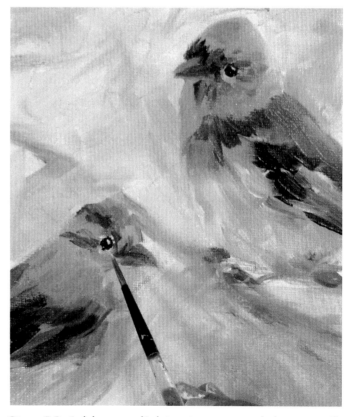

Step 36 Add some lighter tan around the eye of the female to suggest the eye ring. Use a soft grey or light tan to add a shine to the eye.

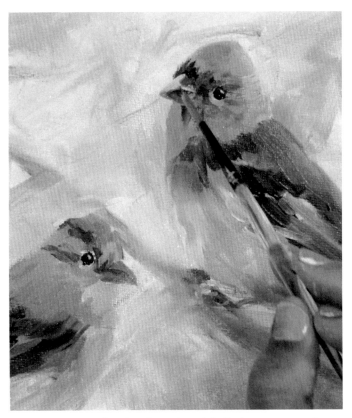

Step 37 Mottle the brush with light grey and add the top of the beak to the male. Leave some of the darker grey from earlier.

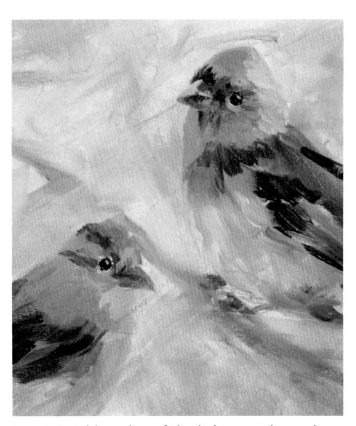

Step 38 Add strokes of the light grey down the back of the head and around the neck a little. Vary the lengths of the strokes.

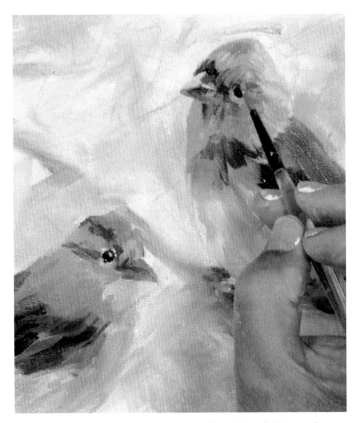

Step 39 Lighten the grey and add additional strokes. Then mottle the oranges and bring the colors together with smaller strokes.

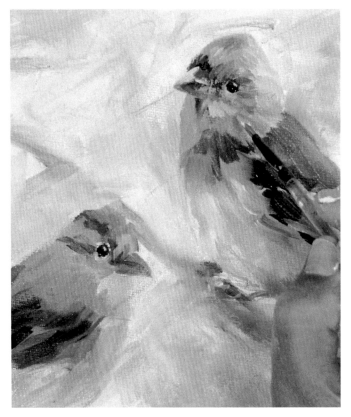

Step 40 Mottle the color a little lighter and add strokes of light to the cheek area and up around the beak.

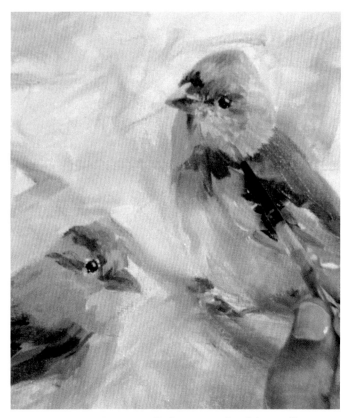

Step 41 Continue to lighten and add small strokes around the face. If you get too much, negative paint it out with some darker tones.

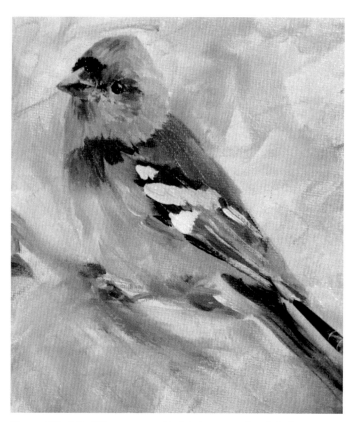

Step 42 Mottle a very light tan and add the white bands to the wings and then the long strokes to suggest the flight feathers.

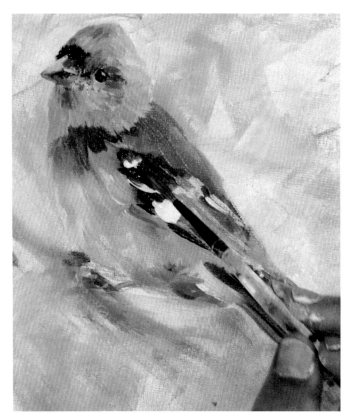

Step 43 Mottle darker brown with Burnt Sienna and Black. Negative paint the white bands on the wings pulling down to leave just a little white at the tips of the wings.

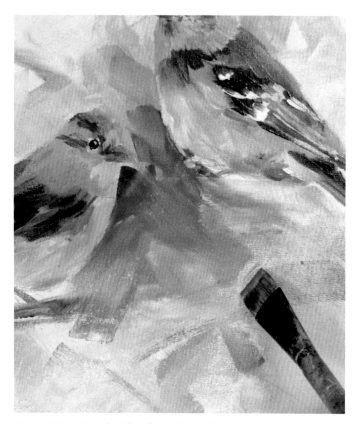

Step 44 Mottle the brush with greens and add soft Pine Green between the birds to darken that area and create more contrast for the birds.

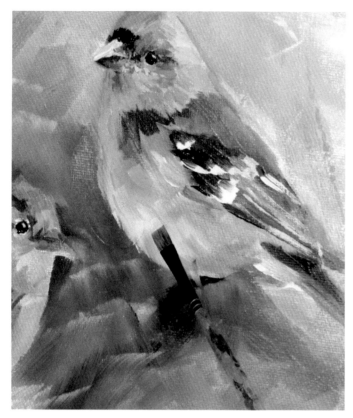

Step 45 Mottle the smaller flat with more white and lighten the breast with additional strokes. Add a few strokes of brighter orange for some contrast.

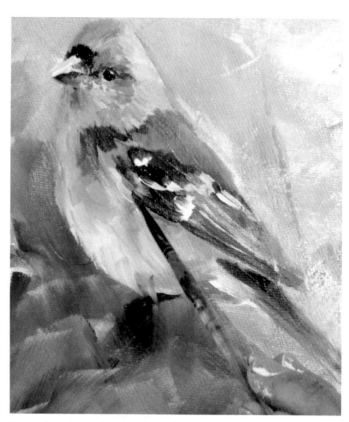

Step 46 Mottle the brush with whites and pull feather strokes over to the wing to set the wing into the body.

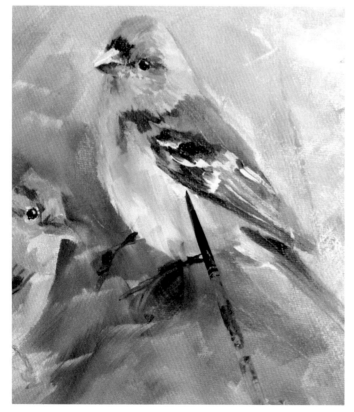

Step 47 Lighten the color and then add light along the wings. Pull down to give movement to the body feathers. Keep these soft.

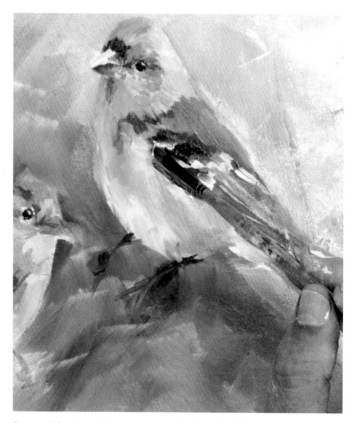

Step 48 Continue to work the lights and then the oranges to weave the colors back and forth to make the different feathers.

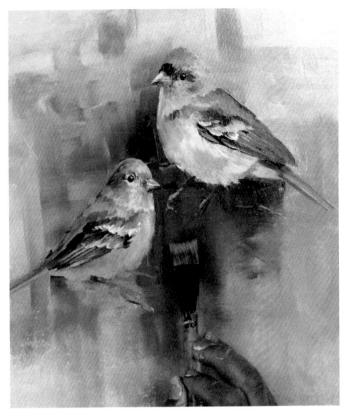

Step 49 Mottle the 3/4 inch flat with some additional Pine Green and Burnt Sienna and darken the color between the birds. I pull in up and down and side to side motions.

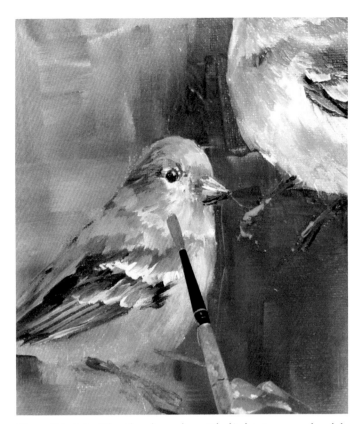

Step 50 Mottle the brush with light tan and add lighter feathers to her face. Add the white to the wings and negative paint like we did on the male.

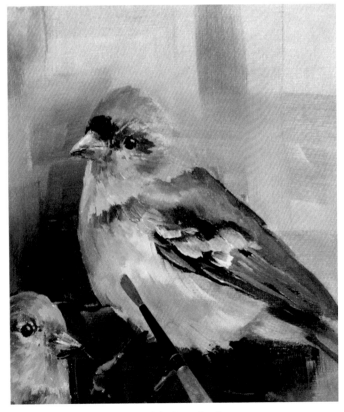

Step 51 After you add the dark greens, restate some of the oranges on the breast of the birds to clean up the edges, making found edges that bring them forward.

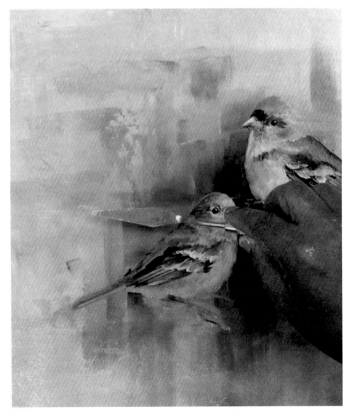

Step 52 Mottle Phthalo Blue with White to make a very light blue. Use the palette knife very flat to add strokes of light blue over the greens for interest.

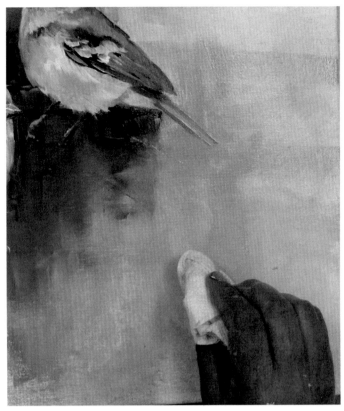

Step 53 Add some lights to the lower section. To vary the look, I soften the color together with strokes of the paper towel. This gives a different look than the palette knife.

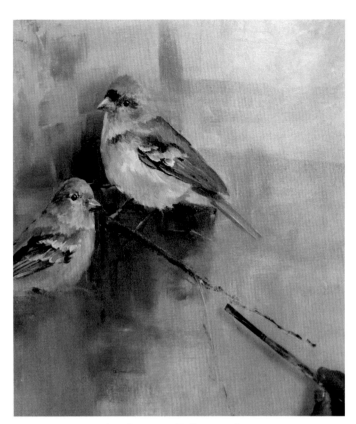

Step 54 Mottle the small flat with Burnt Sienna and touch Pine Green and drag over the surface to begin the branches again.

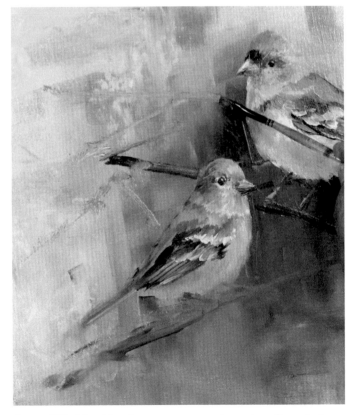

Step 55 Mottle the movement and soften into the background with the brush and palette knife. Very the pressure so some are very soft.

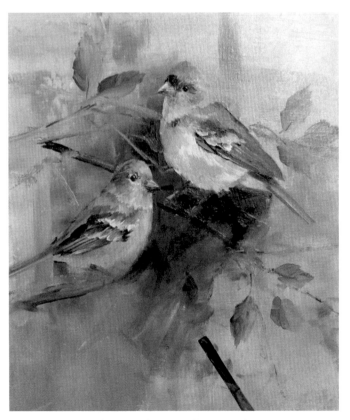

Step 56 Mottle a soft toned green by mixingPine Green with some browns. Begin leaf shapes. Make the leaves more brown and transparent on the outsides.

161

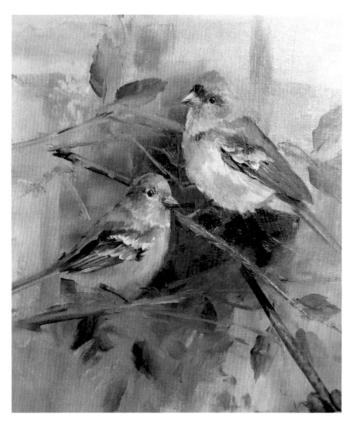

Step 57 Build the branches even more with additional dark browns and greys from the birds.

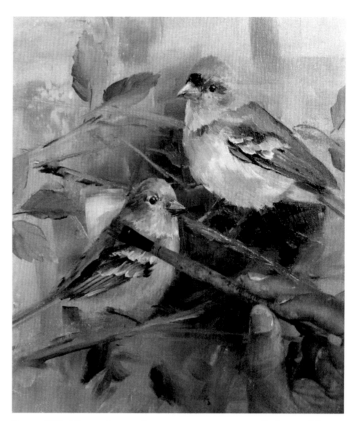

Step 58 Here I put in some contrast light. I like to do this in florals and birds. Mottle the brush with light blue and add casual strokes behind the female. It is through light.

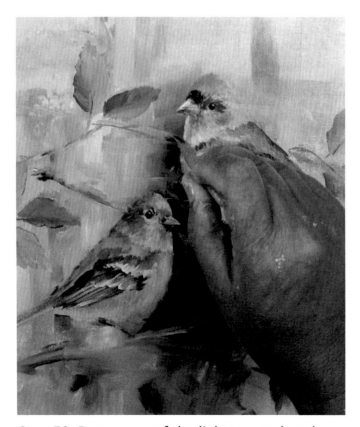

Step 59 Drag some of the lights up and to the sides to soften the light into the leaves.

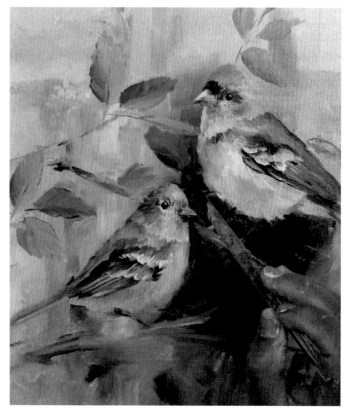

Step 60 Restate some dark leaves around the bird. This also contrasts the blue sky color creating more interest around the birds.

Step 61 Soften the blue with grey and add light to the bottom for soft background interest.

Step 62 Mottle the tip of the round with some light tan and clean up the edges of the female Chaffinch.

Step 63 Here I decided to lighten some of the details on the female Chaffinch to give additional contrast to her face area.

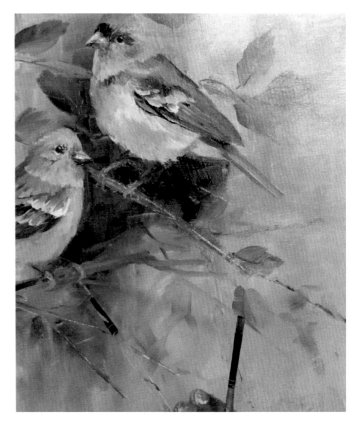

Step 64 I decided to add soft leaves to the light grey area we just added. This gives the impression of some lost leaves and more depth interest to the painting.

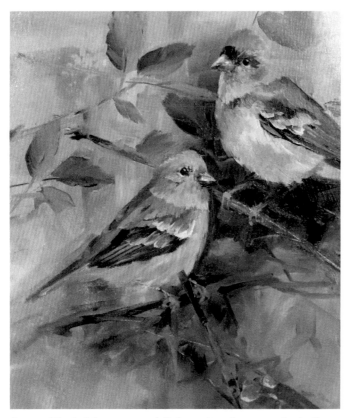

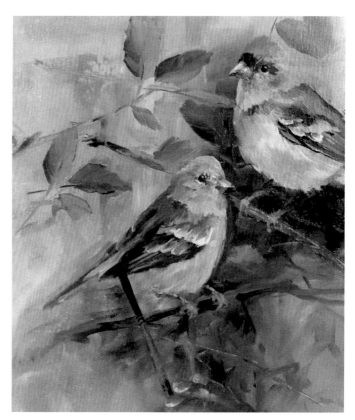

Step 65 Add some additional colors to their feet and then add a few extra strokes of light color over the feet to set them into the body.

Step 66 Here I am cleaning up the edges of her wing and defining them. Since we have more details in the center of the design, we can add additional detail interest to her.

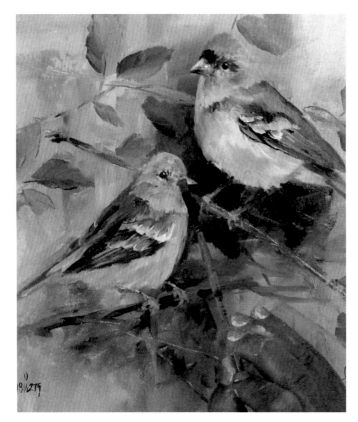

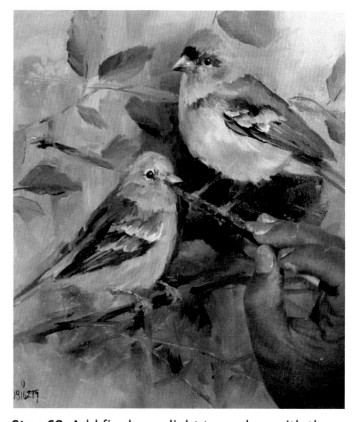

Step 67 I added a little more dark between the birds for contrast. Then I cleaned up the edges of the female with more tan color to bring her forward.

Step 68 Add final very light tan colors with the tip of the round or quill brush. Make very small strokes for feathers to finish. I hope you enjoy and have a great time painting birds!

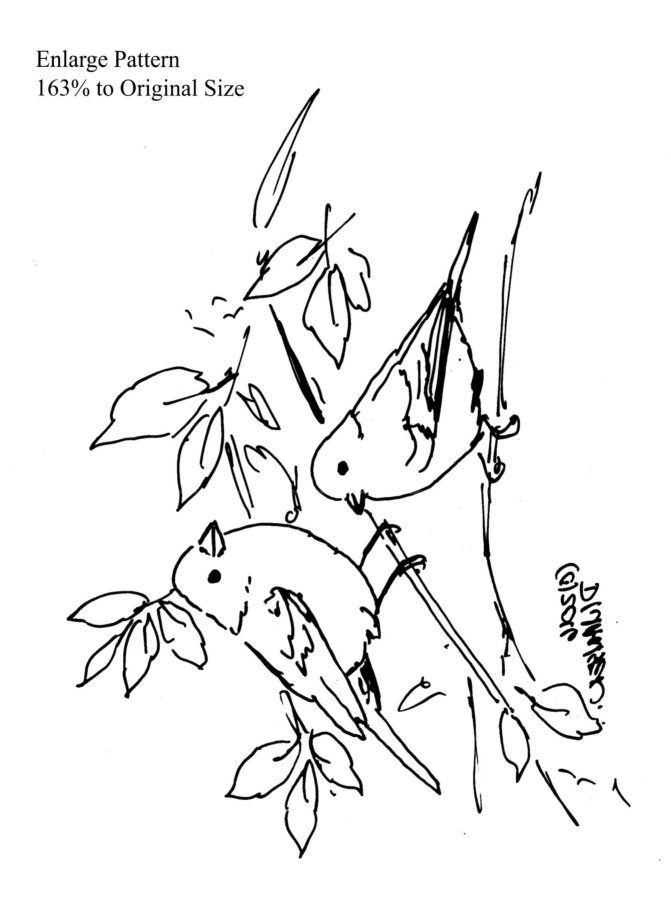

Paint It Simply - Art Videos Direct
Art and Painting Made Simple

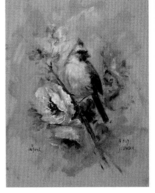
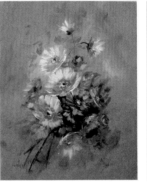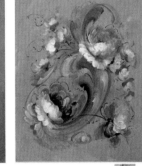

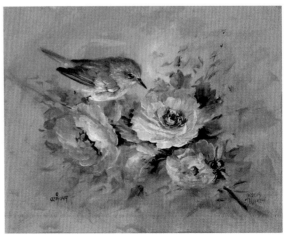

Made in the USA
Middletown, DE
06 January 2019